WATERFALLS OF ONTARIO

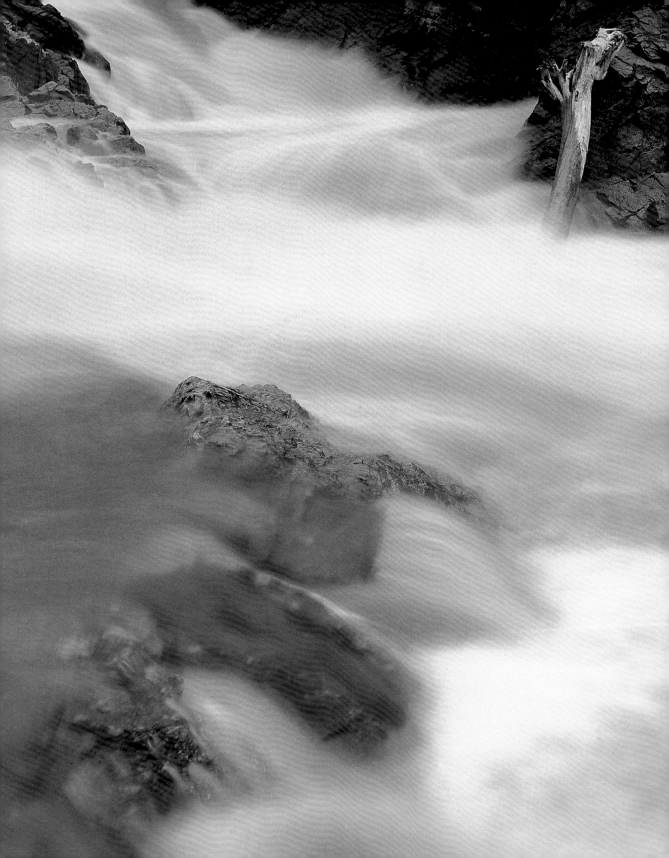

WATERFALLS
OF ONTARIO

Photographs by GEORGE FISCHER

Text by MARK HARRIS

FIREFLY BOOKS

A FIREFLY BOOK

Published by Firefly Books Ltd. 2003

FIRST PRINTING

Publisher Cataloging-in-Publication Data (U.S.)
(Library of Congress Standards)

Harris, Mark, 1970-
 Waterfalls of Ontario / Mark Harris;
 photography by George Fischer. – 1st ed.
[224] p.: ill., photos. (chiefly col.), maps; cm.
Includes index.
Summary: Illustrated guide to eighty-two waterfalls in
Ontario; including photographs, history, geological
features, and regional maps.
ISBN 1-55297-767-6 (pbk.)
1. Waterfalls—Ontario—Guidebooks. 2. Ontario—
Guidebooks. I. Fischer, George, 1954– . II. Title.
551.484 21 GB1425.N4.H37 2003

National Library of Canada
Cataloguing-in-Publication Data

Harris, Mark, 1970–
 Waterfalls of Ontario / text by Mark Harris;
 photography by George Fischer.
Includes index.
ISBN 1-55297-767-6
 1. Waterfalls—Ontario—Guidebooks.
 I. Fischer, George, 1954– II. Title.
GB1430.O58H37 2003 551.48'4'09713
C2003-902809-7

Published in the United States in 2003 by
Firefly Books (U.S.) Inc.
P.O. Box 1338, Ellicott Station
Buffalo, New York 14205

Published in Canada in 2003 by
Firefly Books Ltd.
3680 Victoria Park Avenue
Toronto, Ontario, M2H 3K1

Design: Lind Design, Guelph, Ontario
Printed in Canada by Friesens, Altona, Manitoba

The Publisher acknowledges the financial support of the Government of Canada
through the Book Publishing Industry Development Program for its publishing activities.

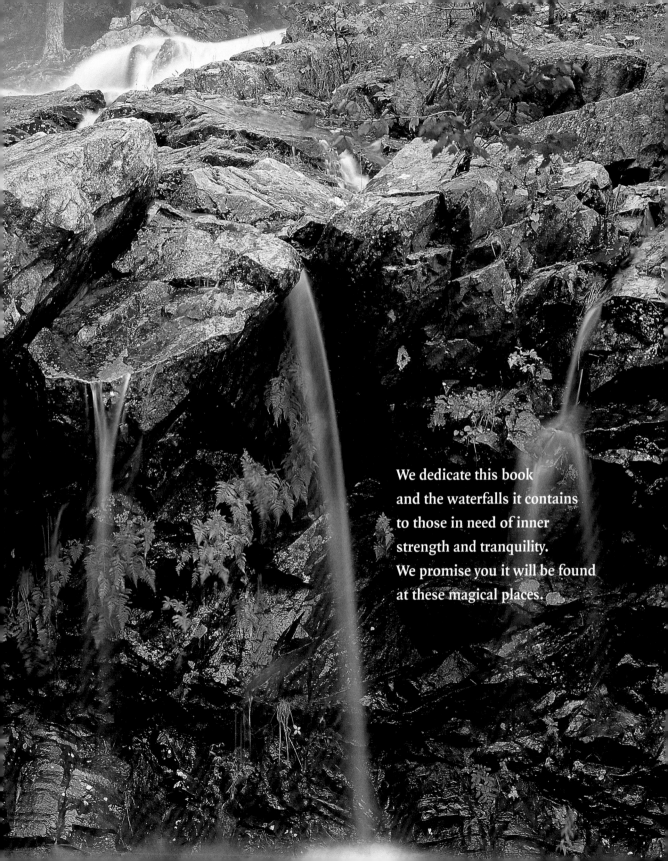

We dedicate this book
and the waterfalls it contains
to those in need of inner
strength and tranquility.
We promise you it will be found
at these magical places.

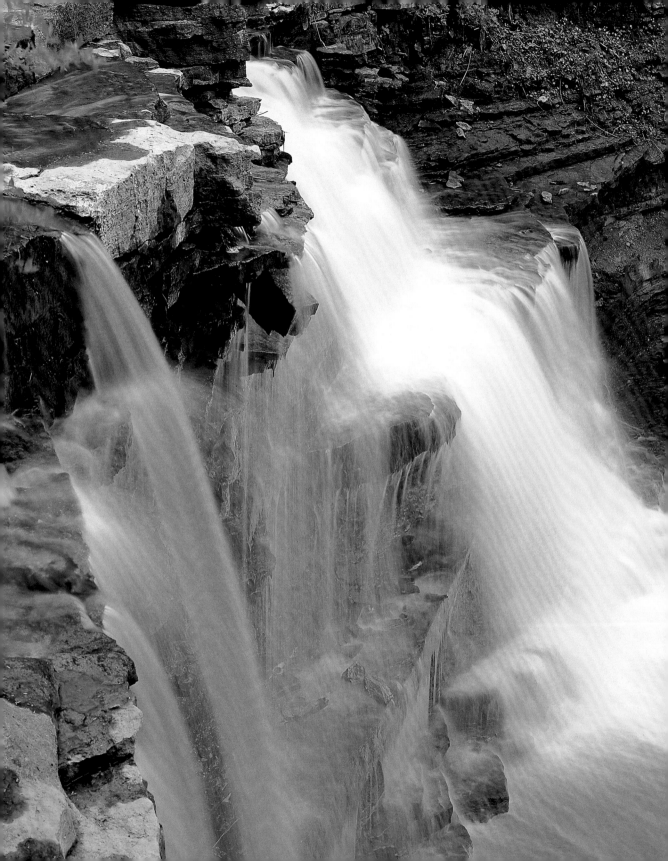

CONTENTS

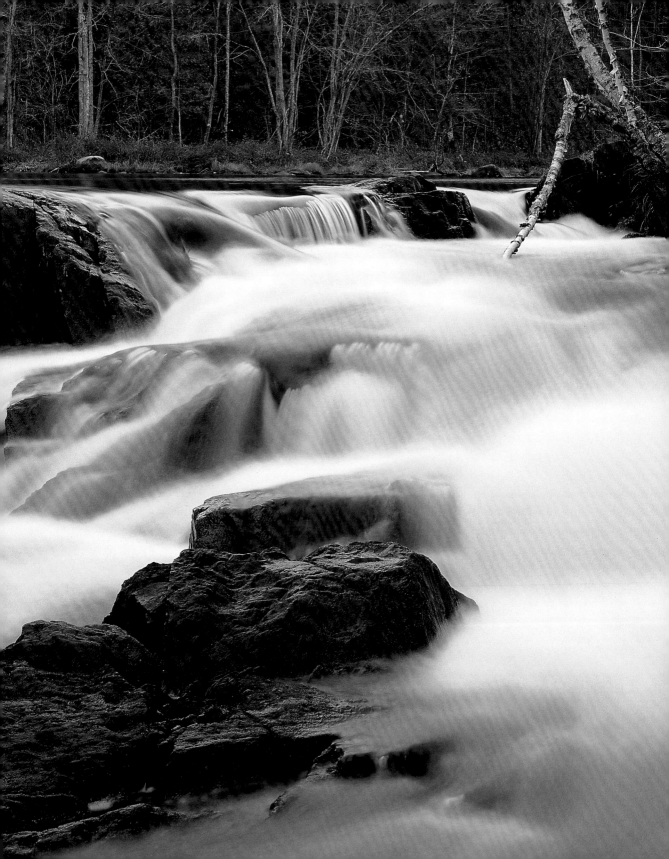

ACKNOWLEDGMENTS

I WOULD LIKE TO THANK the staff of Daymen Photo Marketing – Dave Lemieux, Dieter Frank, Tim McCrimmon and Kevin Lee – for keeping my Mamiya 645af in top working order and for spare cameras and parts when I lost mine in waterfalls. To Jean Lepage, my good friend and assistant, for all the great technical help, moral support and encouragement, and for telling me when a waterfall was too dangerous to climb. Thanks to the Algoma Central Railway in Sault Ste. Marie for the excursion to Agawa Canyon to photograph the three magnificent waterfalls there. To Mark Harris for the unbelievably detailed directions to many of the waterfalls in this book – I never would have found them if not for your directions. To the gang at Steichenlab, thanks for the great job in developing all my waterfall slides – pulled 1 stop! Finally, thank you to the Tim Hortons chain of restaurants. No matter where I was in Ontario, no matter how remote the locale, somehow, magically, a Tim Hortons always appeared out of nowhere, where I could nourish myself with a good soup and sandwich – really!

– GEORGE FISCHER

George Fischer with Jean Lepage

A BRIEF THANKS to everyone who helped me through this project – not only to those who helped during the research and writing of the book itself, but also those who opened my eyes to the beauty of the landscape in which we live. Finally, a special thanks to my wife, Lisa, who has really put up with a lot during the completion of the book. I wouldn't have finished without your encouragement and understanding.

– MARK HARRIS

Mark Harris

FOREWORD

by George Fischer

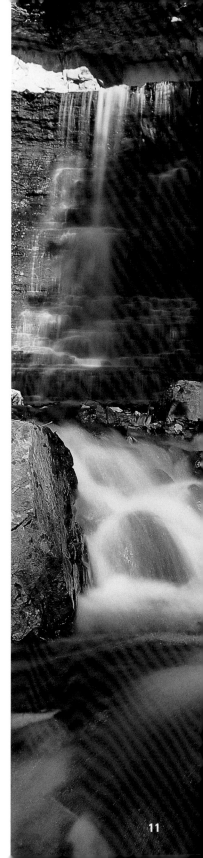

IT WAS A SUNDAY AFTERNOON, my son Sean's 13th birthday and I had just spent the previous two days photographing waterfalls in the Ottawa-Carleton region. On the long drive home to Toronto, my mind drifted back to all the other waterfalls I'd photographed. I reminisced about what I had seen, where I had traveled and what it meant to me. It had been precisely 409 days since I began this project – over a year had gone by in a flash.

After the tragic events of September 11, 2001, I thought about using my photography to produce a book that would help all the people affected. Many individuals suffered enormous loss – of loved ones, trust and innocence. I felt that what people might need most was a chance to connect with their loved ones, embrace spirituality and live for the moment. Maybe by going into nature for a place to meditate, people suffering from stress, loss and depression would at least have a few moments of tranquility and inner peace.

I myself have suffered from chronic depression for over two decades. Thankfully, I have had many years free from the disease, but there have nevertheless been some very difficult years as well. During those times when the depression lingered over me like a dark cloud, I could always find solace in nature. One of my favorite ways of coping was to spend an afternoon at a nearby waterfall. I would sit on a rock, close my eyes and meditate. I could feel the gentle spray on my face and hear the muffled, yet continuous sound of water splashing and rushing over the rocks. Waterfalls left me feeling rejuvenated, in better spirits and always stronger.

I've experienced over a hundred waterfalls, from the very powerful and thundering Niagara Falls to the gentle and sublime Washboard Falls. I have traveled to the "four corners" of the magnificent province of Ontario and all the places in between. Each waterfall was unique and beautiful, and finding them filled me with a sense of anticipation and excitement. Walking through the woods and hearing the muffled roar of water in the distance always

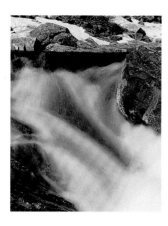

quickened my pulse – and my footsteps. The first glimpse of a white veil of water never failed to inspire me.

To get the best photos, I often climbed down to the base of the waterfall and stood waist-high in the middle of the river with water rushing around my legs and tripod, feeling the force of the river trying to push me downstream. I also stood on the brink of waterfalls before they plunged into the pools below, and even managed to squeeze behind some falls and watch the curtain of water tumble in front of me.

Looking back now, I certainly took a lot of risks in trying to find the best vantage point, the most beautiful angle or the right time of day in which to portray a particular waterfall, but the danger never entered my mind – not even once. This is not to say I didn't have any close calls. Twice, I accidentally slipped on wet rocks, sending my camera and tripod into the raging white foam. I also left lenses behind on rocks, lost rolls of film and dropped my light meter into the river.

Of all the waterfalls we visited, I enjoyed the smaller ones most because of their intimacy, but I can't truly admit to having a favorite one from all the ones I photographed – and I have accumulated over 5,000 shots. What I can admit is that each waterfall had something special to offer, whether it was a glorious rainbow, an early morning mist or a rising moon.

My only major disappointment was that certain waterfalls in the Niagara, St. Catharines and Hamilton areas were spoiled by the garbage in the river. Many waterfalls contained discarded tires, rusted bicycles and shopping carts, beer bottles and, in one case, an entire sofa. I ask the municipalities in these regions to engage in a concentrated clean-up effort to return these waterfalls to their original state of beauty. I also ask all visitors to the falls to clean up their garbage and perhaps even the garbage of others so that we can all enjoy the natural beauty of these waterfalls.

As a final note, I want readers to be aware that I spent countless hours searching the Internet, spent a small fortune on topographical maps and picked the brains of Mark Harris and Rob McAleer for information on the locations of most of the waterfalls in Ontario. I know that I have missed a few, so I am apologizing in advance if I missed a waterfall in your region or town. Please e-mail me at info@georgefischerphotography.com if you have found a "missing" waterfall.

I hope that as you discover the waterfalls that are contained in this book you also find the peace, beauty and inner tranquility you are searching for.

PREFACE

by Mark Harris

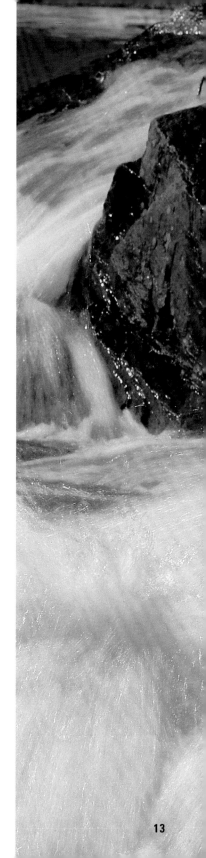

I THINK IT ALL STARTED with my family's excursions to cottage country. My earliest recollections of walking across the crusty, lichen-covered bedrock of Muskoka are surpassed only by memories of magical rapids and chutes of water foaming across the barren landscape. Compared to the suburbia of north Toronto, this land of rock, water and woods seemed like a wonderful new world.

Several years later, when I was a Physical Geography student at Brock University, I was introduced to waterfall appreciation in a more formal way. Each week, my professors would drive us down "Field Trip Road" to various nearby sites along the Niagara Escarpment. Balls Falls, Rockway Falls and Swayze Falls were natural laboratories in which we learned the finer details of geomorphology, hydrology and sedimentology, as well as a few more "ologies" that I've forgotten over the years.

When I inherited my grandfather's manual camera a few years later I began to seek out interesting landscapes to photograph. As a graduate student, I had spent some time in Elora (even leading a few field trips of my own for first-year geology students) and found myself once again captivated by the rushing waters of the Gorge. Realizing the photographic possibilities of waterfalls, I made a few trips to Rock Glen Falls, Niagara Falls and the Bracebridge area, and soon had a small portfolio of photographs that I used to decorate my apartment.

When the Internet burst into the mainstream in the late 90s, I knew that I just had to find my own little niche. At the time, I was finishing my master's thesis, and the idea of building a waterfall webpage to show off my photographs seemed like perfect therapy after staring at page upon page of geochemical data. So, without delaying completion of my thesis (honest!), I scraped together about a dozen photographs of waterfalls and prepared my first webpage.

Soon after it was posted, I discovered that I wasn't alone. There were other waterfall fanatics out there, and some of them were even crazier than I was! Rumors that someone in nearby New York State had cataloged hundreds of waterfalls turned out to be true. If there were that many waterfalls (currently 852) in western New York, just how many were there in Ontario? Unfortunately, it didn't seem like anyone knew. Jerry Lawton's excellent book on waterfalls along the Niagara Escarpment was a step in the right direction, but my geographical curiosity led me to look beyond the Bruce Trail.

The minute that Firefly Books approached me in 2002 with George Fischer's proposal for a book about Ontario waterfalls, it was as though my strange hobby was immediately justified. I wasn't crazy after all! And once I had seen George's splendid photography, I knew that we had a perfect medium through which to convey the magic of waterfalls to others.

What followed was an epic series of waterfall road trips. Searchmont, Arkona, Kinmount, Lasswade, Massey ... I had never heard of any of these places, let alone seen the waterfalls nearby. Just to drive to the 80-odd waterfalls featured in this book would require a one-way trip of several thousand kilometers. An exhaustive (though still incomplete) examination of maps, travel and history books, and Internet resources was next in order to find out more about each of the falls. During my travels and research, I came across many other waterfalls that we did not feature in this book. I admit that neither George or myself have been to all of the sites listed in the Inventory of Waterfalls, although I am certain that each one exists in some form or another.

My only regret is that we didn't have time to visit even more waterfalls prior to completing the book. In particular, our coverage of Northern Ontario is admittedly somewhat sparse. This region is home to many spectacular waterfalls, but we were simply unable to adequately explore this massive area. We were also unable to visit many of the waterfalls, chutes and rapids hidden away in the Ontario wilderness. Most are accessible only by canoe – a challenge which makes them all the more rewarding to visit.

I hope that this book stimulates your enthusiasm for the great outdoors and learning more about our common heritage. Every person that reads this book should make a point of seeing at least a few of these falls for themselves. And even if the waterfalls are your ultimate destination, don't miss the scenery along the way. There is so much to explore in your own backyard, much of it for free. Get out there and see for yourself.

INTRODUCTION

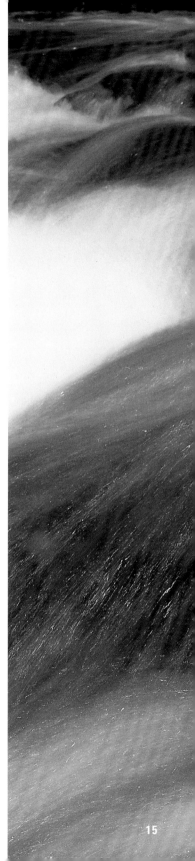

WATERFALLS ARE SPECIAL PLACES. Few features of the natural landscape can command our view like a falling stream of frothing, bubbling water. Long prized by tourists, artists and nature buffs, the sight of a waterfall is irresistible to even those with little or no interest in their natural environment. Waterfalls are perfect places for hiking and exploring, for photography, for nature study and to just get away from it all.

The province of Ontario is blessed with a wide range of falls, with the vast majority situated on public lands. But not all of them are like Niagara! Waterfalls come in all shapes and sizes, from the tiniest little trickles to raging torrents of awesome power, and a wide variety of falls have been selected here to suit all tastes. Some of the smaller falls are arguably little more than bumps on a tiny creek somewhere in the woods. However, finding these can be just as rewarding as visiting the bigger ones, and in many cases you may be lucky to have the waterfall all to yourself.

The only way to fully appreciate the magic of these waterfalls is by visiting. Waterfalls engage all the senses (although in most cases we suggest you don't taste the water). And there is so much to see in addition to the falls themselves. Most of the sites are located a little off the beaten track, reason enough for a road trip to a corner of the province that you've never visited or fully explored. By making stops along the way to see other nearby cultural and physical features of the landscape, your day will be all the more enjoyable.

Understanding Waterfalls

In order to maximize your enjoyment of waterfalls, it is useful to understand a little about the landscape in which they are found. Each waterfall is a product of geology, and many have also had some effect on our society. A complete overview of all relevant facets of the earth and social sciences is obviously beyond the scope of this book, but a brief introduction to "waterfallogy"

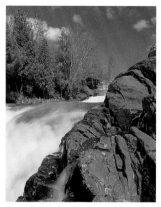

Marshs Falls

should help you to better appreciate the waterfalls described in this book, as well as when you go out and visit them.

Waterfalls occur where a stream or river falls over a ridge of exposed bedrock. This rock is fixed to the ground surface, and is actually the uppermost surface of the Earth's solid crust. Bedrock is found beneath our feet throughout the entire province, but in most places it is covered by a blanket of soil, sand or clay. Exposed at the surface in certain places, like the Niagara Escarpment or the Canadian Shield, bedrock exerts a special quality to the landscape. There are a number of different kinds of bedrock that you will encounter at waterfalls.

Igneous rocks are formed by the cooling and solidification of molten magma rising from the Earth's interior. Sometimes this magma solidified at the Earth's surface at a volcanic eruption, while other times it solidified underground. Those rocks that solidify beneath the surface usually have a salt-and-pepper type appearance, composed of an apparently random assemblage of interlocking mineral grains, each only a few millimeters across. Many readers will be familiar with the pinkish granite rocks common in the Canadian Shield area of the province, as can be seen in the photograph of Aubrey Falls on page 31. Rocks that solidify at the Earth's surface often have a dull, jagged appearance (see the photograph of Silver Falls, page 47). Such rocks include basalt and andesite, and were formed from volcanic eruptions that occurred in the province over one billion years ago.

Over millions of years, existing rocks can be broken down by wind, water, ice and gravity, forming smaller rock fragments or particles that we refer to as gravel, sand and clay. Following many more millions of years, the particles are redistributed across the Earth's surface and often settle at beaches, riverbeds or ocean bottoms. If the particles are eventually compressed and cemented together they may form sedimentary rocks. Since these rocks always form in layers, they are easy to identify (see Devil's Punch Bowl, opposite page). Readers familiar with the Niagara Escarpment will have seen sedimentary rocks like limestone, sandstone and shale. When rock layers are thick, they are said to be massive, but when they are thin, they are said to be thinly bedded. Limestone, dolostone and sandstone tend to be fairly strong rocks, while shale is often so weak that it can be crushed in your hand.

In some cases, existing rocks beneath the Earth's surface can be "squeezed" and "baked" by the extreme pressure and heat. The existing rocks are eventually changed into new rocks, known quite logically as

metamorphic rocks. These rocks are actually quite common in Ontario, covering much of the Canadian Shield. In fact, in many cases rocks considered to be granite by the layperson are actually gneiss (pronounced "nice"), a metamorphic rock that can be formed by the recrystallization of granite. Gneiss can be distinguished from granite by the banded nature of its minerals: instead of the salt-and-pepper appearance, the mineral crystals are oriented in rows of similar colors. Marble and quartzite form from the metamorphosis of limestone and sandstone, respectively.

In addition to bedrock, a waterfall obviously requires some kind of river or stream. Some waterfalls are found on major rivers while others are found on the tiniest of brooks. The size of a river is normally related to the size of its watershed, which is the area of land that contributes drainage water to the river. For example, the Trent River at Healey Falls is fairly sizeable because it drains an area of approximately 9,090 square kilometers (3,510 sq. mi.). We would expect waterfalls on this river to be fairly powerful, although the height of any waterfall would be controlled by the local relief of the bedrock. Compare this to a small creek like Swayze Creek, which drains just a little over 6 square kilometers (2.3 sq. mi.) of land upstream of Swayze Falls.

The amount of water flowing down a stream is referred to as discharge, and is usually measured in cubic meters per second or cubic feet per second. (One cubic meter is equal to 35.3 cubic feet or 264 U.S. gallons.) Most streams experience a wide variation in discharge, which is why waterfalls vary in appearance through the year. During the middle of a long, dry summer, beautiful waterfalls like Indian Falls and Balls Falls frequently dry up because there has not been enough rain to replenish their rivers. On the other hand, heavy spring rains and melting of the winter snowpack can cause rivers to flood to almost unbelievable levels. During the spring of 2000, the Falls at Elora were nearly drowned out by a swollen Grand River, which had already flooded some of the tourist shops located along the river's edge.

Humans can also impact stream discharge in several ways to both the benefit and detriment of our enjoyment of waterfalls. Water control dams in cottage country help maintain water levels in many lakes and streams, thus enabling many waterfalls to flow right through the summer. In contrast, changes to land use and drainage patterns in the watershed that feeds a particular waterfall can drastically alter its appearance. For example, Buttermilk Falls in Hamilton is rarely more than a trickle. Its watershed has been

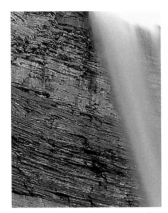

The layered nature of sedimentary rock is well illustrated at the Devil's Punch Bowl.

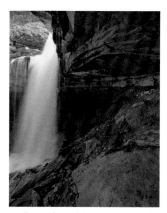

Devil's Punch Bowl (Lower): An example of a plunge-class waterfall

altered so much through urbanization that the falls only run for short periods following heavy rainfall events. Other waterfalls like Magpie Falls or Muskoka Falls can be turned off with a switch when the water's ability to generate electricity is felt to be more important than its ability to generate a beautiful waterfall.

As a stream flows through the landscape, boulders and sand particles are rolled and bounced down the stream by the power of the water. When the stream crosses over bedrock, the sand and rock particles grind away at the bedrock surface, like a continuous supply of liquid sandpaper. The process is called abrasion and slowly allows the river to cut into the solid bedrock. Another process, called plucking, occurs where slabs of rock that have been loosened over the years are picked up by the force of the stream and transported away by the force of the water. Bedrock can also be eroded by the freezing and thawing of water held in cracks (also known as joints or fractures) between the rocks. As water freezes, it expands by 9 percent, and can push small fragments of rock free from the main rock face.

Waterfall Forms

The waterfalls of Ontario have a wide variety of shapes and appearances, and we have devised and used a simple system to classify waterfalls based in part on the physical process by which the waterfall is formed. This system is not universal, and you will encounter different terminology in other sources. In fact, it is curious to note that even in the scientific literature, very few attempts have been made to formally classify waterfalls or document the processes responsible for their formation.

Probably the most familiar form of waterfall is the plunge waterfall. This is exemplified by Niagara Falls itself, where a jet of water falls freely through the air before reaching the base of the waterfall. Plunge waterfalls occur where a layer of erosion-resistant bedrock called "cap rock" overlies more easily eroded bedrock layers which are usually composed of shale. Shale fragments are loosened from the waterfall face by repeated cycles of wetting and drying, and freezing and thawing. Other forces related to groundwater pressures and relief of stresses within the rock mass may also help to dislodge shale fragments. As the shale is eroded away (a process called undercutting), the overlying cap rock is left projecting out over the rock face of the shale. Eventually, the cap rock can no longer support its own weight, and a large slab will break off and crash to the ground.

For a long time it was believed that shale was eroded by "swirling" waters at the base of the falls. While it is easy to see why this could be imagined at Niagara Falls, it would simply not work at most other plunge waterfalls. In many cases, the falling water never comes into contact with the underlying shales, and stream discharges are just too low to create a deep, swirling pool of turbulent water (see Chedoke Falls, page 119). Unfortunately, many information sources still incorrectly refer to the "swirling" process.

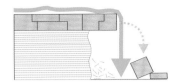

Plunge waterfall

Some plunge waterfalls have a minor break in the water jet partway through the descent, usually caused by one resistant layer of rock found midway up the waterfall face (see Felkers Falls, page 133). Where the concentrated force of the falling river is great enough to erode the bedrock at the base of the falls a plunge pool can develop. Many plunge pools are kept clean of even large boulders by the force of the water – the boulders and cobbles are pushed to the sides of the plunge pool forming a debris ring.

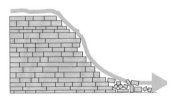

Ramp waterfall

Most tour books and textbooks alike give only the plunge development process for waterfall formation. But what about those waterfalls that do not exhibit a free-falling jet of water? For example, consider Washboard Falls (see page 155). Water does not drop over the top of an overhanging rock ledge, but rather slides down a steeply inclined rock face without ever losing contact with the bedrock surface. This is a ramp waterfall and is usually formed where the bedrock is thinly bedded and belongs to only one rock formation. Since the rock is uniform along the entire face of the waterfall, it erodes at a uniform rate. The thin bedding of the bedrock produces excellent opportunities for the stream to pluck rocks away from the waterfall face. Beamer Falls and Sherman Falls are good examples of ramp waterfalls.

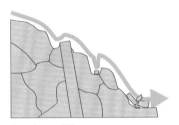

Cascade waterfall

Similar to the ramp waterfall is the cascade class. This is the most common type of waterfall in the province. Like the ramp form, water descends over a cascade waterfall without losing contact with the bedrock. However, the descent is generally more chaotic since the rock is not necessarily uniform across the waterfall face, rock layers may be of varying thicknesses and the orientation of fractures and joints may be quite complex. This form dominates in the Canadian Shield area, where the waterfalls lack the flat-lying sedimentary rocks of the Niagara Escarpment, but instead have rocks that are jointed in all possible directions. Rock pieces of varying size and shape are plucked off the face of the waterfall while abrasion acts to smooth out some rock surfaces (as in Sand River Falls, page 45). Bonnechere Falls, Inglis Falls and Magpie Falls show some of the diversity of cascades.

Step waterfall

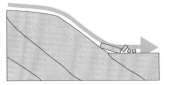

Slide waterfall

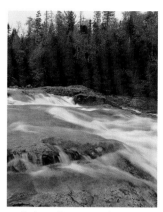

Sand River Falls: An example of a gentle cascade-type waterfall

While rarely seen in Ontario, a special subcategory of the cascade class is the step waterfall. This type occurs where the bedrock is eroded by the removal of large block-shaped slabs (see Fourth Chute, page 193). Another waterfall form that is rare in Ontario is the slide-class waterfall, which occurs when water flows across an inclined layer of bedrock. These are not to be confused with ramp waterfalls because here the water flows parallel to a tilted rock layer, as opposed to across the edges of many thin rock layers. Good examples of slide-class waterfalls are found at Long Slide and Port Sydney Falls.

There are four other waterfall classes. Trickles are formed where very small brooks descend over a rock face without exhibiting any evidence of erosion other than removal of vegetation from the rock. Over time, trickles might be expected to mature into plunge- or cascade-class waterfalls if erosion becomes significant. Where a steep stream descends through a boulder-choked channel but does not interact directly with underlying bedrock, we use the term talus falls. Such features are quite common along the Niagara Escarpment, usually forming where the escarpment is less well defined. Rapids are swiftly moving sections of streams where the stream surface is broken by boulders protruding from the streambed, while chutes are swiftly moving sections of streams that flow over bedrock. These last two definitions are of course debatable and grade continuously from one to the other.

Our system of classification is not perfect, and many waterfalls are actually a combination of two or more different classes. One thing that all waterfalls have in common, however, is that they all "move" slowly upstream. The process takes hundreds to thousands of years. Nowhere is this more apparent than at Niagara, where the falls has "eaten" its way into the rocks of the Niagara Escarpment for 11 kilometers (7 mi.) from Queenston to the present-day falls. If Niagara Falls continues to live for thousands of years, it may eventually eat its way to Lake Erie. Other waterfalls have carved their own, albeit shorter, gorges. Those waterfalls formed on sedimentary rocks tend to have better defined gorges since the rock is relatively easily eroded. Conversely, many waterfalls in igneous and metamorphic rocks have not yet formed a gorge, because these rocks are so much more resistant to erosion (see Bridal Veil Falls in Algoma, page 35).

Waterfalls and Society

Waterfalls have always been important to people, and their importance to the development of Ontario cannot be understated. Since the waterways of the province once served as major transportation corridors, the first inhabitants of Ontario would have seen waterfalls as barriers. This perception was shared by early European explorers, who had to portage their giant canoes around many rapids and waterfalls on their expeditions to the interior. Even now, water-borne traffic continues to bypass waterfalls using locks (as is the case at Healey Falls, Rideau Falls and Burleigh Falls).

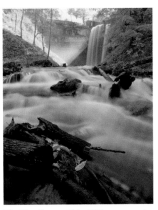

The Morningstar Grist Mill museum at DeCew Falls is open to the public during summer.

As settlement progressed across the province, lands beside waterfalls became some of the most sought-after properties due to the source of natural power. Falling water was used to turn mill wheels in a variety of early industries. Gristmills used the power of the water to turn large disklike milling stones of granite or quartzite to grind wheat to flour and bran. Sawmills made use of the power to first move vertical saws, and then later circular saws. Late in the 19th century, textile mills developed, most notably in the Mississippi Valley, including Mill Falls and Pakenham Falls.

Many mills still exist today, and a few found next to waterfalls are open to the public, including the Morningstar Grist Mill at DeCew Falls, and the McDougall Mill Museum beside Second Chute in Renfrew. Other mills have been converted to different uses, including the Inn beside the falls at Elora, the restaurant beside Mill Falls in Hamilton, the little tea room overlooking Yarker Falls and the condominiums beside Mill Falls in Almonte.

Very often the mills served as catalysts for settlement. Many communities developed around waterfalls, and many small towns in Ontario are still centered about their waterfalls. And because the waterfall was normally the narrowest point of the river, many towns built road bridges right over the top of the falls, as was the case at Albion Falls, Bracebridge Falls and Fenelon Falls.

A little over a hundred years after the natural power of waterfalls first turned the millstones of early Ontario mills, the same power source was put to use to turn turbines to generate hydroelectric power. The first hydroelectric installation in Ontario was constructed in 1882 on the Ottawa River at Chaudière Falls to supply electricity to nearby sawmills. Hydroelectric stations mushroomed across Ontario in the early 20th century, and Canada soon became the world's leading producer of hydroelectric power. More

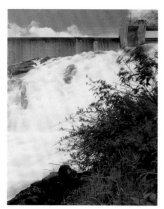

The dam at High Falls (York River) helps to maintain water levels in Baptiste Lake.

power is produced from falling water in Ontario than by all other methods (including nuclear) combined. In fact, so dominant is the use of hydroelectric power, that many Ontario residents refer to their electricity supply simply as "hydro."

Unfortunately, the generation of hydroelectric power is not always waterfall-friendly. To harness the power of falling water, it needs to be diverted away from the waterfall, and delivered to the generating station. Water is typically transferred downhill to the station by means of giant pipes called penstocks. The water is used to turn the giant propeller blades of the turbines which, in turn, power the electrical generators. When water levels are low, some waterfalls are literally shut off, as engineers divert all available water to the generating station (see Magpie Falls, page 40, and Muskoka Falls, page 84). Other waterfalls have been modified or even obliterated by the construction of large concrete dams, which serve to increase the "head" and therefore the generation potential of a power plant, as is the case with High Falls on the York River.

Finally, waterfalls have always been tourist attractions. Early explorers were terrified at their first sight of Niagara Falls, a spectacle unlike anything in the known world at the time. Soon after, however, the falls were exploited for profit, with early entrepreneurs charging admission to watch daredevils cross the gorge on tightropes. More recently, the popularity of the province's waterfalls as destinations for day-trip ecotourism has increased. The "Festival of the Falls" takes place in Bracebridge every year and showcases the town's 22 waterfalls. Similarly, both Hamilton and Owen Sound make good use of their numerous waterfalls in tourist brochures and on webpages. It is our hope that this book will persuade still others to take up "waterfalling," and experience first-hand some of Ontario's natural legacy.

Using this Book

The book has been divided into five sections to describe five different "waterfall regions" in the province. A total of 82 different waterfalls are featured, and hints to the location of other nearby waterfalls worthy of a visit are provided. Detailed directions to each waterfall are included, although we assume that you can find your way to the main highways in the province. Note that use of the word "highway" always refers to the provincial highways maintained by the Ontario government, which are always signed with a number and the "King's Highway" designation. Roads at the county, district

or regional municipality level are identified by the county name followed by the road number. Local roads are maintained by individual municipalities and are referred to by their local name.

One of the most valuable tools for any waterfall trip is a good map, and we recommend that you purchase some of the fine "town and country" style maps produced by either MapArt or Rand McNally. These maps identify just about every country road, as well as many more villages, rivers and lakes not normally shown on standard roadmaps.

In addition to photographs, descriptions and directions for each waterfall entry, we have included a fact box to provide you with quick tips about visiting a waterfall site. Our use of the word **County** refers to one of Ontario's 49 different counties, regional municipalities or districts. The **Nearest Settlement** is typically the closest named location on a detailed roadmap. This way, you can use your map's gazetteer to quickly locate the local area in which a waterfall is found. The **River** heading is simply the name of the stream on which the waterfall is located.

Class refers to the form and shape of the waterfall as described on pages 18–20 in the Waterfall Forms section. The **Trail Conditions** heading refers to the ease and safety of any path required to actually view a waterfall. It does not suggest that all paths around the site are traversed with equal ease and safety, and you should always exercise caution when exploring any site. Some trails marked as "easy" may be traversed by wheelchair, although we have reserved "wheelchair accessible" for only those trails which, in our opinion, pose no major challenges to wheelchair travel. "Moderate" trails may have a few short hills or rocky sections, but would otherwise be walkable by all but the youngest or oldest of visitors. The **Activity** heading attempts to give some idea of how peaceful or busy the waterfall site is expected to be on an average day. **Walking Time** gives an approximate time required to walk from the parking area to the waterfall viewing area.

Many travel guidebooks attempt to rate a waterfall simply by its height. We have found that this tends to give a false impression of the importance or interest of the waterfall. Our **Size** heading is a more qualitative measure of the physical dimensions (height, width, water volume) of the waterfall. Since size often has little to do with the overall visiting experience, however, we have also given each waterfall a **Rating**. This is our subjective measure of the overall interest of the waterfall site, and is based on ease of viewing, potential for hiking, photographic possibilities and development of the site.

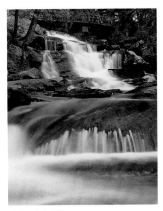

Little High Falls

COUNTY: **Muskoka**
NEAREST SETTLEMENT: **Bracebridge**
RIVER: **Potts Creek**
CLASS: **Cascade**
TRAIL CONDITIONS: **Moderate**
ACTIVITY: **Busy**
SIZE: **Small**
RATING: **Average**
NTS MAP SHEET: **31E/3**
UTM COORDINATES: **17T, 633650, 4994150**
WALKING TIME: **5 minutes**

A sample fact box

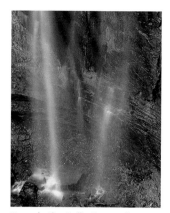

To get the "lacy" effect in your photographs, you must be able to slow down your camera exposure to 1/8 second or slower. You will also need a tripod.

Waterfalls that provide several hours' worth of exploration possibilities are considered to be outstanding, while those without surrounding trails or that are uninspiring are considered poor or mediocre.

The **NTS Map Sheet** is the code for the appropriate 1:50,000 scale topographic map produced by Canada's Department of Energy, Mines and Resources. These maps are available in many outdoors/camping shops as well as some independent book shops. Simplified digital copies are also available online at the government's Toporama website (toporama.cits.nrcan.gc.ca).

The **UTM Coordinates** give the exact geographic coordinates of each waterfall. These coordinates may be used with a topographic map or a Global Positioning System (GPS) receiver. We have provided three values: the UTM zone, the easting and the northing. The easting and northing are synonymous with longitude and latitude, respectively. Rather than using degrees, minutes and seconds, however, the UTM coordinates are based on meters, and are much more convenient to work with. Using the proper topographic map, you can pinpoint a waterfall by the following method. Use the second and third digit of the easting to find the appropriate vertical blue gridline on the map. Use the third and fourth digit of the northing to find the appropriate horizontal blue gridline on the map. Next, use the fourth digit of the easting and fifth digit of the northing to get the fraction of the distance to the next blue gridline (that is, if the fourth digit of the easting is 6, then the point is 6/10 of the way to the next highest vertical blue gridline). The intersection of the two points is the exact location of the waterfall.

Serious adventurers may wish to purchase a GPS receiver. These handheld units track the position of a network of satellites and give the user an exact position on the Earth's surface. GPS receivers are becoming increasingly popular and are now available in the $200 to $300 range at many sporting goods stores. More expensive units are capable of giving positions to the nearest meter, which makes use of the last digit of the easting and northing values. The UTM zone value is only important when using a GPS receiver.

A Special Word About Safety and Respect for the Environment

While waterfalls are beautiful places to visit, remember that they can also be very dangerous. Steep rock cliffs are located immediately adjacent to all but the smallest waterfalls noted in this book. In some cases, local authorities have constructed safety fences at the most heavily traveled spots. In others, there is nothing to separate the visitor from steep vertical drops. And even where high cliffs are absent, algae-covered rocks beside swift-moving waters can be just as treacherous. As inviting as a particular photographic angle may appear, do not jeopardize your safety.

There are also a few features of the living world that need to be respected. Poison ivy is common at many waterfall sites, as it enjoys the dry, rocky landscape usually associated with most waterfalls. You are well-advised to learn to identify the plant, usually a low shrub with a woody stem and leaves in clusters of three ("Leaves of three, let it be"). Also, the Algoma region, the more remote parts of the Cottage Country and Ottawa Valley regions, and the northernmost portion of the Lake Huron region (Bruce Peninsula) are located in bear territory. The chances of seeing a bear in the wild continue to be very, very slim however, and in all of their outdoor excursions in Ontario, the authors have yet to encounter a bear or even any signs of one. Just to be cautious, waterfall visitors new to the backwoods should familiarize themselves with bear safety issues.

Finally, inclusion of a waterfall in this book does not guarantee that it is located on public property. At the time of writing, it is our opinion that unless specified, all of the featured waterfalls are located on public lands. Please respect any "No Trespassing" signs that are subsequently erected, and if in doubt, please ask about access. Many waterfalls throughout the world have been closed to the public as a result of fatal accidents, recurring litter problems or a lack of respect of the land. Please be sure to do your part to ensure that as many as possible of these beautiful features of the landscape will remain open to all of us to enjoy.

What should I bring on a waterfall trip?

· Suitable clothing for the season
· Insect repellent and/or sunscreen
· Detailed roadmaps
· Sturdy hiking shoes or boots
· Rubber boots for taking photographs in shallow water
· Extra socks in case of a "soaker"
· Whistle, for safety
· Camera and tripod (the tripod is necessary to get a sharp photo)
· Notebook

ALGOMA

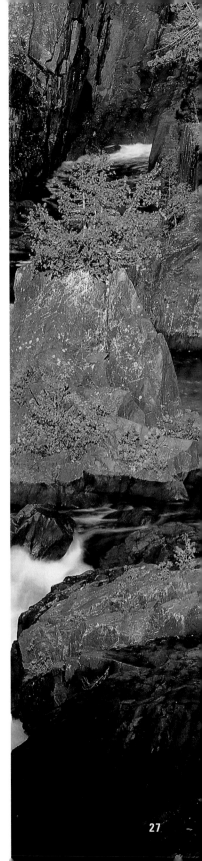

ALGOMA'S WATERFALLS are not only large and beautiful, but for the most part they have not been spoiled by bridges, hydroelectric dams and littering. If you really want to get away from it all, this region is ideal! When driving the Algoma region, remember to plan ahead and keep a close eye on your fuel gauge. Even along Highway 17, service stations are very infrequent, and other than in Sault Ste. Marie and the small town of Wawa, motels and stores are rare.

If you are returning home to southern Ontario, why not visit Whitefish Falls and then Bridal Veil Falls and High Falls on Manitoulin Island? The scenery along Highway 6 is excellent and you can take a shortcut to the Lake Huron region via the Chi-Cheemaun Ferry from South Baymouth to Tobermory.

Recommended tour

Following the very scenic route along Highway 17 north from Sault Ste. Marie to Wawa, visit Chippewa Falls, Magpie Falls and Silver Falls. Spend the night in Wawa and be sure to visit the big goose. On your way back, spend a few hours at Sand River, and then visit Crystal and Minnehaha Falls in Sault Ste. Marie.

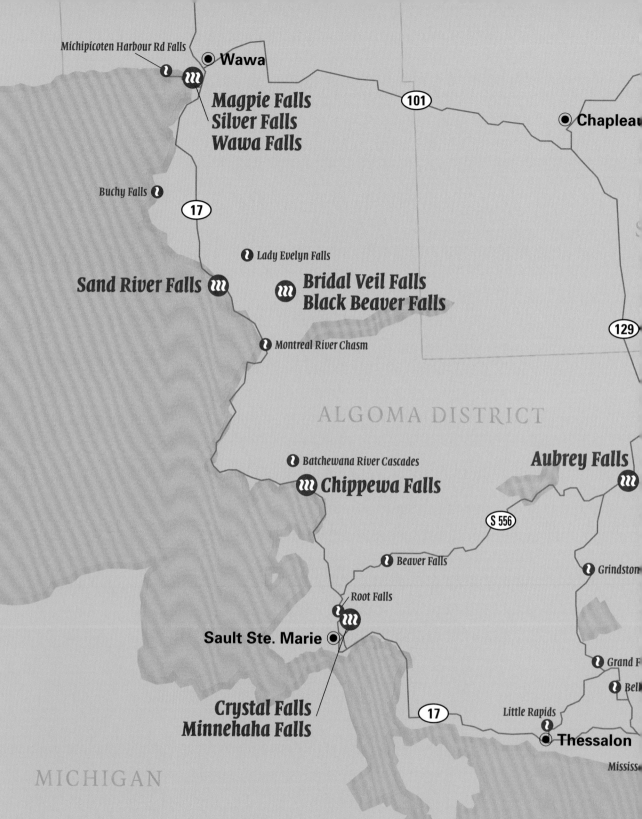

Michipicoten Harbour Rd Falls

Wawa

101

Chapleau

Magpie Falls
Silver Falls
Wawa Falls

Buchy Falls

17

Lady Evelyn Falls

Sand River Falls

Bridal Veil Falls
Black Beaver Falls

129

Montreal River Chasm

ALGOMA DISTRICT

Batchewana River Cascades

Aubrey Falls

Chippewa Falls

S 556

Beaver Falls

Grindston

Root Falls

Sault Ste. Marie

Grand F

Bel

Crystal Falls
Minnehaha Falls

17

Little Rapids

Thessalon

MICHIGAN

Mississe

28

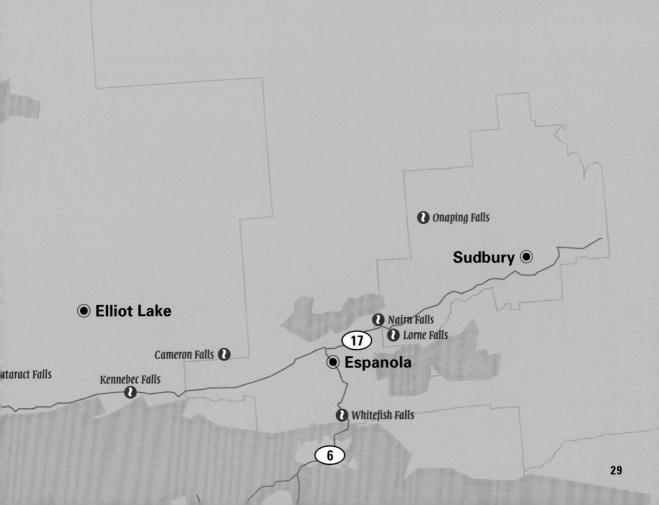

ALGOMA

KILOMETERS

URY DISTRICT

⚲ Onaping Falls

Sudbury ◉

◉ Elliot Lake

⚲ Nairn Falls
⚲ Lorne Falls

(17)

Cameron Falls ⚲

◉ Espanola

ataract Falls

Kennebec Falls ⚲

⚲ Whitefish Falls

(6)

29

Aubrey Falls

🚗 Be sure to stock up on gas, food and drink along the Hwy. 17 corridor before heading to Aubrey Falls. From Sault Ste. Marie, go east on Hwy. 17, then north on Hwy. 129 for at least an hour and a half. The access road to the falls is marked by a sign on the east side of Hwy. 129, and is 5 to 10 minutes north of Hwy. 556. Follow the dirt road to the parking lot, and look for a sign showing the trail map. Note: Outhouse washrooms are the only amenities available at the parking lot.

COUNTY:	Algoma
NEAREST SETTLEMENT:	Aubrey Falls
RIVER:	Mississagi River
CLASS:	Plunge
TRAIL CONDITIONS:	Moderate
ACTIVITY:	Quiet
SIZE:	Very large
RATING:	Good
NTS MAP SHEET:	41 J/14
UTM COORDINATES:	17T, 331611, 5197555
WALKING TIME:	10 minutes

Aubrey Falls isn't easily incorporated into a day trip to a number of waterfall sites. Located about two hours from Sault Ste. Marie, this waterfall is the most remote included in this book. Nevertheless, the long drive to this site is highly recommended since this can be one of the most spectacular waterfalls in Ontario. The drive along Highway 129 alone is worth the trip, as its high rock cliffs and dozens of lakes provide for outstanding photography.

Aubrey Falls is big! At 53 meters (174 ft.), it's as high as Niagara, although obviously not nearly as wide. Still, under high flows, this is a powerful waterfall which is separated into no fewer than eight distinct falls.

From the parking lot, a well-groomed trail leads through a young forest of white birch, poplar and white pine, which is still regenerating after a large fire in 1948. The trail is about 800 meters (0.5 mi.) long and leads to a wooden footbridge over the Mississagi River. The view of the lower gorge is spectacular, even though only the lower portion of the waterfall is visible.

Continuing over the bridge, turn left and walk up one of the several trails along the narrow ridge of forested land between the falls and the dam. Although the trails are not well marked and there is no main viewing platform, several outstanding views of the falls are possible. Other trails lead south toward the generating station. Access to the gorge is probably very dangerous, and is certainly discouraged.

In 1969, Ontario Hydro completed the third of four large hydroelectric generating stations on the Mississagi River at this site. The dam extends over 300 meters (985 ft.) in length and required some 76,000 cubic meters (2.7 million cu. ft.) of concrete during construction. While most of the river's flow is diverted to the generating station (rated at 148 MW), 8.5 cubic meters (300 cu. ft.) per second is allowed to flow over the waterfall from Victoria Day to the end of October. This flow makes for an impressive spectacle, but one still wonders what this waterfall must have looked like prior to the construction of the generating station.

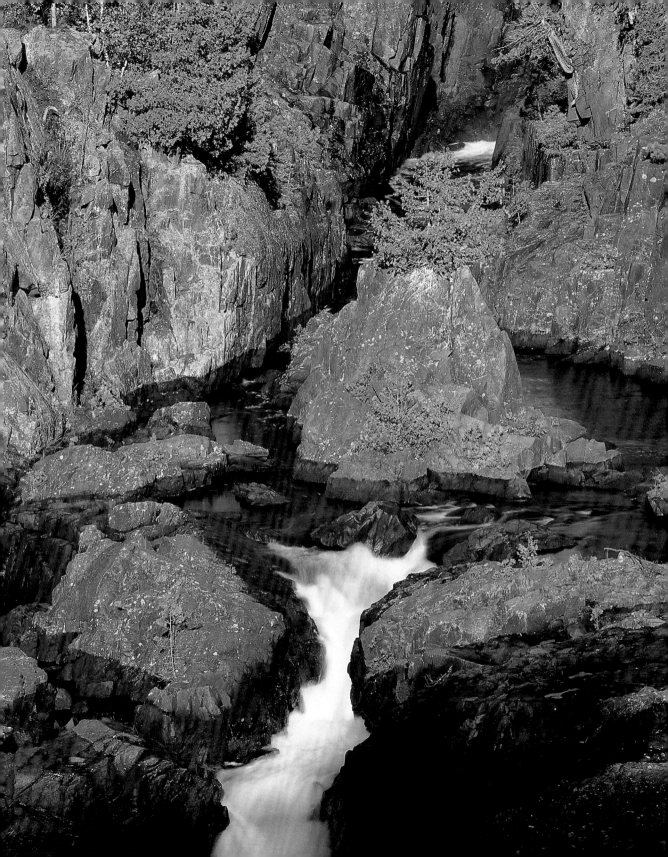

Black Beaver Falls

🚗 **Board the Algoma Central Railway tourist train to Agawa Canyon, which leaves very early in the morning from Sault Ste. Marie. Since this famous route has long been a favorite for its outstanding scenery, the daily trips are often sold out, so call ahead to reserve a seat. The train station is located at 129 Bay St. (Hwy. 17B) in Sault Ste. Marie, beside the Station Mall. The trip to the canyon takes about three and a half hours and passes beautiful scenery, including pristine forests, deep river valleys and high wooden train trestles. Once you arrive at Agawa Canyon, look for the signs for the Talus Trail. The hike to the falls is at least a 30-minute trip, so plan your time accordingly.**

COUNTY:	**Algoma**
NEAREST SETTLEMENT:	**Agawa Canyon**
RIVER:	**Beaver Creek**
CLASS:	**Cascade (Steep)**
TRAIL CONDITIONS:	**Moderate**
ACTIVITY:	**Moderate**
SIZE:	**Medium**
RATING:	**Average**
NTS MAP SHEET:	**41 N/8**
UTM COORDINATES:	**16T, 689600, 5254600**
WALKING TIME:	**30 minutes**

Black Beaver Falls is located in the spectacular Agawa Canyon, which is reached only by rail. The trip to the canyon is breathtaking, and so are its three beautiful waterfalls. While not nearly as powerful as most of the other waterfalls in the Algoma region, Black Beaver Falls is definitely taller than most, with a total height of over 50 meters (165 ft.). The creek spills over the side of the Agawa Canyon and bounces over a steep granite bedrock face about 3 to 15 meters (10 to 50 ft.) in width before draining into the Agawa River. The highly variable discharge of the creek leads to the ever-changing appearance of the falls, as water follows several different paths to the bottom depending on the stream flow. Two viewing platforms provide good views of both the north and south falls.

The Algoma Central Railway was initiated in 1899 with the ultimate goal of providing a rail route to Hudson Bay. When iron ore was discovered at nearby Wawa, a spur line was also laid to the town. Ore trains stopped running from Wawa in 1998, and the rail line never made it past Hearst, stopping more than 300 kilometers (185 mi.) short of Hudson Bay. But the railway continues to serve as an important tourist line, delivering tourists not only to Agawa Canyon and Hearst but also dropping them off at just about any point along the way. Increasingly, many adventurers are using the railway as a shuttle to the Sand and Montreal rivers. From there, groups canoe for several days downstream to Lake Superior, passing many little-known scenic waterfalls and rapids along the way.

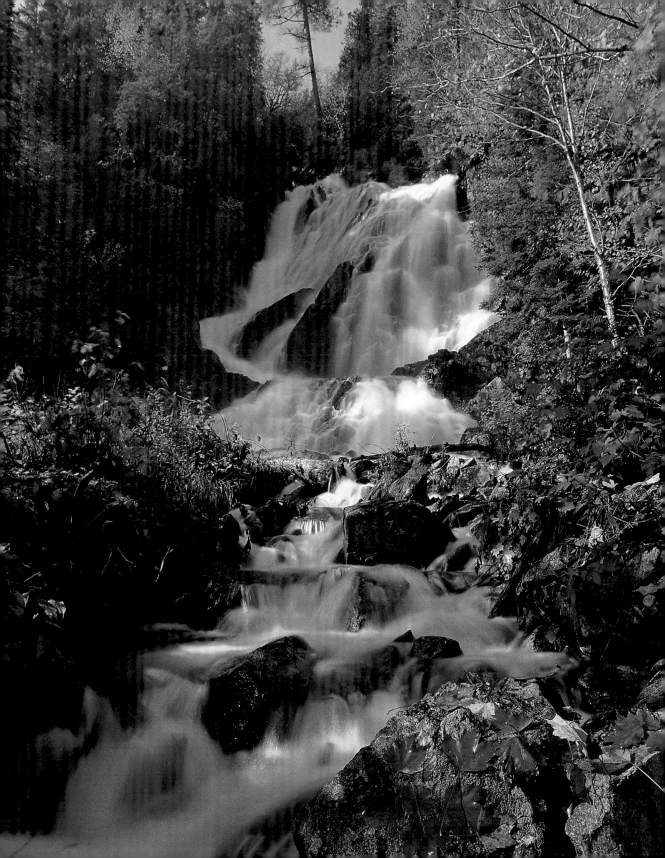

Bridal Veil Falls

🚗 Follow the directions to Black Beaver Falls (page 32). Continue past Black Beaver Falls along the Talus Trail for another 10 minutes. The waterfall is located on the far side of the Agawa River, and can only be viewed from the platform on the west side. Since the stopover is just two hours, it is impossible to see all of the spectacular sites in the Agawa Canyon. If you have some time left after visiting the two tall waterfalls, you can walk to the other end of the canyon and follow the shorter Lookout Trail to the 14-m (46 ft.) high Otter Creek Falls. But a word of warning: Don't miss the train back to Sault Ste. Marie! The only other way out of the canyon is a 20-km (12 mi.) hike along the railway to Frater Rd. followed by a 8-km (5 mi.) hike to Hwy. 17 at Agawa Bay.

Bridal Veil Falls is located in the Agawa Canyon, and is even taller than nearby Black Beaver Falls, with a total height well in excess of 60 meters (200 ft.). Unlike Black Beaver Falls, this waterfall tumbles almost directly into the Agawa River. Its fall is broken into three main sections, each nearly vertical, that vary in width from 2 to 20 meters (7 to 65 ft.) depending on stream flow.

In recent winters, Bridal Veil Falls has become a popular destination for ice climbers. Visitors with crampons and an attitude for adventure may climb the frozen Bridal Veil Falls, as well as several dozen other possible ice walls along the route.

Bridal Veil Falls is a name frequently given to waterfalls in North America. One of the better known is the smaller waterfall to the south of the main section of the American Falls at Niagara. Others are found in British Columbia, Utah, Oregon and North Carolina.

Ontario also has at least one additional waterfall with the same name, found on Manitoulin Island at the picturesque village of Kagawong. It is a beautiful medium-sized plunge waterfall about 12 meters (40 ft.) in height.

COUNTY:	Algoma
NEAREST SETTLEMENT:	Agawa Canyon
RIVER:	Agawa River Tributary
CLASS:	Cascade (Steep)
TRAIL CONDITIONS:	Moderate
ACTIVITY:	Moderate
SIZE:	Large
RATING:	Mediocre
NTS MAP SHEET:	41 N/8
UTM COORDINATES:	16T, 689600, 5254600
WALKING TIME:	40 minutes

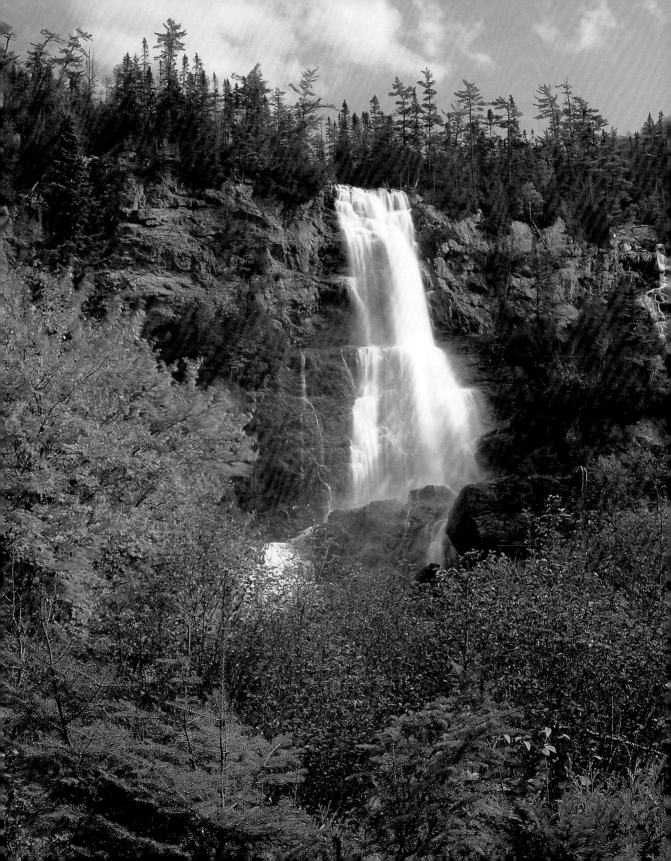

Chippewa Falls

🚗 **Drive north along Hwy. 17 for about 50 km (30 mi.) from 5th Line in Sault Ste. Marie. Watch for signs for the Chippewa River, and park in the lot beside the river on the right side of the highway. Follow the short path along the river into the woods to the top of the falls. To reach the upper falls, continue along the path upstream for a few hundred meters, but be aware that this path is a little more challenging. The path continues to flatter sections upstream along the river, quickly leaving the crowds behind. Before leaving the falls, be sure to visit the historical plaque in the parking lot. This spot is the official midway point along the Trans-Canada Highway, which stretches 7,821 km (4,860 mi.) between St. John's, Newfoundland, and Victoria, British Columbia.**

COUNTY:	Algoma
NEAREST SETTLEMENT:	Chippewa Falls
RIVER:	Chippewa River
CLASS:	Cascade
TRAIL CONDITIONS:	Easy
ACTIVITY:	Busy
SIZE:	Large
RATING:	Outstanding
NTS MAP SHEET:	41 K/16
UTM COORDINATES:	16T, 695953, 5200602
WALKING TIME:	2 minutes

About a 45-minute drive north of Sault Ste. Marie, Chippewa Falls is a fantastic waterfall to visit. The falls can be a powerful cascade almost 100 meters (325 ft.) wide and 20 meters (65 ft.) high. When the discharge is much lower, however, the river is constricted to run through a few narrow depressions in the rock. While this leaves much of the streambed high and dry, this is by far the most interesting time to visit the many nooks and crannies of the waterfall.

A protected walkway along the highway bridge provides a panoramic view of the whole scene. For a more intimate encounter, follow the short path from the parking lot to the crest of the lower waterfall. Here you can carefully explore the riverbed beside the falls, or watch the many anglers fishing for trout and salmon below the falls.

Most of the bedrock exposed around the falls is pink granite, which in typical fashion is quite dull in appearance, having been weathered by the elements for centuries. But even an amateur geologist will note the completely different black rocks covering the granite on the face of the waterfall. This is basalt – a fine-grained rock that is essentially the hardened remains of a lava flow that spread over the granite hundreds of millions of years ago. At the upper falls, a similar rock formation creates a small escarpment that controls the position of the waterfall. If you examine the black basalt rock closely, you should find large potholes in the riverbed. These are large circular depressions formed by the erosive power of the river. Some are up to 1 meter (3 ft.) deep and even greater in width.

Crystal Falls

🚗 Crystal Falls is located in Kinsmen Park situated at the northeast edge of Sault Ste. Marie. Go north on Hwy. 17 to 6th Line and head east. A small waterfall (root cascade) is located just south of the road immediately after turning off the highway. Continue east on 6th Line, following the road around the bend to the entrance to Kinsmen Park. If the gate is closed, you will need to park here and walk for about 10 minutes. Follow the driveway down the hill to the big parking lot by the pond. Take the short trail north of the parking lot to Crystal Falls. When you return, take the short trail south from the parking lot to Minnehaha Falls.

COUNTY:	Algoma
NEAREST SETTLEMENT:	Sault Ste. Marie
RIVER:	Crystal Creek
CLASS:	Cascade
TRAIL CONDITIONS:	Wheelchair accessible
ACTIVITY:	Moderate
SIZE:	Medium
RATING:	Outstanding
NTS MAP SHEET:	41 K/9
UTM COORDINATES:	16T, 708850, 5163315
WALKING TIME:	5 minutes

A good job has been done to ensure that this beautiful waterfall can easily be enjoyed by everyone. A long sturdy boardwalk leads visitors to the base of the falls, and at the same time serves to keep your feet dry. A sturdy staircase leads through the evergreen forest to a viewing platform located partway up the waterfall. You can continue further up the hill but you will need to follow the rough trail over the rocks.

Near the top of the waterfall, a wooden footbridge crosses the creek and provides a splendid top-down view of the cascade. A sign indicates that the path continues on to form a portion of the Voyageur Trail which, when completed, will connect South Baymouth on Manitoulin Island to Thunder Bay, some 800 kilometers (500 mi.) away.

A unique feature of this waterfall is the "bathtub" located at the base of the falls. The bathtub is formed by a continuous low outcrop of gneiss bedrock containing a deep plunge pool that appears to be somewhat elevated over the surrounding terrain. During high flows, water in the pool froths and churns like in a jacuzzi. As inviting as the pool may look on a hot summer day, avoid the temptation to jump in. Swimming can be extremely dangerous and is strictly prohibited.

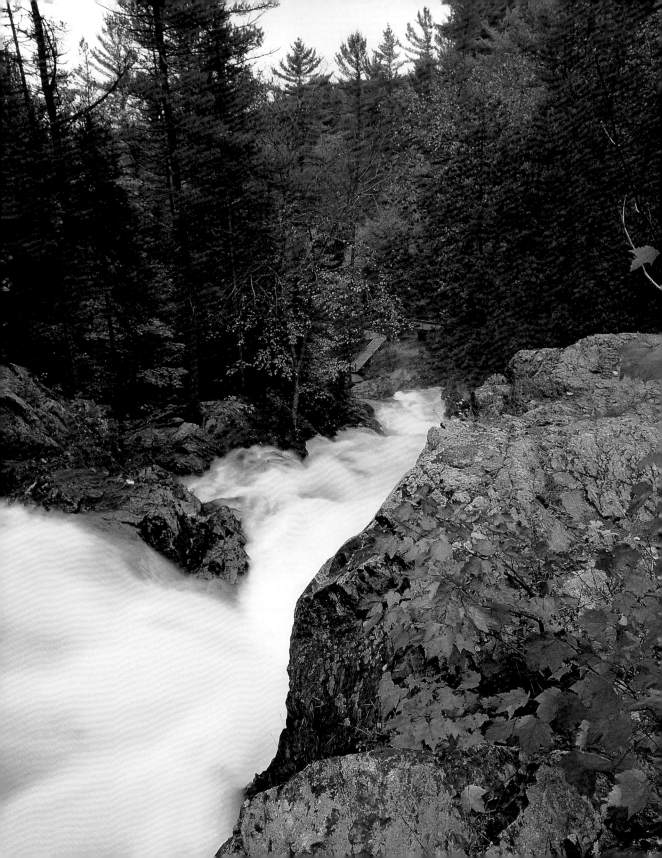

Magpie Falls

🚗 **From the big goose at Wawa, drive south on Hwy. 17 for about 3 km (2 mi.) and watch for the signs. A well-signed winding gravel road leads for 2 km (1.2 mi.) to a large parking lot at the base of the waterfall. It should be noted that this waterfall is often called Scenic High Falls, and was historically known as Michipicoten Falls. Another High Falls about 10 km (6 mi.) east on the Michipicoten River is marked on some maps. This site has been significantly modified by a hydroelectric generating station, and pedestrian access may be difficult, if not impossible. The same is probably true for nearby Steephill Falls and Scott Falls, although what remains of these falls may be reached by canoe.**

COUNTY: Algoma	
NEAREST SETTLEMENT: Wawa	
RIVER: Magpie River	
CLASS: Cascade (Steep)	
TRAIL CONDITIONS: Wheelchair accessible	
ACTIVITY: Busy	
SIZE: Large	
RATING: Good	
NTS MAP SHEET: 41 N/15	
UTM COORDINATES: 16T, 662063, 5314233	
WALKING TIME: 0 minutes	

Along with the big goose located closer to town, Magpie Falls is one of the Wawa area's most well-known landmarks. At approximately 21 meters (70 ft.) high and 50 meters (165 ft.) wide, the waterfall is impressive and well deserving of its alternate name, "Scenic High Falls."

The Magpie River makes an abrupt 90-degree turn to the southwest at the base of the falls. As a result, an excellent elevated viewing area just steps from the falls permits a breathtaking direct view of the cataract. A short path from the parking lot leads up the right side of the falls to a rugged, yet protected viewing area beside the crest of the falls.

The waterfall has cut into fine-grained red granodiorite bedrock, and fractures in the bedrock have influenced the shape of these falls. The face of Magpie Falls has developed along fractures that are oriented from southwest to northeast, and "dip" into the ground at a steep angle of about 70 degrees.

A sign at the parking lot indicates where the more adventurous can join the Voyageur Trail, which will eventually stretch almost 1,000 kilometers (625 mi.) to Thunder Bay. French fur traders traveled along this route in the early part of the 18th century and would have been treated to an even more spectacular version of Magpie Falls than what we see today.

Hidden behind the woods to the left of the falls is the Harris Generating Station operated by Great Lakes Power Ltd. For the generating station to develop approximately 12.5 MW of power, much of the river's discharge has been diverted away from the falls by a long, low dam, which is just visible along the top of the falls. A row of tiny floodgates in the dam allow the power company to control the amount of flow allowed over the falls. Incredibly, this big waterfall can actually be shut off completely at the flick of a switch! Fortunately, however, considerable flow is maintained during daylight hours.

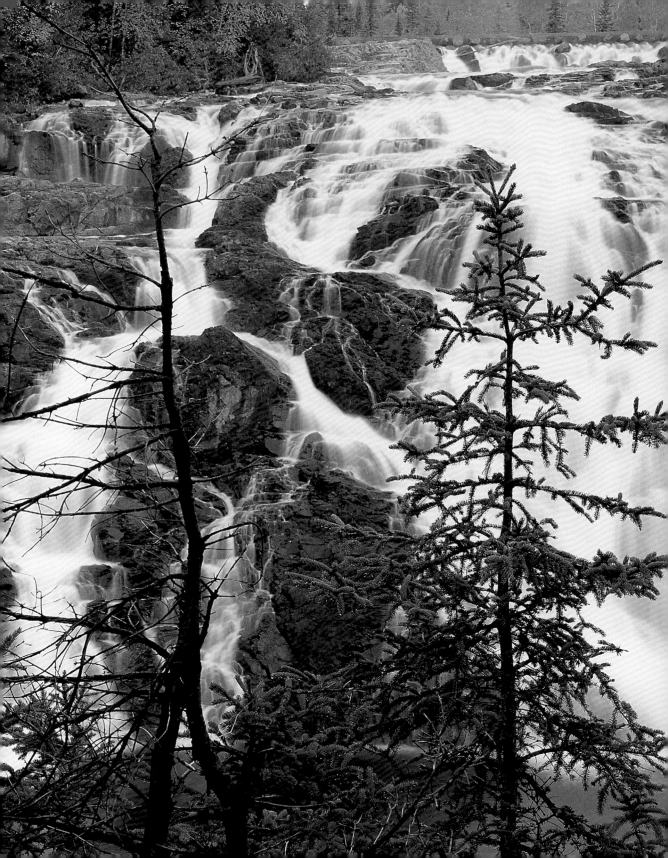

Minnehaha Falls

🚗 **Minnehaha Falls is located on the northeast edge of Sault Ste. Marie, in Kinsmen Park. Follow the directions to Crystal Falls (page 38), but when you reach the parking lot beside the pond, walk south. The falls are located at the south end of the pond. If water levels are too high to permit crossing the dam, you can reach the far side of the river by crossing the bridge at the upstream end of the pond. Caution! Do not cross the fence along the gorge, as it is a very steep drop.**

Minnehaha Falls is located about 500 meters (1,650 ft.) downstream from Crystal Falls, but has not been as fully developed for tourism as its upstream neighbor. Visiting this waterfall is more difficult than Crystal Falls due to the local topography. Unlike Crystal Falls, Minnehaha Falls has eroded a deep and narrow gorge into the bedrock. Steep rock walls make it very difficult to get up close to the waterfall, and a tall chain fence on the right bank keeps visitors back from the brink. The view is somewhat better from the left bank, although the waterfall is surrounded by a heavy forest. Getting a good photograph of Minnehaha Falls is difficult, but not impossible. And even though the waterfall is not the most spectacular tourist draw around, the trails around its gorge provide for some good hiking.

Immediately upstream of the waterfall is the small W.C. Thayer Memorial Dam, which maintains water levels in the pond. The first 4 to 5 meters (13 to 16 ft.) of the waterfall is actually formed by the dam. A micro-power station has been installed at the dam by the Kinsmen Club, and produces about 200 kW. The pond is approximately 75 by 300 meters (250 by 1,000 ft.) and is periodically stocked with rainbow and speckled trout by the Kinsmen. Swimming is encouraged here in summer, so bring your bathing suit.

COUNTY:	Algoma
NEAREST SETTLEMENT:	Sault Ste. Marie
RIVER:	Crystal Creek
CLASS:	Cascade
TRAIL CONDITIONS:	Moderate
ACTIVITY:	Moderate
SIZE:	Medium
RATING:	Mediocre
NTS MAP SHEET:	41 K/9
UTM COORDINATES:	16T, 708828, 5163269
WALKING TIME:	7 minutes

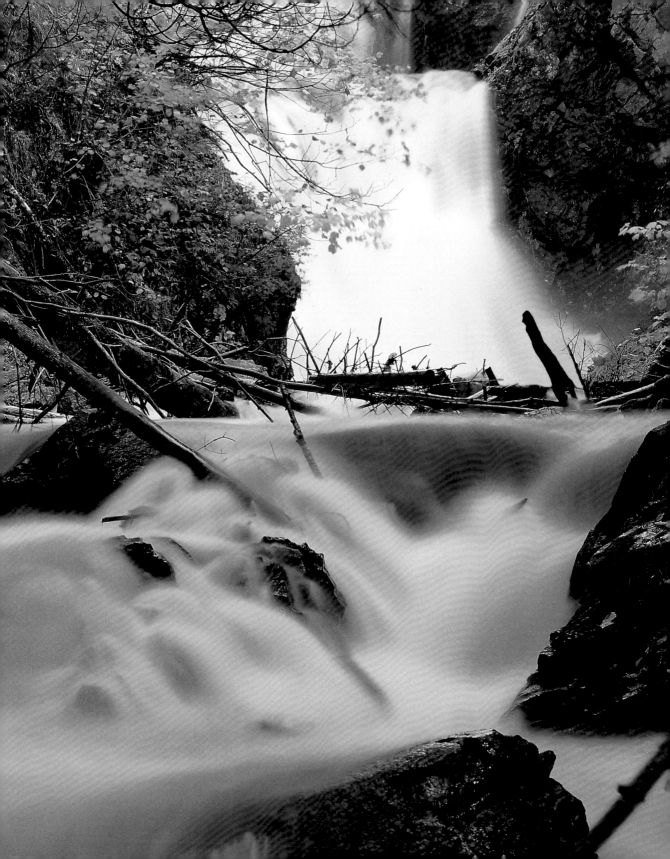

Sand River Falls

🚗 **Drive north on Hwy. 17 from Sault Ste. Marie for about 145 km (90 mi.) to the Sand River parking lot, located 15 km (9 mi.) north of the small settlement of Agawa Bay. Park in the lot and pay the small admission fee. If you've brought a canoe, you may wish to paddle upstream on the Sand River for about 10 km (6 mi.) to Lady Evelyn Falls, a highlight of the Sand River Canoe Route. A few other smaller rapids and waterfalls are found along the route. About 10 to 12 km (6 to 7 mi.) to the south along the highway, be sure to make a quick stop at the bridge over the Montreal River. A stunning chasm lies right under the highway.**

COUNTY:	Algoma
NEAREST SETTLEMENT:	Agawa Bay
RIVER:	Sand River
CLASS:	Cascade
TRAIL CONDITIONS:	Moderate
ACTIVITY:	Moderate
SIZE:	Medium
RATING:	Outstanding
NTS MAP SHEET:	41 N/7
UTM COORDINATES:	16T, 670478, 5256137
WALKING TIME:	7 minutes

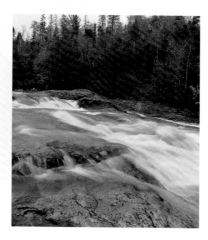

The stretch of the Sand River immediately upstream of Highway 17 is a photographer's dream! Over a mile of unspoiled waterfalls, rapids and pools provide lots of photographic and exploration possibilities.

There are three larger waterfalls; each of them cascades down about 5 to 8 meters (16 to 26 ft.). The first waterfall is roughly 300 meters (1,000 ft.) upstream from the parking lot. The stretch of the river leading up to this waterfall is one long series of rapids, cascades and chutes. If the water level is low enough, you can walk right out on the bare granite bedrock to explore the smoothed and sculpted riverbed. Approximately 700 meters (2,300 ft.) further upstream is the second large waterfall, located at the far end of a long, narrow pond. If you are one of the few visitors to continue for still another 600 meters (2,000 ft.) upstream, you will be treated to a third large waterfall located at the upstream end of a large pond.

As a popular destination in the Lake Superior Provincial Park, this site attracts a lot of visitors during the warm summer months. Most tend to visit only the lower reaches of the river, near the parking lot and picnic tables. Some move further upstream to fish for brook trout, and still fewer walk the entire route to the upper falls, which is a three-hour return trip. This is actually the last portion of the Sand River Canoe Route, which is a very demanding 56-kilometer (35 mi.) route winding through the park. The footpath running east beside the river is called the "Pinguisibi" Trail, which is an Ojibwa name meaning "river of fine white sand."

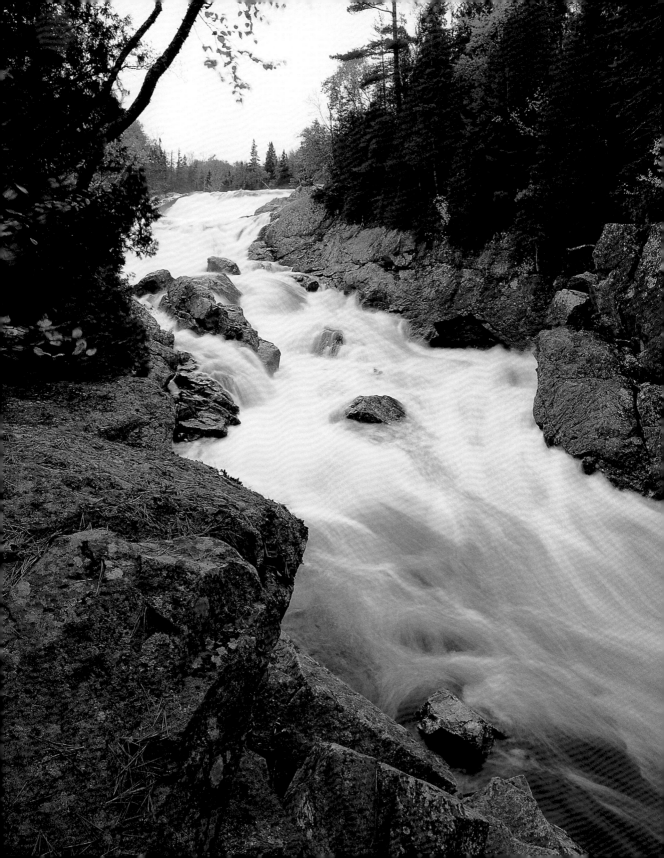

Silver Falls

🚗 From Wawa, drive south on Hwy. 17 for about 5 km (3 mi.) to Michipicoten River Village Rd. and turn right. Turn right again at the next main road, and follow the road around the bend to the left. As the road approaches a bridge over the river, park in the clearing on the right side of the road. If water levels are low enough you can choose to walk toward the lower falls along the far edge of the big pool in the river. Otherwise, look for the footpath leading into the woods from the small parking area on the far side of the bridge. A five-minute walk up the path leads to the crest of the lower falls. The upper falls may also be viewed from this spot, or by following further up the slope through the forest.

COUNTY:	Algoma
NEAREST SETTLEMENT:	Wawa
RIVER:	Magpie River
CLASS:	Cascade (Steep)
TRAIL CONDITIONS:	Moderate
ACTIVITY:	Quiet
SIZE:	Medium
RATING:	Good
NTS MAP SHEET:	41 N/15
UTM COORDINATES:	16T, 662040, 5312065
WALKING TIME:	5 minutes

Silver Falls is a great place to explore. Unlike Magpie Falls, which is just 2.8 kilometers (1.7 mi.) upstream, you can walk right out onto the bedrock and stand just a few steps from the falls.

Silver Falls has not experienced the tourist development that has popularized Magpie Falls, and thus no guardrails or staircases have been built. As a result, the site is natural, rugged and dangerous. Be sure not to let young children run free here!

The erosive power of the Magpie River has carved a giant pocket out of the gray volcanic bedrock. The lower falls sits at the upper end of the pocket, and a little powerful chute has formed at the other end, where the bedrock constricts the river to a width of just a few meters. The little pool between the falls and the chute is bordered on the side by a massive sheer wall of rock, probably 30 meters (100 ft.) high. Standing guard over the whole scene is an ancient twisted cedar tree just to the left of the falls.

By following the footpath along the right bank of the river, you can make your way up to a broad, open terrace of boulders beside the crest of the lower falls. From here, the river appears to slide along a steep convex slab of rock before breaking into a true plunge-class waterfall in its lower sections. Behind the lower falls, the upper falls appear from around the corner. Upper Silver Falls is clearly not as photogenic as the lower falls. The river has exposed a 50-meter (165 ft.) width of bedrock, but at lower stream flows, the river spreads out and trickles its way through four or five different channels. This creates an ever-changing, but somewhat messy pattern of small waterfalls each between 3 and 6 meters (10 and 20 ft.) high.

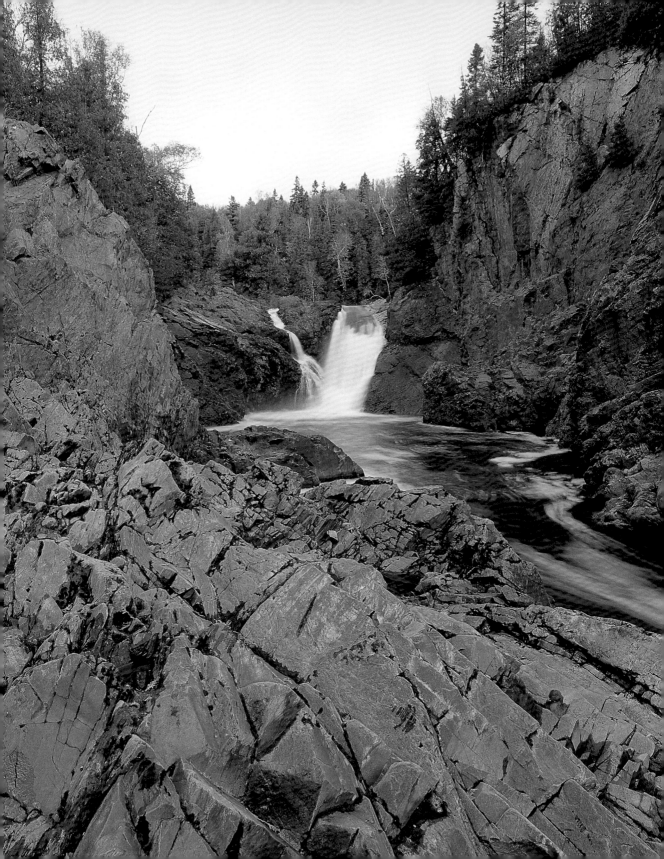

Wawa Falls

🚗 Follow the directions to Silver Falls (page 46). Wawa Falls may be viewed by looking downstream from the bridge, but two short trails allow you to take a much closer look. Beside the bridge, there is a short path leading to the bare bedrock right beside the falls. For a more panoramic view, walk back east along the road for a few meters to a trail. It is best viewed from the bedrock below. Look for the path leading downstream into the thin woods near the bridge.

COUNTY:	Algoma
NEAREST SETTLEMENT:	Wawa
RIVER:	Magpie River
CLASS:	Cascade
TRAIL CONDITIONS:	Moderate
ACTIVITY:	Moderate
SIZE:	Medium
RATING:	Average
NTS MAP SHEET:	41 N/15
UTM COORDINATES:	16T, 661891, 5312039
WALKING TIME:	2 minutes

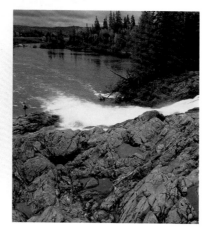

Wawa Falls is a name often used for the lowest of three cascades at Silver Falls. It is a few hundred meters downstream of Silver Falls, about 50 meters (165 ft.) downstream of the bridge over the river. Unlike its upstream neighbor, Wawa Falls is not constrained in a tall, narrow gorge. The river flows over a wide expanse of gray-green volcanic bedrock, tumbling into a small bay. The waterfall is well exposed to the sky, offering excellent photographs from the rocky point that extends into the bay. Across the bay, you can see the marina at the confluence of the Magpie and Michipicoten rivers.

A careful look at the bedrock on the rocky point below the falls reveals a jagged, pyramidlike surface. The rock has almost no vegetation, except for a few lichens and mosses. But these lowly plants are the start of an important ecological process known as primary succession. As lichens gain a foothold on the bare rock, their remains will pave the way for a thin layer of soil. More complex plants will begin to grow where the soil accumulates, unless the whole deposit is washed away by a flood!

Below the left side of the waterfall, a stretch of darker gray rock about 70 centimeters (28 in.) wide cuts across the bedrock for a few dozen meters. This is a dike, formed by the intrusion of newer igneous rock into the existing bedrock. But "newer" is relative. The rocks of the Canadian Shield in this area are well over a billion years old.

After visiting Wawa Falls, drive about 4 kilometers (2.5 mi.) further northwest to beautiful Sandy Beach on Lake Superior. Another 3 kilometers (2 mi.) along is a pretty little waterfall tucked away in the woods, just visible from the northeast corner of the intersection of the road to Michipicoten Harbour (Michipicoten Harbour Road Falls).

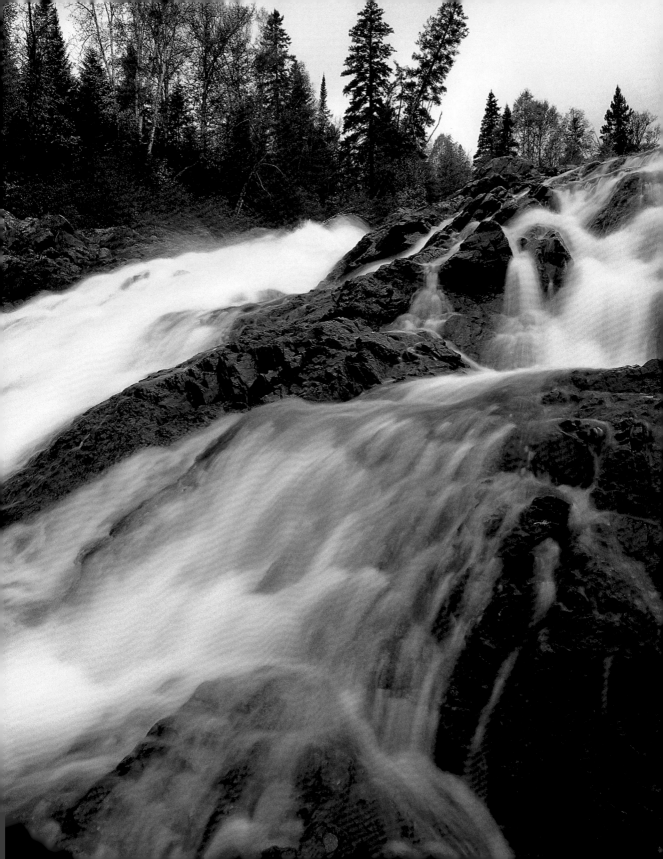

COTTAGE COUNTRY

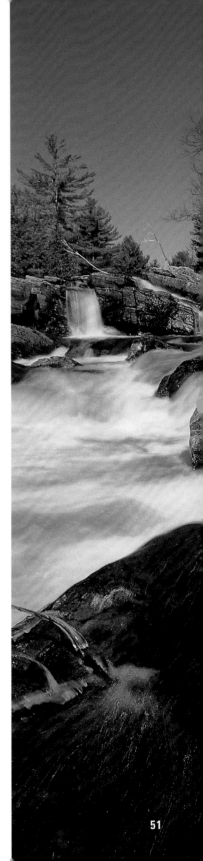

AN ABUNDANCE of water and wilderness has long attracted city dwellers to this region on summer weekends. Only a few hours' drive from the major population centers to the south, the region provides well over a hundred waterfalls to explore – the town of Bracebridge alone boasts 22! The area's road network is very good, but be aware that you can drive on the back roads for many kilometers without passing a gas station or general store.

Muskoka boasts big, powerful waterfalls found on rugged Canadian Shield country, while Haliburton offers smaller waterfalls on beautiful little creeks draining the forested highlands. Waterfalls in the Kawartha region are formed on both the Canadian Shield and on limestone, giving them a steplike appearance.

Recommended tour

Visit Muskoka Falls and then drive to Bracebridge where you can visit Bracebridge Falls, Wilsons Falls and the three waterfalls at High Falls (Bracebridge). If time permits, drive out to little Dee Bank Falls or Rosseau Falls.

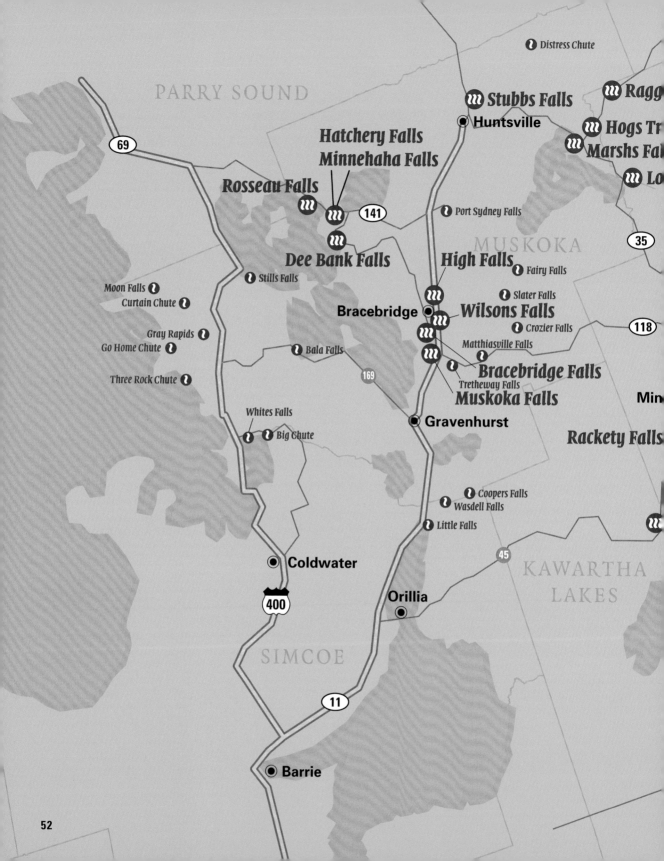

PARRY SOUND

69

Distress Chute

Stubbs Falls

Ragg

Huntsville

Hogs Tr

Marshs Fal

Hatchery Falls
Minnehaha Falls

Lo

Rosseau Falls

141

Port Sydney Falls

MUSKOKA

35

Dee Bank Falls

High Falls

Fairy Falls

Stills Falls

Moon Falls

Slater Falls

Wilsons Falls

Curtain Chute

Bracebridge

Crozier Falls

118

Gray Rapids

Bala Falls

Matthiasville Falls

Go Home Chute

Bracebridge Falls

Three Rock Chute

Tretheway Falls

169

Muskoka Falls

Min

Whites Falls

Big Chute

Gravenhurst

Rackety Falls

Coopers Falls

Wasdell Falls

Little Falls

45

KAWARTHA
LAKES

Coldwater

400

Orillia

SIMCOE

11

Barrie

52

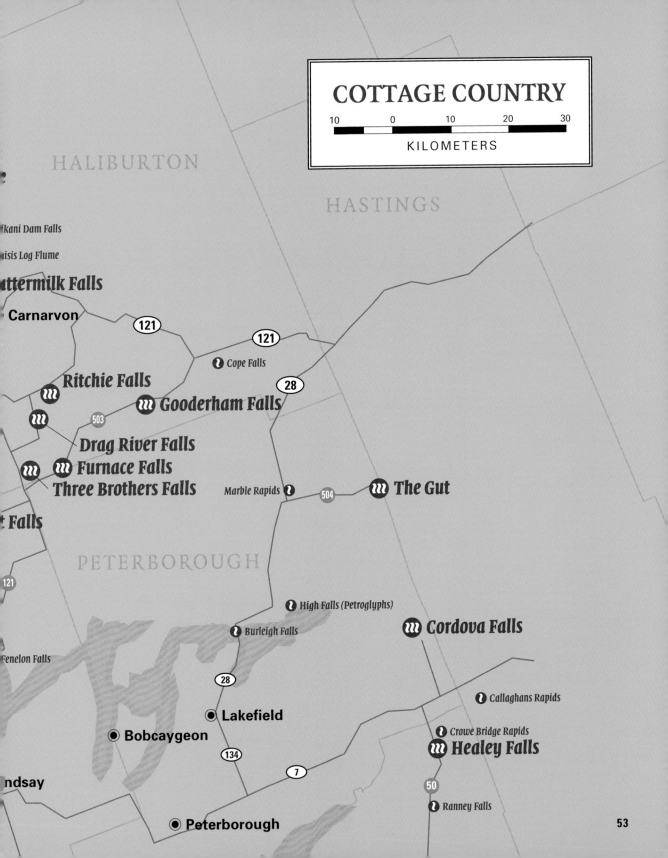

10 0 10 20 30

KILOMETERS

HALIBURTON

HASTINGS

ikani Dam Falls

nisis Log Flume

ttermilk Falls

Carnarvon

121

121

Cope Falls

Ritchie Falls

28

Gooderham Falls

503

Drag River Falls

Furnace Falls

Three Brothers Falls

Marble Rapids 504 **The Gut**

t Falls

PETERBOROUGH

121

High Falls (Petroglyphs)

Cordova Falls

Burleigh Falls

enelon Falls

Callaghans Rapids

28

Crowe Bridge Rapids

Lakefield

Healey Falls

Bobcaygeon

134

7

50

ndsay

Ranney Falls

Peterborough 53

Bracebridge Falls

🚗 Follow Hwy. 11 north to Muskoka Rd. 42 (Taylor Rd.) and go west. Turn left at Cedar Lane, and after 2 km (1.2 mi.), turn right on Entrance Dr. Park in the municipal lot located on the left side of the road, just before the road makes a sharp bend to the left. At the right side of the parking lot, a short trail descends the hill to a small woods beside the river. Turn left at the base of the hill and proceed to the small viewing platform built beside the waterfall. Before returning to the parking lot, take the very short walk up the river to the 3-m (10 ft.) high upper falls.

COUNTY:	Muskoka
NEAREST SETTLEMENT:	Bracebridge
RIVER:	Muskoka River (North Branch)
CLASS:	Cascade (Steep)
TRAIL CONDITIONS:	Easy
ACTIVITY:	Very busy
SIZE:	Large
RATING:	Average
NTS MAP SHEET:	31 E/3
UTM COORDINATES:	17T, 633258, 4988661
WALKING TIME:	5 minutes

Once you've seen Bracebridge Falls, it isn't difficult to understand why Bracebridge developed where it did. Taking advantage of its source of natural power, the town grew around – and partially over – its waterfall. The upper falls are all but hidden under the Entrance Street Bridge, while the main falls have been significantly modified by a concrete dam and nearby rail and road bridges. These falls are a good visual example of the connection between nature and society. The waterfall is obviously the focal point of the town, and through the development of the splendid Bracebridge Bay Park, it is clear that this is recognized by the people of Bracebridge. An excellent viewing platform has been constructed beside the falls, providing an intimate experience with the waterfall, even when flows are high. The town's Canada Day festivities include fireworks displays over the bay, just below the falls.

On the far side of the river, closer to the upper falls, an old brick and stone building housed one of the first hydroelectric generating stations in Ontario. Built in 1892, and bought by the town in 1894, this station was the first in the province to be operated by a municipality. Another brick building located downstream of the main falls houses a second generating station which was built by the town in 1902 and still generates 600 kW of electricity. But hydroelectric development was not the first use of water power at Bracebridge. As early as 1862, a sawmill operated on the east side of the river; gristmills, flour mills and woolen mills sprang up later. The Bird Woollen Mill was constructed in the 1870s and became the town's biggest. One of the buildings associated with the mill still exists and currently houses both the Bracebridge Chamber of Commerce and a restaurant.

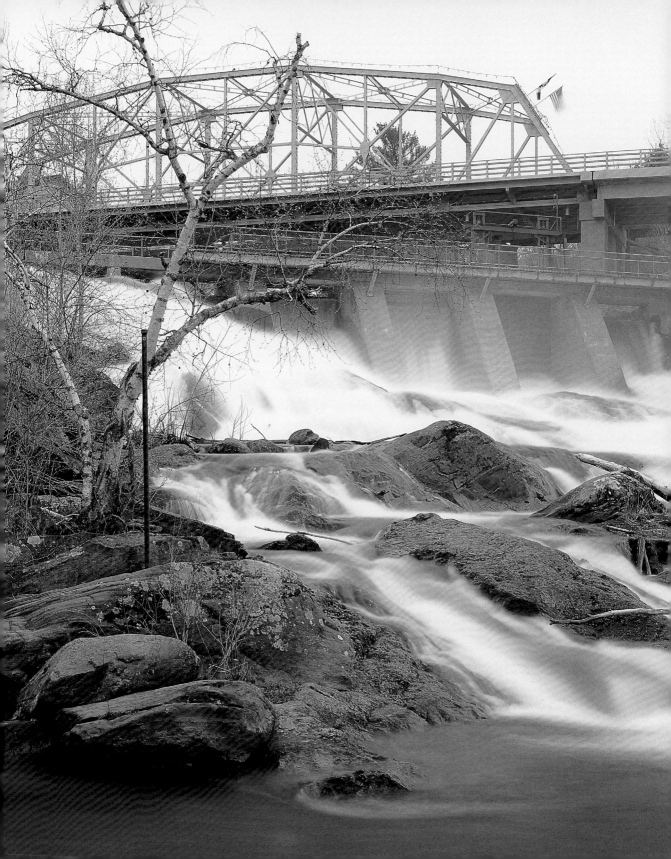

Buttermilk Falls

🚗 **Drive north on Hwy. 35 to Canarvon, about 85 km (55 mi.) north of Lindsay. Continue north on Hwy. 35 for almost 8 km (5 mi.) to Buttermilk Falls. Just before crossing over the river, there is a parking lot on the left side of the road. Park in the lot, and walk across the dam to the gravel laneway. Turn left and walk down the hill. Partway down the hill, turn left on the path that leads into the forest toward the falls (please respect private property). For the Kennisis Log Flume, drive 4 km (2.5 mi.) further north along Hwy. 35 and turn right onto Haliburton Rd. 13. Drive for 3 km (2 mi.) to Big Hawk Lake Rd. and turn left. The parking area for the log slide is about 3 km (2 mi.) along this road, on the right.**

COUNTY: Haliburton	
NEAREST SETTLEMENT: Buttermilk Falls	
RIVER: Kennisis River	
CLASS: Slide	
TRAIL CONDITIONS: Moderate	
ACTIVITY: Quiet	
SIZE: Medium	
RATING: Average	
NTS MAP SHEET: 31 E/2	
UTM COORDINATES: 17T, 677389, 4995737	
WALKING TIME: 5 minutes	

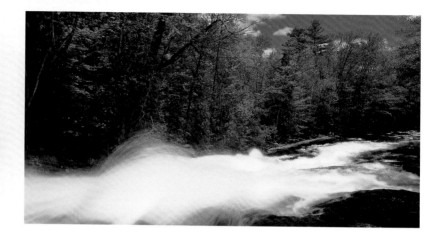

Buttermilk Falls is an interesting site even though the once-natural falls have been partially modified by a concrete log chute. The waterfall is located between Halls Lake and Boshkung Lake, where a short channel of the Kennisis River flows under the highway, through a dam, and then down through a beautiful forested valley. The upper portion of the channel has been diverted into a concrete sluiceway, about 3 to 4 meters (10 to 13 ft.) wide. Encountering little resistance, the river picks up speed along the sluiceway, and then blasts out of the sluice onto bare gneiss bedrock midway down the slope. At higher flows, the water shoots a few meters into the air as it encounters protruding ridges on the rock face. From here, the river bounces and jumps a further 50 meters (160 ft.) downstream over a giant bedrock ramp before regaining its composure and emptying into Boshkung Lake about 100 meters (325 ft.) further south. The total drop in elevation between the two lakes is 18 meters (60 ft.).

An interesting site nearby is the old Kennisis log flume. This wooden flume was once used to help guide logs down the Kennisis River from Big Hawk Lake to Halls Lake. Currently under restoration, the site is an interesting place to visit, not only to see a piece of lumbering history, but also for the scenic drive up the road to Big Hawk Lake. The deep narrow gorge at the log flume is quite impressive for the area.

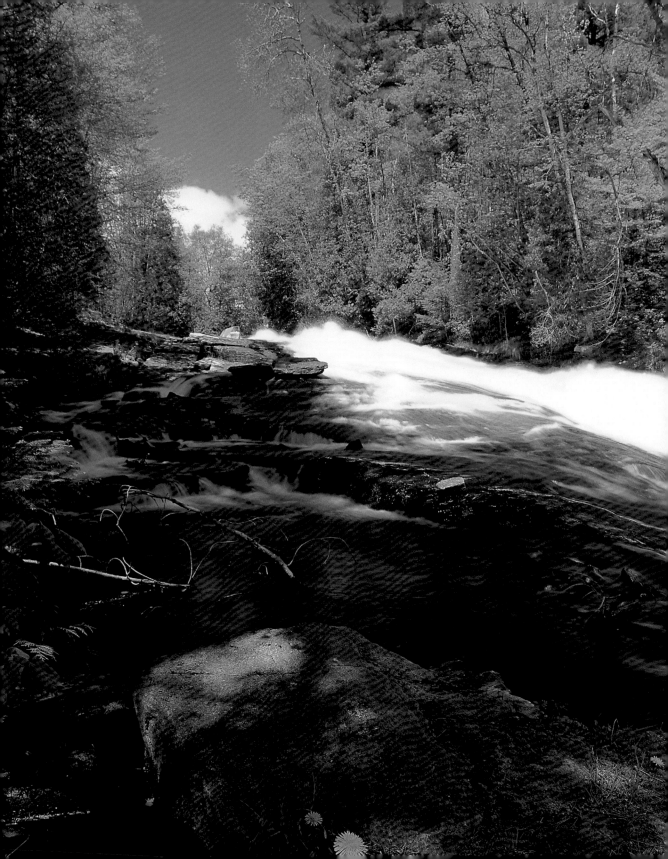

Cordova Falls

🚗 Follow Hwy. 7 east from Peterborough to Havelock. Drive east for a further 10 km (6 mi.) to 2nd Line, and turn left. Follow this road north until it meets Peterborough Rd. 48, and continue north for 6.3 km (4 mi.) to Preston Rd. Turn left on Preston Rd., and then turn right onto Fire Rd. 18 (also marked as Fish Hatchery Rd.). Visit the upper falls first by following this road north for 3.5 km (2 mi.), keeping to the left, except where you see a one-way sign. The dam and falls are less than a minute's walk from the gravel parking lot near the south shore of Cordova Lake. For the middle falls, drive south on the southbound one-way road, but keep to the right and turn down the short driveway beside the long wooden penstocks.

COUNTY: Hastings	
NEAREST SETTLEMENT: Cordova Mines	
RIVER: Crowe River	
CLASS: Cascade	
TRAIL CONDITIONS: Moderate	
ACTIVITY: Quiet	
SIZE: Small	
RATING: Good	
NTS MAP SHEET: 31 C/12	
UTM COORDINATES: 18T, 275752, 4937548	
WALKING TIME: 2 minutes	

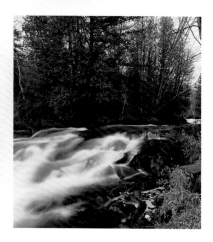

This is an interesting place to explore, and a perfect spot for a picnic. There are at least three little waterfalls along this stretch of the Cordova River, which drops a total of 28 meters (92 ft.). The largest is found immediately below a dam at the southern outlet of Cordova Lake. Here, the Crowe River tumbles down a narrow rocky channel perhaps 100 meters (325 ft.) long. The river drops about 10 meters (30 ft.), falling not as one main cascade, but rather in at least five distinct smaller drops, separated by short pools. By walking along a poorly marked trail leading south from the dam, you can get to the lower reaches of the falls.

The bedrock at Cordova Falls is different than at most other sites, giving the falls a distinctive appearance. It is probably amphibolite, a jet black metamorphic rock. The stratified rock layers "dip" into the earth at an angle of about 75 degrees.

Middle Cordova Falls is perhaps the most photogenic of the three waterfalls, forming a pretty, 5-meter (16 ft.) high cascade set among cedars and hemlocks. It is partially hidden behind the little Cordova Lake Hydroelectric Generating Station, and is difficult to view up close without a little adventuring. A portion of the river's discharge that would have flowed over these falls is diverted at the upper falls and delivered 200 meters (650 ft.) to the hydroelectric plant by a long, wooden penstock. Opened in 1992, the station generates a peak output of 780 kW, which is enough to power about 50 homes. It might supply 51 homes if the leaks in the penstock were fixed!

The lower falls are the smallest, but are located beside a beautiful rock-floored clearing in the woods. You'll find them hidden at the end of a short driveway on the right side of the road a few minutes' drive further south.

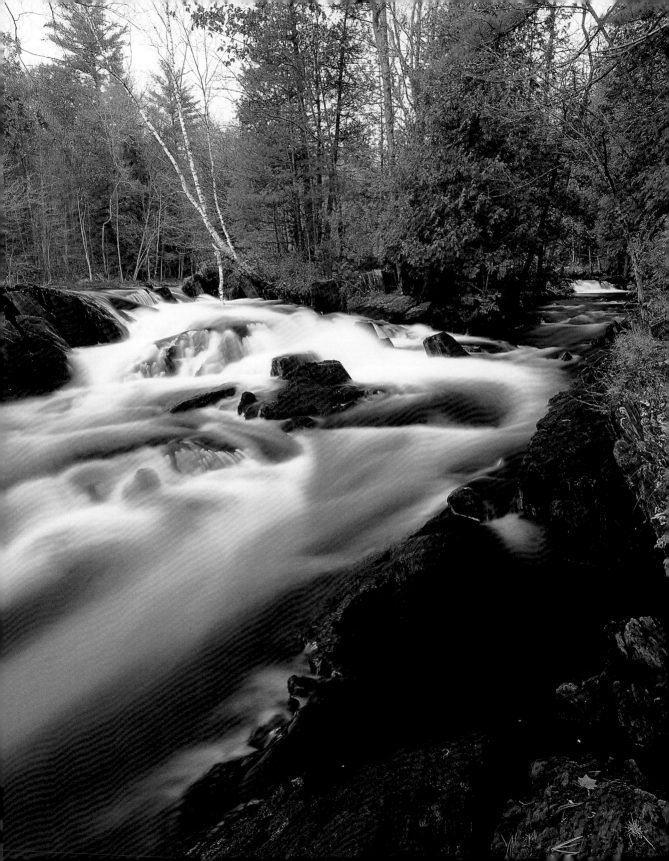

Dee Bank Falls

🚗 Follow Hwy. 11 north past Bracebridge to Hwy. 141. Go west on Hwy. 141 to Ullswater, and turn left on Muskoka Rd. 24. Follow this road south for about 5 km (3 mi.) and turn left on North Shore Rd. (If you cross the bridge over the Dee River, you've gone too far.) Drive along North Shore Rd. for about 300 m (1,000 ft.) and park on the shoulder. If you listen, you should hear the falls, which are about 200 m (650 ft.) through the open forest. There is no properly marked trail, so just find your way down the slope to the river. Please be mindful of private property.

COUNTY:	Muskoka
NEAREST SETTLEMENT:	Dee Bank
RIVER:	Dee River
CLASS:	Slide
TRAIL CONDITIONS:	Moderate
ACTIVITY:	Quiet
SIZE:	Small
RATING:	Average
NTS MAP SHEET:	31 E/4
UTM COORDINATES:	17T, 616251, 5003701
WALKING TIME:	5 minutes

This isn't a big waterfall by any means, but it is found in an interesting stretch of river that may be explored. The Dee River drains Three Mile Lake to Clark Pond and then to Lake Rosseau. The river braids around several tiny bedrock islands composed of banded gneiss, some with little cascades on either side. You can walk out onto the bedrock beside the water, and even onto the islands during periods of low flow.

At the largest waterfall, the river doesn't fall over a prominent ledge of rock, but rather slides over the flat surface of a steeply inclined gneiss formation. Dee Bank Falls is one of the few examples of the slide class of waterfall included in this collection.

John Shannon built a sawmill at these falls, some time after 1868. A few years later, he built a large grist-mill at the base of the falls, which was reported to have been one of the largest in the county at the time. Now the remnants of the mills are gone, and the site has reverted to a pleasant natural setting.

About 2.5 kilometers (1.5 mi.) downstream from Dee Bank Falls you may visit Clark Falls, where the Dee River empties into Lake Rosseau. Here, a steep cascade a few meters in height is formed where the river crosses a resistant ledge of gneiss and migmatite bedrock.

Archibald Taylor built a sawmill here around the time of Canada's Confederation (1867). A wooden dam was constructed to increase the available head for the mill. Unfortunately, Taylor's mill burned in 1929, although it is reported that you can still explore its foundations. There is currently no access by road, so you will need to use a boat or canoe to visit Clark Falls.

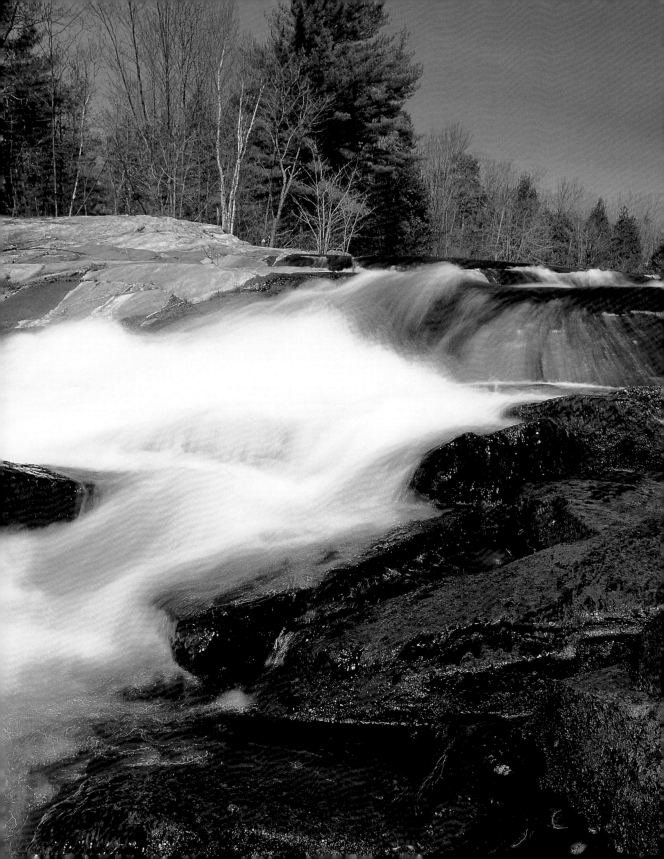

Drag River Falls

🚗 **Drive north on Hwy. 35 to Norland, and turn right on Kawartha Lakes Rd. 45. Then follow this road to Kinmount, and turn left on Kawartha Lakes Rd. 121. Drive north for 7.3 km (4.5 mi.) to Haliburton Rd. 1, and turn right. Follow the road for almost 10 km (6 mi.) until you reach Station St. in the little settlement of Gelert; turn right and park where the road meets the Haliburton Rail Trail, just a few hundred meters to the east. Walk north along the trail for about 400 m (1,300 ft.) to the short steel bridge. Continue just past the trestle and turn right, down the hill into the forest. Stay close to the river and you will come upon the waterfall after about a 10-minute walk.**

COUNTY:	Haliburton
NEAREST SETTLEMENT:	Gelert
RIVER:	Drag River
CLASS:	Cascade
TRAIL CONDITIONS:	Difficult
ACTIVITY:	Remote
SIZE:	Small
RATING:	Mediocre
NTS MAP SHEET:	31 D/15
UTM COORDINATES:	17T, 688392, 4973746
WALKING TIME:	15 minutes

One of the smallest waterfalls covered in this book, Drag River Falls is just a little bigger than a bedrock rapid, but it is one of those places where you can sit for hours, forgetting about the troubles of the day. You will most likely have this waterfall all to yourself, not only because of its size, but also due to the challenging trail conditions.

The two tiny falls are set along an unspoiled section of the Drag River surrounded by a thick cedar forest. If you're lucky, you may find a very weak path winding through these woods on the way to the falls. More likely, you will need to make your own way through the thick jumble of fallen trees and underbrush.

It is recommended that you visit Drag River Falls with a friend because of its remote location and difficult trail. Access can be especially difficult in the wintertime, but immediately following a fresh snowfall the site takes on a dreamy quality that immediately captures the imagination of the landscape photographer.

As you make your way toward the falls, you will be walking along the route of the abandoned roadbed of the Victoria Railway, which ran between Lindsay and Haliburton from 1874 to 1888. It was eventually absorbed by Canadian National Railways in 1923, and then finally abandoned in 1981.

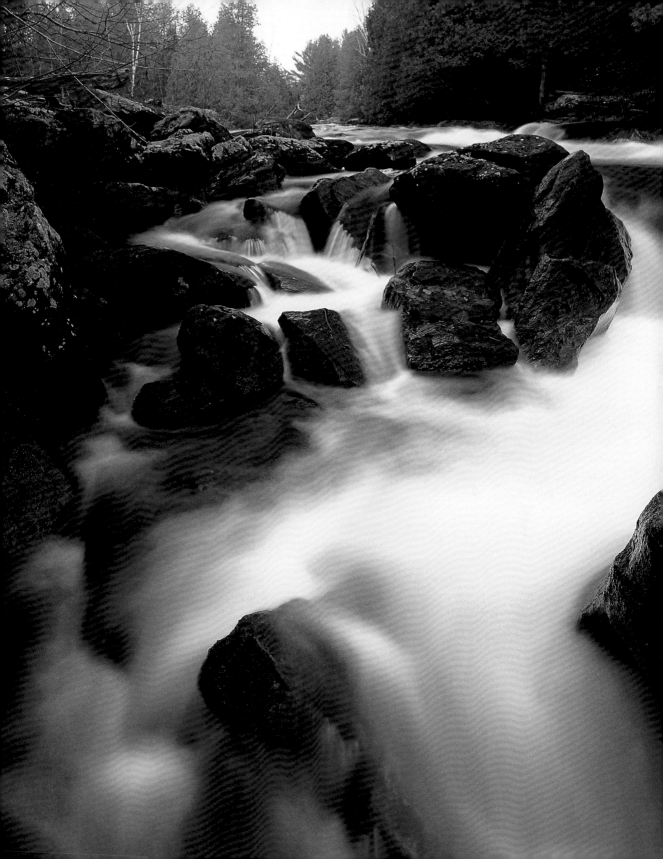

Elliott Falls

🚗 Follow Hwy. 35 north to Norland, which is about 45 km (28 mi.) north of Lindsay. Continue north for another 2.7 km (1.7 mi.) and turn right onto Elliott Falls Rd. Drive to the end of this short road and park in the gravel parking lot by the Gull River. Walk towards the power dam to the right, and then across the catwalk over the dam to the left bank of the river. A number of trails set out into the forest from this point. Follow the trail that leads downstream to the right and stays within view of the river at all times. The path is rocky but passable, and the walk down to the main falls takes only a few minutes.

COUNTY: **Haliburton**

NEAREST SETTLEMENT: **Norland**

RIVER: **Gull River**

CLASS: **Cascade**

TRAIL CONDITIONS: **Moderate**

ACTIVITY: **Moderate**

SIZE: **Medium**

RATING: **Good**

NTS MAP SHEET: **31 D/10**

UTM COORDINATES:
17T, 672200, 4956735

WALKING TIME: **5 minutes**

Elliott Falls is a pretty little waterfall typical of most of the falls in Haliburton County: a series of low cascades on a small river. This site has been significantly modified by a hydroelectric dam, but still contains enough natural scenery to make for an interesting visit.

A small hydroelectric generating plant was developed by the Elliott Falls Power Corporation in 1988. The plant was redeveloped in a portion of the original powerhouse, first built in 1904. The plant generates an average annual output of 510 kW, which is sufficient to power about 500 homes. From late spring to early fall, some discharge is permitted to bypass the power plant through two openings in a small dam. The western opening allows some water to flow through a long, narrow concrete sluiceway built on top of bare rock, and at higher flows, releases some water over a bare bedrock section that was once the main falls. The eastern opening carries water along a long, narrow rocky channel to the main falls.

The main falls are located about 100 meters (325 ft.) downstream of the power station and dam. Here, the water pokes its way through a 10-meter (30 ft.) wide section of highly fractured gneiss bedrock, which dips gently to the east. A wide spread of small boulders lies on the riverbed below the falls, and may represent rock eroded and carried down by the river during higher flows.

The Gull River opens to a wide pool below the waterfall and hydroelectric station. In summer, swimming and wading are possible in the pool below the main falls.

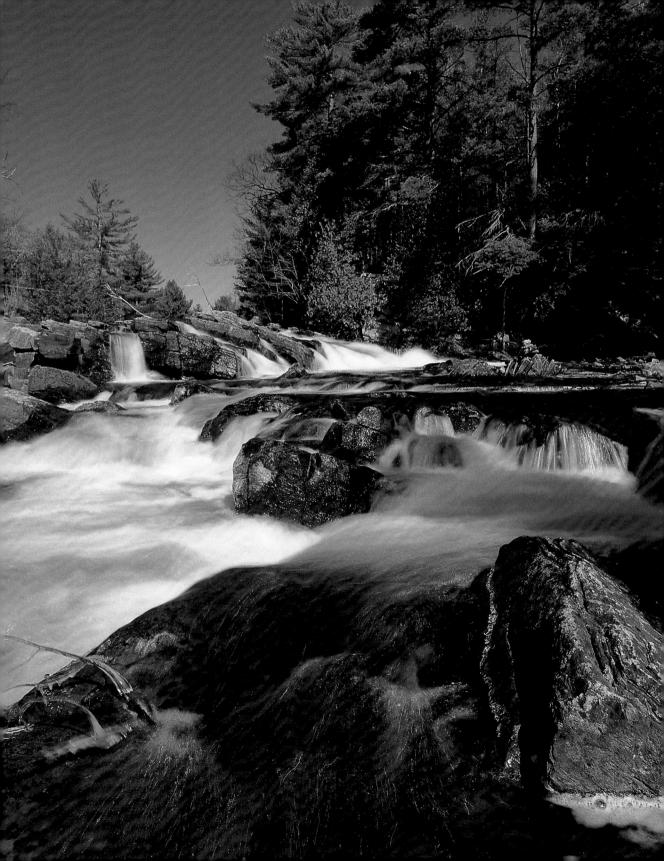

Furnace Falls

🚗 Follow Hwy. 35 north to Norland. (Here you may consider visiting nearby Elliott Falls.) At Norland, turn right onto Kawartha Lakes Rd. 45 and drive to Kinmount. At Kinmount, turn right onto Kawartha Lakes Rd. 121, but be ready to turn left (east) onto Peterborough County Rd. No. 503 towards Gooderham. Furnace Falls is located on the south side of the road, about 10 km (6 mi.) past Kinmount. The total trip from Norland is about 25 km (15 mi.). At the time of writing, overnight camping was not permitted at this park.

COUNTY:	Haliburton
NEAREST SETTLEMENT:	Furnace Falls
RIVER:	Irondale River
CLASS:	Cascade
TRAIL CONDITIONS:	Easy
ACTIVITY:	Moderate
SIZE:	Small
RATING:	Mediocre
NTS MAP SHEET:	31 D/15
UTM COORDINATES:	17T, 692710, 4966545
WALKING TIME:	1 minute

Since the Irondale River drops just a little over 1 meter (3 ft.) at Furnace Falls, this site can be disappointing to some visitors at first. The 4-hectare (10 acre) passive park surrounding the site is nevertheless a great stop for a picnic. The falls, while small, are picturesque and during summer make for a fun place for kids to splash about in the water.

Furnace Falls is only about 75 meters (250 ft.) upstream from Haliburton County Road No. 503, so this is far from a quiet oasis. The falls are formed on a wide knickpoint of gneiss and are found below a gentle stretch of the river. Trails from the parking area lead to slightly more secluded spots along the river, although you should (as always) respect private property.

Furnace Falls gets its name from the blast furnaces that were built in the area during the late 19th century to smelt iron ore. The falls are about three-quarters of the way along a 30-kilometer (18 mi.) canoe route between Gooderham and Kinmount. This trip takes two to three days, and reportedly requires about a dozen portages around small bedrock rapids. More experienced paddlers can follow the river a further 45 kilometers (28 mi.) south to Fenelon Falls.

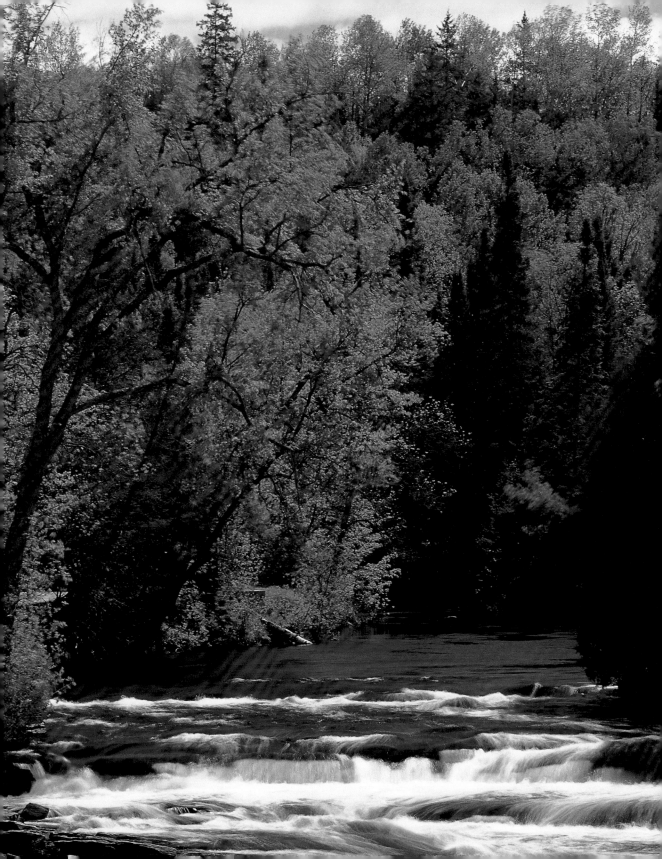

Gooderham Falls

🚗 Follow the directions to Furnace Falls (page 66), and continue east along Haliburton Rd. 503 for about 19 km (12 mi.). Once you reach the village of Gooderham, turn left onto Pine Ave. and drive up the hill. Turn left onto Lakeshore Rd. and park near the little bridge over the dam. A good view of the whole site is available from the bridge over the dam, but by scrambling down the rocky hill just east of the bridge, you can get a better view of the falls.

This little waterfall is worth a stop if you're in the area. It's hidden behind some warehouses at the back of the little village of Gooderham, but has not been developed as a tourist attraction.

The waterfall is situated immediately below a water control dam at the south end of Gooderham Lake. It is a narrow cascade about 7 to 8 meters (23 to 26 ft.) high, with much of its descent framed by a jumbled mass of boulders and cedar trees. In a few places the creek slides over exposed bedrock that slopes downhill at about 30 degrees. The bedrock is probably amphibolite, a dark-colored rock that forms from the metamorphosis of existing dark igneous rocks like basalt or diabase.

The village of Gooderham was incorporated in 1873. Originally known as Pine Lake (a local name for Gooderham Lake), it is not entirely clear why the name of the village was changed. One story goes that a sales representative from the Gooderham and Worts distillery in Toronto came to the settlement, and soon after his visit, the village took on its new name.

Water power in Gooderham allowed the development of sawmills, gristmills and shingle mills. Along the left bank of the falls the ruins of an old wooden penstock can be examined. The wood has long disappeared, but the metal rings and concrete footings are barely visible below the cedars.

Gooderham became more prosperous when the Irondale, Bancroft and Ottawa railway arrived sometime in the early 1890s. This rail line was to have connected Toronto to the Ottawa Valley, with the intention of shipping recently discovered iron ore deposits. Unfortunately, the railway never made it past Bancroft, and was abandoned in 1960. The little Gooderham train station is reported to have been moved to serve as a nearby residence.

COUNTY:	Haliburton
NEAREST SETTLEMENT:	Gooderham
RIVER:	Irondale River
CLASS:	Cascade
TRAIL CONDITIONS:	Moderate
ACTIVITY:	Moderate
SIZE:	Small
RATING:	Mediocre
NTS MAP SHEET:	31 D/16
UTM COORDINATES:	17T, 706717, 4976042
WALKING TIME:	2 minutes

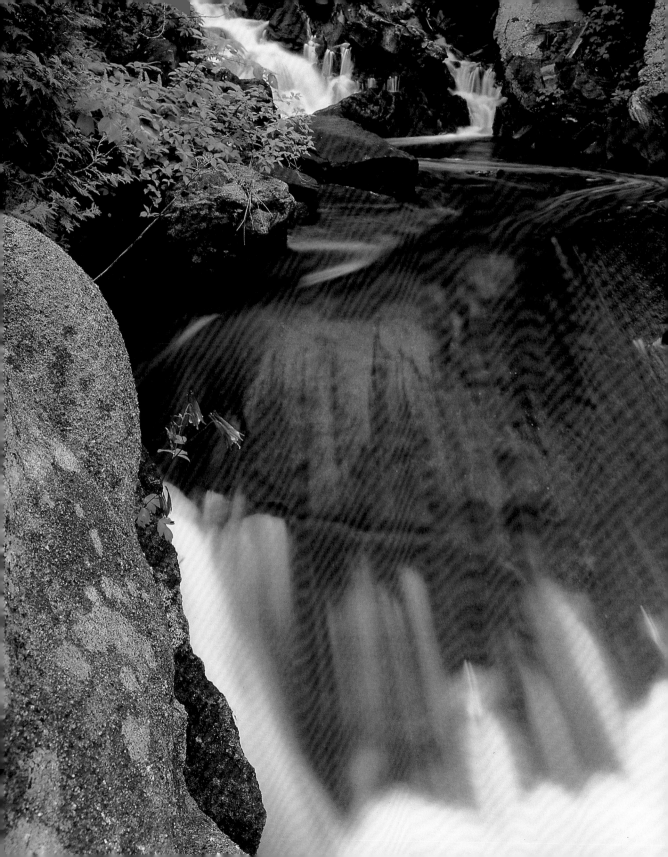

Hatchery Falls

🚗 **To visit Hatchery Falls, drive north on Hwy. 11 past Bracebridge. Exit Hwy. 11 at Hwy. 141 and go west for about 18 km (11 mi.) to Fish Hatchery Rd. Turn right and drive for 1 km (0.6 mi.) to the Skeleton Lake Fish Hatchery complex, which is a cluster of small white buildings on the left side of the road. Park here and walk straight across the wide field to the trail leading into the woods. The quiet walk to the falls is less than 15 minutes and contains several informative signs. For Port Sydney Falls, exit Hwy. 11 at Hwy. 141 but instead go east on Muskoka Rd. 10. Follow this road for 4.5 km (3 mi.) to Ontario St., turn left and continue to the little park on the left side of the road.**

COUNTY:	**Muskoka**
NEAREST SETTLEMENT:	**Ullswater**
RIVER:	**Skeleton River**
CLASS:	**Cascade**
TRAIL CONDITIONS:	**Moderate**
ACTIVITY:	**Remote**
SIZE:	**Small**
RATING:	**Average**
NTS MAP SHEET:	**31 E/4**
UTM COORDINATES:	**17T, 616498, 5008801**
WALKING TIME:	**15 minutes**

In a county with so many big, well-known waterfalls, Hatchery Falls is a nice surprise. It is a little gem of a waterfall, hidden in the woods at the end of a pretty forest path. Unlike some of the other popular falls nearby – including Bracebridge Falls, Muskoka Falls and Trethewey Falls – Hatchery Falls has not been spoiled by any ugly concrete bridges, steel dams or channelization schemes. This is the real thing!

The little creek tumbles about 8 meters (26 ft.) over a steep cascade into a nice, clear plunge pool surrounded by high rocky hills. If you don't own a canoe, but are looking for a quiet, secluded waterfall in cottage country, this is just about perfect. The walk to the falls is roughly 15 minutes long and passes about a dozen informative signs that explain the local forest ecosystem.

Hatchery Falls gets its name from the fish hatchery that operated at the site. At one time, trout fingerlings were produced here to be released into local creeks. The Ministry of Natural Resources closed the hatchery in 1991, but white buildings and ponds associated with the hatchery are still visible near the entrance to the park. In addition to trout, bass from Big Bass Bay near Parry Sound were brought to the hatchery to raise stock for various Muskoka area lakes. Although this fish hatchery is now closed, the Province of Ontario continues to stock lakes and streams with fish. In 1999, the Province released 8.8 million fish, about half of which were released to inland waters.

While in the area, you can also visit nearby Port Sydney Falls, an interesting slide-class waterfall located at the south end of Mary Lake. This was once the site of a large mill complex, but now a small dam above the falls helps to maintain water levels in the lake.

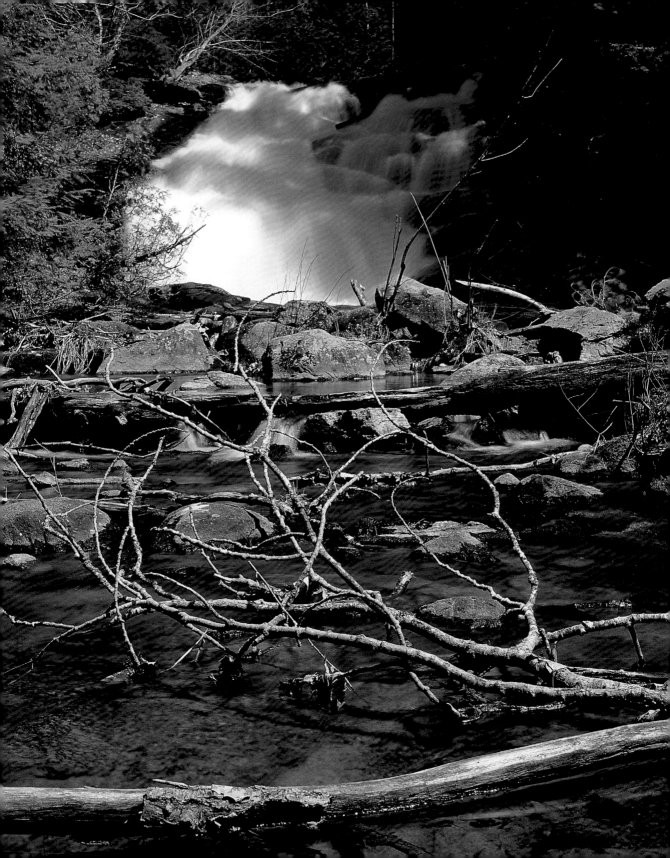

Healey Falls

🚗 Take Hwy. 115 to Peterborough and follow the expressway to the end. At the end of the expressway, turn right (east) onto Hwy. 7. After about 30 minutes, head south on Peterborough Rd. 30, and drive for another seven or eight minutes. Just before you cross the long bridge over the Trent River, watch for Woodland Estates Rd. on the left. This is a small public residential road. The "private" sign refers to the house property on the right side of the road. Simply follow this road to the end, and park in the gravel lot.

COUNTY:	Northumberland
NEAREST SETTLEMENT:	Healey Falls
RIVER:	Trent River
CLASS:	Step
TRAIL CONDITIONS:	Easy
ACTIVITY:	Moderate
SIZE:	Large
RATING:	Good
NTS MAP SHEET:	31 C/5
UTM COORDINATES:	18T, 278427, 4917401
WALKING TIME:	1 minute

The Trent River drains much of central Ontario, including much of the Kawartha Lakes. As a result, the flow over Healey Falls is usually significant, even during the summer. Some of the river's flow is diverted for the power generating station located on-site, but the rest is allowed to fall over a 150-meter (500 ft.) wide series of limestone steps. Each of the hundreds of small steps is a different thickness, varying from thin to massive bedding. Look for potholes in the bedrock, but also watch out for slippery sections covered in algae. If the river flow isn't too great, you can carefully walk right out onto the bedrock beside the waterfall. According to Environment Canada, the average stream discharge at

Healey Falls is about 50 cubic meters (1,750 cu. ft.) per second, but has varied from as much as 286 cubic meters (10,100 cu. ft.) per second to as little as 0.6 cubic meters (233 cu. ft.) per second.

Visitors can wander around this site for a few hours. In addition to the falls, Locks 15, 16 and 17 of the Trent-Severn Canal are located about a five-minute walk to the west. A concrete trail leads up over the long dam structure. The trail becomes a long concrete berm that supports the approach channel to the locks. Use caution here! While the water is only about 1 meter (3 ft.) below the edge of the walkway, there are no railings; if you fell in, you'd find it very difficult to climb up the featureless, near-vertical concrete face of the berm. But don't stray too far toward the other side of the berm either, since the ground is covered in poison ivy!

The walk to the locks also takes you past the Healey Falls Generating Station. The station was built in 1912–14 and contains three giant feeder pipes, each 3.6 meters (12 ft.) in diameter.

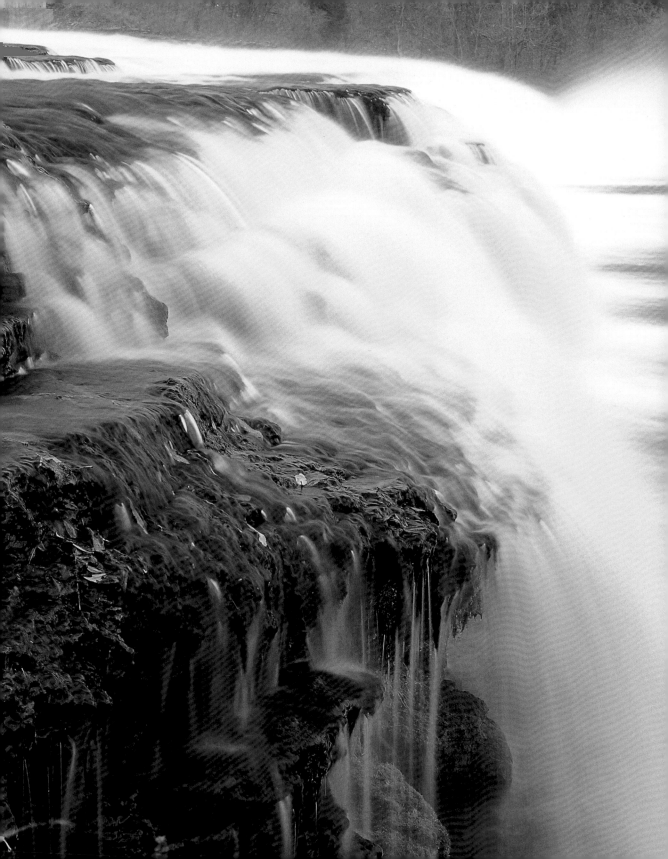

High Falls

🚗 To visit High Falls, exit Hwy. 11 at Muskoka Rd. 117 and go west. The entrance to the municipal park is immediately west of the expressway on the right. Park in the lot and walk due north to the waterfall. A prefabricated "Bailey bridge" over the top of the waterfall was installed in 2000 in order to connect two sections of the Trans-Canada Trail System. This provides an excellent panoramic view of the entire site from above. Two other little waterfalls are found at this park. Follow the short walking trails to see Potts Falls and Little High Falls on Potts Creek.

COUNTY:	**Muskoka**
NEAREST SETTLEMENT:	**Bracebridge**
RIVER:	**Muskoka River (North Branch)**
CLASS:	**Cascade (Steep)**
TRAIL CONDITIONS:	**Easy**
ACTIVITY:	**Very busy**
SIZE:	**Large**
RATING:	**Good**
NTS MAP SHEET:	**31 E/3**
UTM COORDINATES:	**17T, 633648, 4994230**
WALKING TIME:	**2 minutes**

This is arguably the most spectacular of the waterfalls in the Cottage Country region. It has even been referred to as the Niagara of the North. The pseudonym is a bit of a stretch – that title is more aptly applied to Kakabeka Falls, near Thunder Bay. Nevertheless, High Falls is a stunning waterfall.

The Muskoka River thunders over a nearly vertical 14-meter (45 ft.) high cliff of gneiss bedrock. The falls are broken into two sections by a small rocky island. At one time there were actually three sections, but in 1948, the town of Bracebridge built a generating station on the most northern section. This power station develops about 800 kW by diverting up to 10.1 cubic meters (356 cu. ft.) of the river's discharge.

Fortunately, the power plant is hidden from the view of visitors to High Falls Park on the south side of the river. Unfortunately, plans to expand the power capacity of the site threaten to permanently diminish the magnificence of the falls. Hydroelectric power is often touted as "environmentally friendly," but this is a grim reminder that there are costs which are difficult to measure.

Due to the size and accessibility of High Falls, it is usually very busy during the summer tourist season. During the hottest months, swimmers can be seen at the base of the falls, followed closely by paddle boats and canoes from several nearby family campgrounds. The best time to visit the falls is probably during late May to June, when stream flows are still high, but the crowds have not returned. Keep in mind, of course, that at this time of year the swarms of black flies are out in full force.

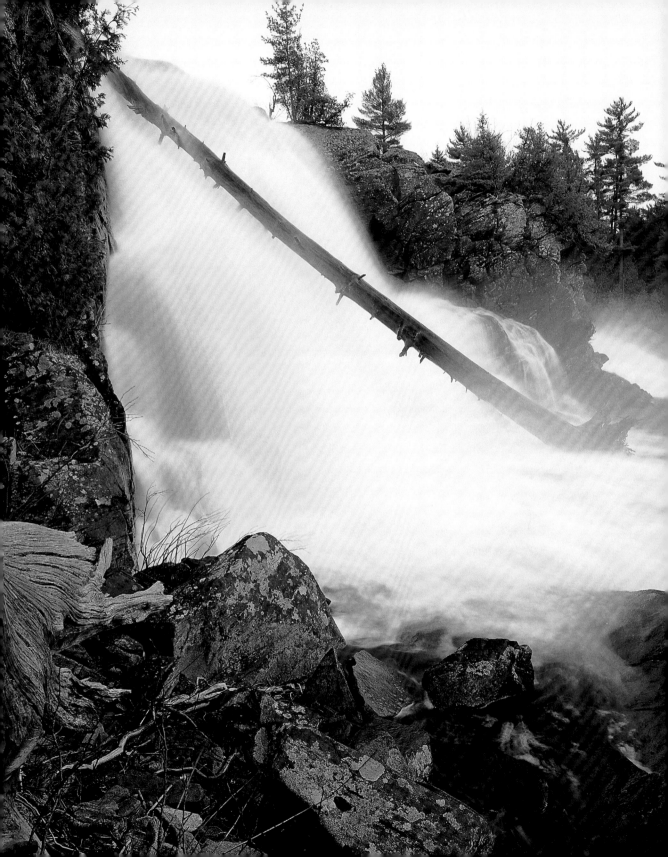

Hogs Trough

🚗 Follow Hwy. 11 to Huntsville and exit east onto Hwy. 60. Follow Hwy. 60 towards Algonquin Park. About 2.1 km (1.3 mi.) past Hwy. 35, turn right onto Oxtongue River Rapids Rd. This scenic gravel road leads past some homes into a beautiful hardwood forest. After 1.6 km (1 mi.), you will reach a very small picnic area beside a small but picturesque set of rapids on the Oxtongue River. Park here and walk upstream 750 m (0.5 mi.) along the banks of the swift-moving creek. The walk to Hogs Trough is about 15 to 20 minutes, and passes several other small rapids.

COUNTY:	**Muskoka**
NEAREST SETTLEMENT:	**Dwight**
RIVER:	**Oxtongue River**
CLASS:	**Cascade**
TRAIL CONDITIONS:	**Difficult**
ACTIVITY:	**Quiet**
SIZE:	**Medium**
RATING:	**Good**
NTS MAP SHEET:	**31 E/7**
UTM COORDINATES:	**17T, 660860, 5022150**
WALKING TIME:	**20 minutes**

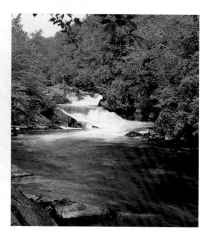

Hogs Trough is a neat waterfall, worth the effort that it takes to visit. The Oxtongue River falls roughly 8 meters (25 ft.) through an interesting V-shaped notch in the bedrock. Unlike most of the falls in this book, the gneiss bedrock here has developed in well-defined layers that have been tilted at about 30 degrees. This produces a narrow channel through which the water must constrict as it flows downstream. At moderate to high flow, the scene is one of rugged natural beauty, as the river foams and froths its way down the narrow tree-lined chute.

The Oxtongue River is just one of dozens of rivers draining Ontario's crown jewel of wilderness parks, the 7,700-square-kilometer (3,000 sq. mi.) Algonquin Provincial Park. Each of these rivers loses elevation as it flows away from its headwaters somewhere in the Algonquin highlands towards its ultimate outlet along the St. Lawrence Seaway. This book includes some of the major waterfalls on these rivers, including those along the Oxtongue, York and the Bonnechere, but there are no doubt hundreds of little-known yet picturesque waterfalls and rapids within the Algonquin area, most reserved only for trippers willing to venture into the interior by canoe. Federal topographic maps show no fewer than five separate "High Falls" within the park boundaries. To whet your appetite, try finding the falls near Achray, High Falls near Kingscote Lake or the dozens of named rapids along the Petawawa River.

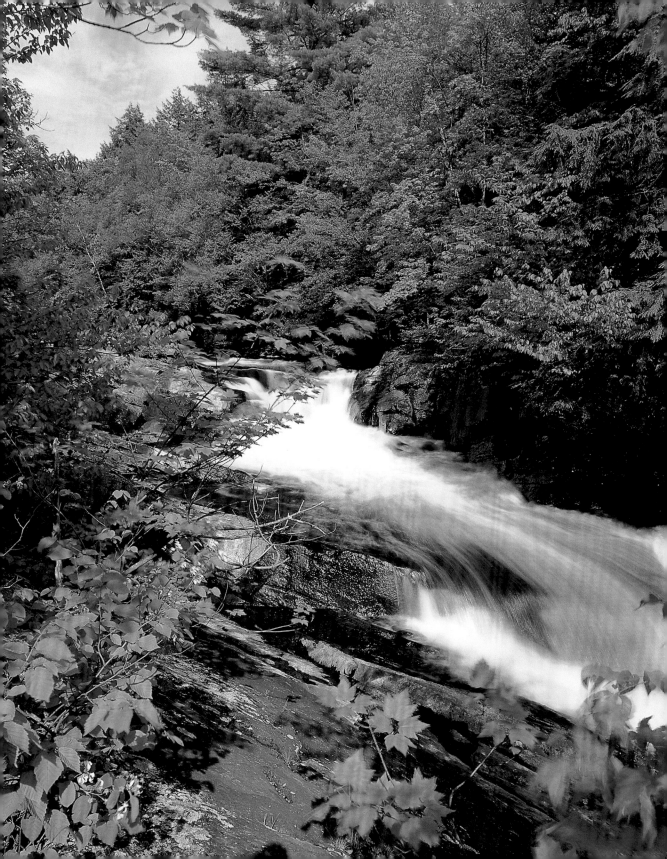

Long Slide

🚗 **Follow the directions to Buttermilk Falls (page 56), and continue north for roughly 30 km (18 mi.) along Hwy. 35. Once you've reached Dorset, turn right onto Haliburton Rd. 8. About 600 m (2,000 ft.) along this road, Haliburton Rd. 8 turns right. Head right and follow the road west for about 2.5 km (1.5 mi.). As the road makes a broad bend to the left, you should see the Hollow River valley behind a thin line of trees. A little gravel driveway on the left side of the road leads to nothing but large boulders, placed to prevent you from driving too far. Park here and walk downhill to the base of the falls.**

COUNTY:	Haliburton
NEAREST SETTLEMENT:	Dorset
RIVER:	Hollow River
CLASS:	Slide
TRAIL CONDITIONS:	Moderate
ACTIVITY:	Quiet
SIZE:	Small
RATING:	Average
NTS MAP SHEET:	31 E/7
UTM COORDINATES:	17T, 668231, 5013915
WALKING TIME:	2 minutes

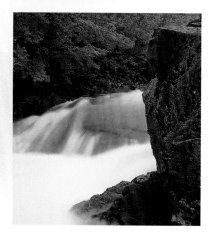

This waterfall is a stretch of little cascades and rapids on the Hollow River, terminating at a slightly bigger waterfall. Long Slide consists of a few small slides over a flat bedrock surface that is tilted about 30 degrees. Each slide is only a meter or two in height, and at low flow the river shoots over the rock in thin sheets of water, barely a centimeter thick. While not a big waterfall, it is quite pretty and definitely unique. At one time, a 210-meter (700 ft.) long log slide was constructed at the site in order for lumbermen to drive their logs around the falls.

From the road, the reach of the river upstream from the falls is hidden by an interesting bedrock ridge. This long narrow hill of tilted gneiss, about 15 meters (50 ft.) in height, starts at the falls and parallels the river for several hundred meters upstream. You can safely climb up the gentle side of the ridge on the side facing the road, but be careful once you get to the top. It is a near vertical drop of 15 meters (50 ft.) to the bed of the river. A site here beneath the white pines would be a unique spot for a picnic, provided of course you visit when the black flies aren't ridiculously oppressive.

Before leaving the Dorset area, be sure to visit the famous Dorset Scenic Lookout Tower. Built originally in 1922 as a forest fire watchtower, the 25-meter (80 ft.) high tower now provides tourists with a spectacular view of the beautiful Haliburton highlands.

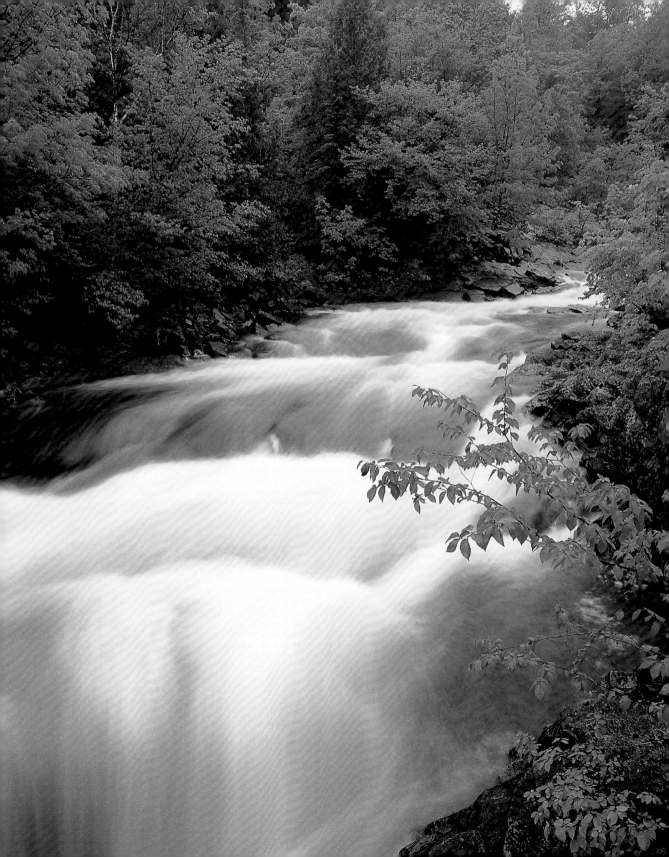

Marshs Falls

🚗 **Follow Hwy. 11 north to Huntsville, and turn east on Hwy. 60. Follow Hwy. 60 past Dwight to Hwy. 35 and head south. About 1.7 km (1 mi.) along Hwy. 35, the falls are barely visible on the right side of the highway. However, parking on the highway is not recommended, so instead go south to Muskoka Rd. 21 and turn right. Turn right again at the first road and drive a few hundred meters to the waterfalls. The land north and south of the waterfall is private property, but you may be able to obtain permission to visit the waterfall from Copps Trading Post in Dwight. Please respect private property at all times.**

COUNTY:	**Muskoka**
NEAREST SETTLEMENT:	**Dwight**
RIVER:	**Oxtongue River**
CLASS:	**Cascade**
TRAIL CONDITIONS:	**Moderate (Private)**
ACTIVITY:	**Moderate**
SIZE:	**Small**
RATING:	**Mediocre**
NTS MAP SHEET:	**31 E/7**
UTM COORDINATES:	**17T, 657687, 5019572**
WALKING TIME:	**5 minutes**

Marshs Falls is a little waterfall a short distance upstream from the outlet of the Oxtongue River at Lake of Bays. The upper cascade is about roughly 3 meters (10 ft.) high and 5 meters (16 ft.) wide, and is framed by the stone foundations of an old bridge, very likely the predecessor of the modern highway bridge to the east. The lower falls can be found about 20 meters (60 ft.) further downstream. This is a wider cascade, broken into several different falls by large boulders and tiny bedrock islands. Unfortunately, public access to Marshs Falls may be threatened. The property on the north side has been developed into a private residence, while the southern property was for sale at the time of writing. It is possible that in the future, the only way to visit the falls will be by canoe. The round trip from the beach at Dwight is reported to take a little less than four hours, most of which is consumed by the 3.8-kilometer (2.4 mi.) trip along the meandering Oxtongue River.

Marshs Falls is named after Captain G.F. Marsh, who purchased three 40-hectare (100 acre) lots around the site in the 19th century. He founded the Huntsville and Lake of Bays Navigation Company to transport lumber – and later tourists – around the area. Marsh was also instrumental in establishing the Portage Railway that once provided a connection between Lake of Bays and Peninsula Lake. With a total length of just 2.5 kilometers (1.6 mi.) the line was billed as the "smallest commercially operated railway in the world." The railway closed in 1958, but you can still ride the Portage Flyer steam engine at Muskoka Heritage Place, located on Muskoka Road 2, just east of Huntsville (open May to October, except on Sundays and Mondays).

Minnehaha Falls

🚗 Exit Hwy. 11 at Hwy. 141 and go west. Drive for about 18 km (11 mi.) to Fish Hatchery Rd. Continue for another 1.3 km (0.8 mi.) along the highway. As the road descends around a long left-hand bend, look for a safe place to park along the outside of the curve. On the right side of the road, you should be able to find a drainage ditch leading away from the road. Walk a little way down the road and try to find a safe, easy spot to descend the hill. Follow your ears! Remember, it is safest to visit such secluded spots with a friend. This site is not recommended for visitors with small children or for the elderly.

COUNTY: **Muskoka**

NEAREST SETTLEMENT: **Ullswater**

RIVER: **Skeleton River**

CLASS: **Cascade**

TRAIL CONDITIONS: **Difficult**

ACTIVITY: **Quiet**

SIZE: **Small**

RATING: **Average**

NTS MAP SHEET: **31 E/4**

UTM COORDINATES: **17T, 616068, 5008334**

WALKING TIME: **5 minutes**

What a nice surprise! This is a beautiful, clean little waterfall, completely unspoiled and almost completely secluded. And even though it's quite close to Highway 141, motorists speeding along the highway wouldn't even know it exists. The waterfall is hidden at the bottom of a steep, forested valley on the north side of the highway. There are no trails to the bottom, and if you want to see this waterfall, you must be prepared to scramble down a steep hill, likely getting at least a little dirty along the way. The waterfall is composed of two steep cascades, each probably 2 to 3 meters (6 to 10 ft.) high and up to 5 to 6 meters (16 to 20 ft.) wide at higher flows.

The Skeleton River drains scenic Skeleton Lake, located upstream. According to legend, some bones were found by surveyors along the north shore of the lake. When asked, an Indian chief recalled how one winter, many years before, a group had set up camp on the shores of the lake. For some reason, food was scarce and many in the group had become weak from hunger. One young boy became too weak to move on. His mother, not wishing to leave the boy, stayed behind and, sadly, the two died of starvation.

By many accounts "Minnehaha" is reported to mean "laughing waters." Others suggest the word more appropriately means "waterfalls." Perhaps its most famous usage, however, is by American poet Henry Wadsworth Longfellow for the name of the heroine in his poem, "The Song of Hiawatha."

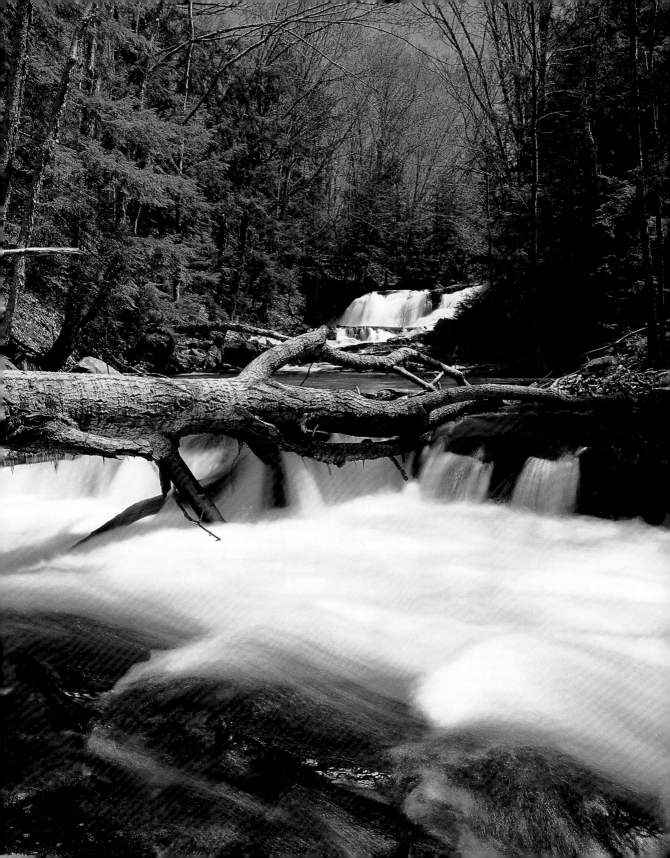

COTTAGE COUNTRY

Muskoka Falls

🚗 Drive north on Hwy. 11, past Gravenhurst to Hwy. 118. Exit on Hwy. 118 east, and go north on Muskoka Falls Rd. Park at the river, on the right side of the road. A magnificent view of much of the chasm is available from the bridge over the river. If you walk to the right, under the Hwy. 11 bridge, a weak trail over the gneiss bedrock allows you to explore the rest of the gorge. Use caution here though, since once you leave the road, there are few safety fences separating you from a very deep and dangerous gorge.

COUNTY: Muskoka	
NEAREST SETTLEMENT: Muskoka Falls	
RIVER: Muskoka River (South Branch)	
CLASS: Cascade	
TRAIL CONDITIONS: Wheelchair accessible	
ACTIVITY: Busy	
SIZE: Large	
RATING: Average	
NTS MAP SHEET: 31 E/3	
UTM COORDINATES: 17T, 633763, 4984629	
WALKING TIME: 1 minute	

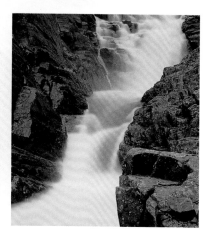

At 33 meters (108 ft.), Muskoka Falls has the highest total fall of the many waterfalls in the Bracebridge area. While not as impressive nor as visitable as High Falls (Bracebridge), this waterfall can be a stunning spectacle of power at just the right time of year. At the wrong time of year, however, it is nothing more than a deep, dry chasm.

One of the earliest hydroelectric power stations in Muskoka was built here in 1907 by the town of Gravenhurst. As part of the development, a water level dam was constructed to divert water to the generating station. Three 305-meter (1,000 ft.) long penstocks deliver water to the generating station, which generates a maximum of 4 MW of power. As a result of the hydroelectric power development, the best time to visit this waterfall is during the spring, when significant snow melt means that excess water must be allowed through the falls.

Muskoka Falls is also commonly referred to as "South Falls," a name originally used to distinguish it from the "North Falls" at Bracebridge. Other names for it have included "Great Falls," "Grand Falls" and "Wild Falls," each implying how magnificent the site must have been before it was developed for power generation.

Even though such wild stream flows are now rare, the site is still an interesting stop. The river has cut an 800-meter (0.5 mi.) long deep scar in the gneiss bedrock that was partially hidden – inconsiderately – under the expressway overpass.

Hanna Chutes is another small waterfall that has been all but obliterated by a hydroelectric development, and is barely visible across the bay above Muskoka Falls.

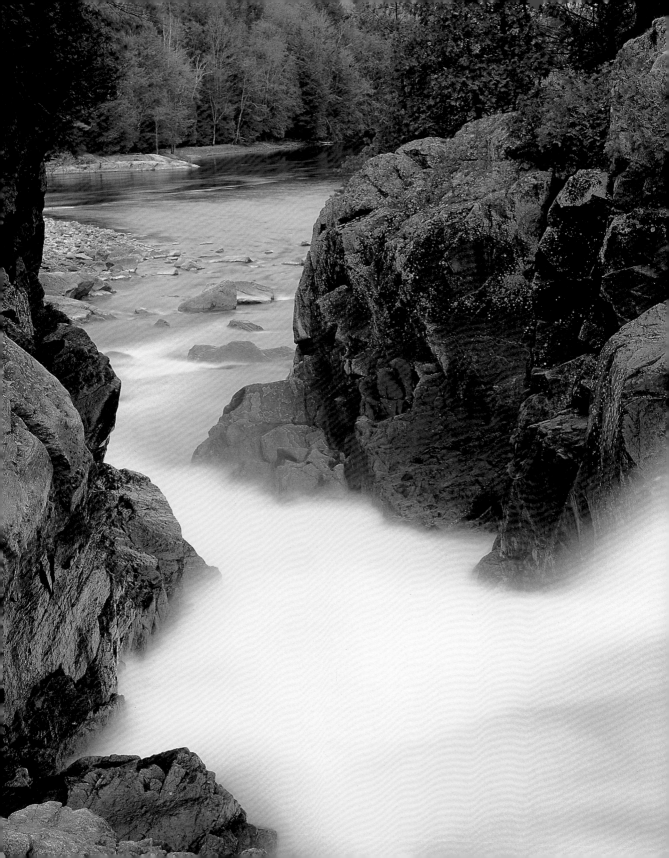

Rackety Falls

🚗 **Drive north on Hwy. 35 past Lindsay to Norland. Continue north to the small community of Moore Falls and turn left onto Haliburton Rd. 2. Follow this scenic road for about 12 km (8 mi.) to Rackety Trail, and turn right. Drive along Rackety Trail for another 2.5 km (1.5 mi.) to a small parking area on the side of the road beside Little Bob Lake. The small cascade starts immediately below the dam and continues along to the other side of the road. For Fenelon Falls, drive north on Hwy. 35 past Lindsay. Turn east on Kawartha Lakes Rd. 121 and drive for five minutes to Fenelon Falls. Cross the bridge and turn right into the parking lot on the far side of the river.**

COUNTY:	**Haliburton**
NEAREST SETTLEMENT:	**Deep Bay**
RIVER:	**Bob Creek**
CLASS:	**Cascade**
TRAIL CONDITIONS:	**Moderate (Private)**
ACTIVITY:	**Quiet**
SIZE:	**Small**
RATING:	**Mediocre**
NTS MAP SHEET:	**31 D/15**
UTM COORDINATES:	**17T, 675524, 4970477**
WALKING TIME:	**2 minutes**

Don't go out of your way to see this waterfall, as it is not big, not spectacular, and not highly photogenic. Nevertheless, if you are in the area to see the other waterfalls along the Highway 35 corridor, it offers a nice little pit stop where you can rest.

The waterfall is found downstream of a small water level dam at the south end of Little Bob Lake. Water shoots over a small slide section immediately below the dam and then passes under the road through a small culvert. On the other side of the road, there is a small cascade, roughly 3 meters (10 ft.) high and 2 meters (7 ft.) wide. From here, the river tumbles into a beautiful little pool about 20 meters (65 ft.) into the forest. The scene is quite peaceful, and you will likely have the falls all to yourself. However, you need to be careful that you don't trespass on private property lining the south side of the river.

While in the area, be sure to visit Fenelon Falls. This much larger waterfall is just a few minutes east of Highway 35, located in the heart of the town with the same name. Found at the narrows between Cameron Lake and Sturgeon Lake, it is a wide plunge-class waterfall about 8 meters (26 ft.) in height. The power of the falls has been harnessed by a hydroelectric generating station which develops a maximum of 2.6 MW of power. A series of informative signs on the viewing platform beside the falls helps to explain the operation of the plant.

Like at other towns dependent upon their waterfalls – including Bracebridge and Bala – a road bridge has been constructed right on top of Fenelon Falls. While some argue that this ruins the view, it is a strong reminder of the importance of waterfalls to the development of our society.

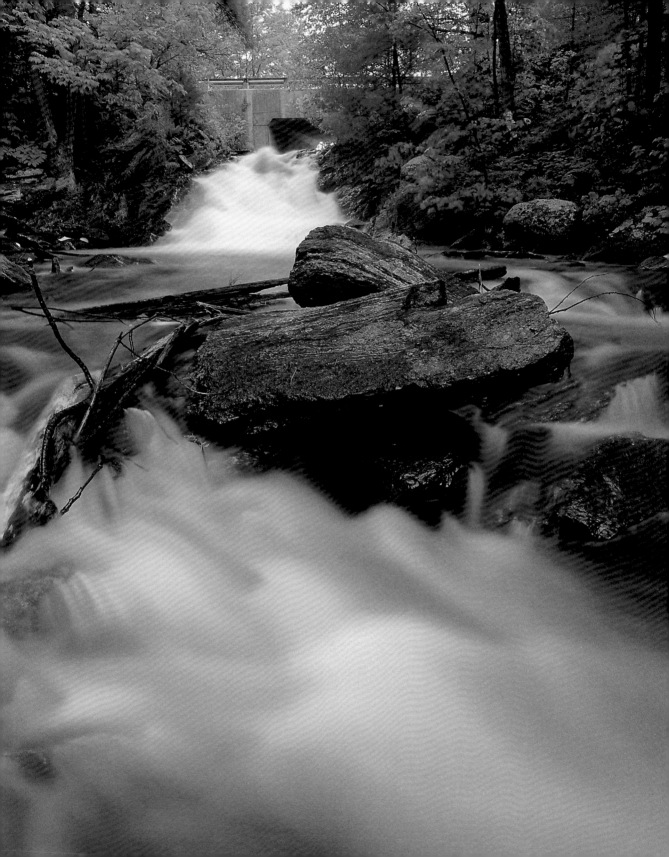

Ragged Falls

🚗 Drive north along Hwy. 11 to Huntsville and exit east onto Hwy. 60. Follow Hwy. 60 for 34 km (21 mi.) towards Algonquin Park. A few miles past Oxtongue Lake there is a short laneway on the left leading to the falls (watch for the signs). Please pay the small fee at the parking lot. The walk to the falls has a few steep hills but is just over five minutes long. If you have a canoe, you might want to paddle 2.7 km (1.7 mi.) upstream to the more secluded Gravel Falls (also known as High Falls). Further west along Hwy. 60, a short drive along Oxtongue Rapids Rd. takes you to lovely picnic spots along the river.

COUNTY:	**Muskoka**
NEAREST SETTLEMENT:	**Oxtongue Lake**
RIVER:	**Oxtongue River**
CLASS:	**Cascade**
TRAIL CONDITIONS:	**Moderate**
ACTIVITY:	**Busy**
SIZE:	**Large**
RATING:	**Outstanding**
NTS MAP SHEET:	**31 E/7**
UTM COORDINATES:	**17T, 663992, 5028427**
WALKING TIME:	**10 minutes**

This is a big one! And because it is located just a short distance southwest of the western entrance to Algonquin Park, it is often a popular destination during the summer tourist season. The Oxtongue River drops over 20 meters (65 ft.) here through a steep, chaotic cascade through the woods. The waterfall is most spectacular when the winter snow pack melts, sending forth a torrent of brown foaming waters. Most visitors, however, see one of the ever-changing forms of the waterfall exhibited during the summer, when low river discharges expose much of the rockbed completely hidden during high flow. At such times you can safely scramble over the face of the waterfall and explore its many nooks and crannies. For a completely different experience, you can visit the waterfall during winter, but you would have to park along the highway and walk in about 700 meters (0.4 mi.) along the access road.

A log slide built by the Gilmore Bros. company around 1893 allowed lumber firms to drive their logs down the river without having them pulverized by the raging waters at the falls. Gilmore Bros. used an intricate system of slides and jack-ladders to move some logs via Lake of Bays to Raven Lake, which was one of the northernmost portions of the Trent River watershed. From here, logs could be driven all the way to Trenton, on Lake Ontario. A few years later the site was actually considered for the location of a generating station to feed power to Huntsville. Unlike Bracebridge and Gravenhurst, that third main town along the Highway 11 corridor was not blessed with a large waterfall nearby. Fortunately for waterfall lovers, however, the site was considered too remote and too rugged for power development.

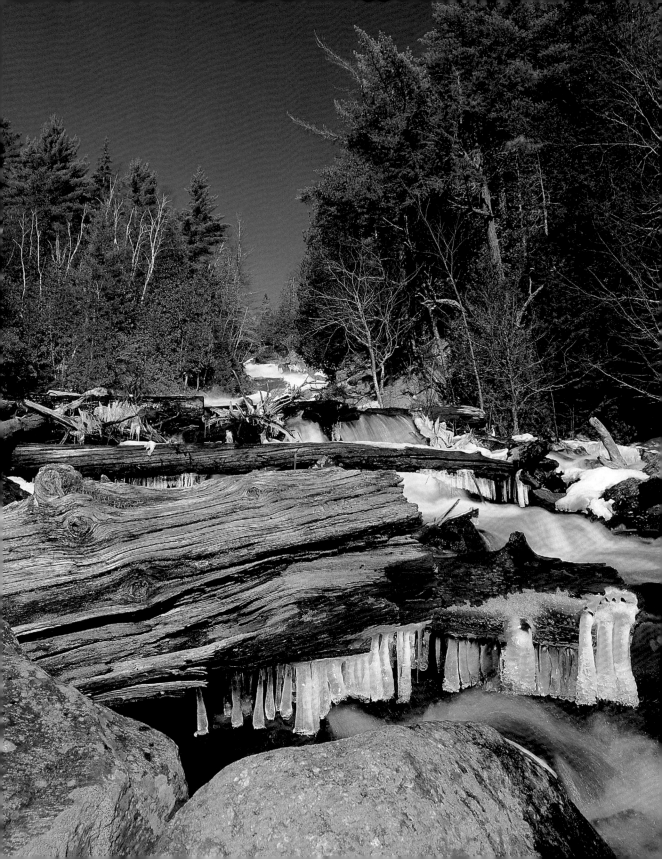

Ritchie Falls

🚗 Follow the directions to Drag River Falls (page 62), but continue north on Haliburton Rd. 1. Stay on this road as it bends to the right a few kilometers after Gelert. Continue on a further 5.2 km (3.2 mi.) past the curve, until you reach Ritchie Falls Rd. Turn right and continue for 2.6 km (1.6 mi.) to the little parking area on the left, just before the bridge over the creek. Walk across the bridge. The upper falls are visible from the side of the road, while a short path a little further ahead on the left leads through the spruce trees to the middle and lower falls.

COUNTY:	Haliburton
NEAREST SETTLEMENT:	Lochlin
RIVER:	Burnt River
CLASS:	Cascade
TRAIL CONDITIONS:	Easy
ACTIVITY:	Quiet
SIZE:	Small
RATING:	Average
NTS MAP SHEET:	31 D/15
UTM COORDINATES:	17T, 689897, 4977950
WALKING TIME:	1 minute

Ritchie Falls is very small, but nevertheless very pretty. This is one of the nicest little waterfalls to picnic beside, and there are a few tables beside the river for just this reason. (As always, be sure to help keep this area clean to ensure that the tables are still around for your next visit.)

There are actually three tiny falls here, each separated by short, clear pools in the river. The upper part of the waterfall is a 3-meter (10 ft.) high cascade falling through a narrow notch in the bedrock. Unfortunately, it has been mostly covered by the Ritchie Falls Road bridge. But the little one-lane bridge adds its own charm to a nice picture, which may be framed by the tall cedars on either side of the river. About 75 meters (250 ft.) downstream, the middle and lower falls are barely 2 meters and 1 meter (6 ft. and 3 ft.) high respectively, but nevertheless exude relaxation.

As you're walking along the riverbank, keep an eye on the water. A sign indicates that this stretch of the river was stocked with brown trout by the Burnt-Irondale River Fisheries Enhancement Association in 1997.

If you travel further along Ritchie Falls Road, you will meet the Haliburton Rail Trail. Turn left and you can walk or cycle 5 kilometers (3 mi.) to Drag River Falls, 16 kilometers (10 mi.) to Three Brothers Falls or 52 kilometers (32 mi.) to Fenelon Falls.

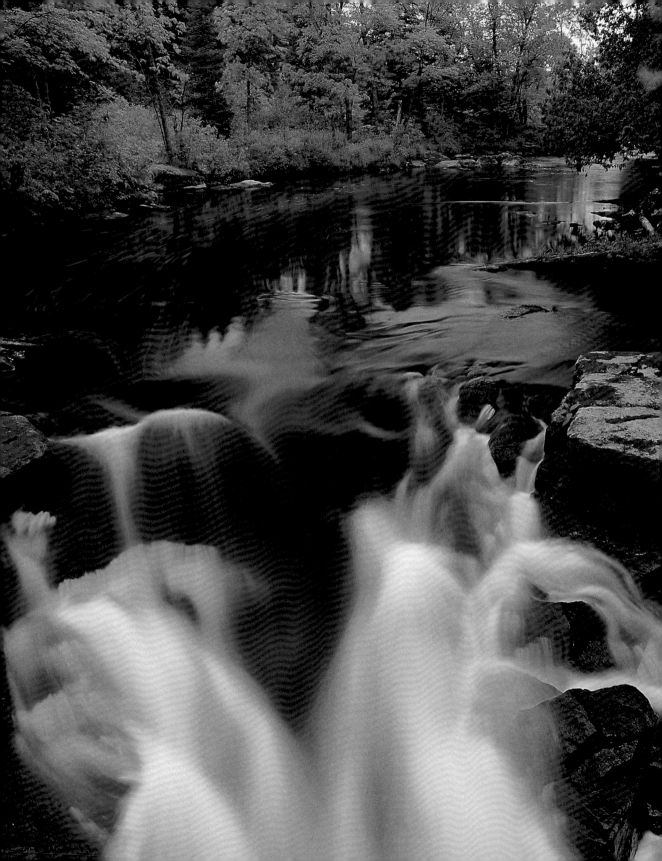

Rosseau Falls

🚗 Drive north on Hwy. 400 and continue north along Hwy. 69. Turn right at Hwy. 141 and drive east to the small village of Rosseau at Muskoka Rd. 3. Continue east for 5.5 km (3.4 mi.) to the upper falls, which you should see on the right side of the road. As always, be sure to park well off to the side. For the lower, more interesting falls, turn around and drive back west for 1.1 km (0.7 mi.) to Rosseau Lake Rd. 3. Turn left and drive for 1.6 km (1 mi.) to a narrow one-lane bridge over the river. Find a safe place to park and walk back to the little bridge. After you've taken in the panoramic view of the falls, woods and the distant lake, walk down along the bedrock towards the falls.

COUNTY:	**Muskoka**
NEAREST SETTLEMENT:	**Rosseau Falls**
RIVER:	**Rosseau River**
CLASS:	**Cascade**
TRAIL CONDITIONS:	**Moderate**
ACTIVITY:	**Quiet**
SIZE:	**Medium**
RATING:	**Good**
NTS MAP SHEET:	**31 E/4**
UTM COORDINATES:	**17T, 610252, 5009372**
WALKING TIME:	**1 minute**

There are actually two waterfalls on the Rosseau River – one at Highway 141 and one on a short sideroad – yet neither is well known, and they are rarely referenced in any tourism literature. The failure of these falls to attract more attention is puzzling, but may have something to do with the variability of their flow. Rosseau Falls can really put on a show when the river is flooded, but for much of the year the scene is far more tranquil. Large broken slabs of gneiss lining the waterfall channel could only be moved by very powerful flows. Indeed, an Environment Canada stream gauge shows that the river's discharge can vary by almost four orders of magnitude: from a historic low of just 0.01 cubic meters (0.4 cu. ft.) per second to a historic high of 84 cubic meters (2,965 cu. ft.) per second.

The upper waterfall is a 5-meter (16 ft.) high cascade, falling in three or four loosely defined steps over gray gneiss bedrock. It is easily viewed from the south side of Highway 141. The lower waterfall is bigger and more complex, tumbling for perhaps 150 meters (500 ft.) along a gently inclined bedrock ramp. At lower flows, this is a really neat place to explore. Please respect the private property along the edge of the river as you approach the lake.

Lake Rosseau is believed to be named after Jean-Baptiste Rosseau, a fur trader and interpreter working in the area in the late 18th century. Today, the lake is one of Muskoka's most popular, lined by million-dollar cottages and exclusive lodges. Several famous Hollywood stars are reputed to own posh cottage properties on the shores of this lake, but don't let this distract you from the waterfalls.

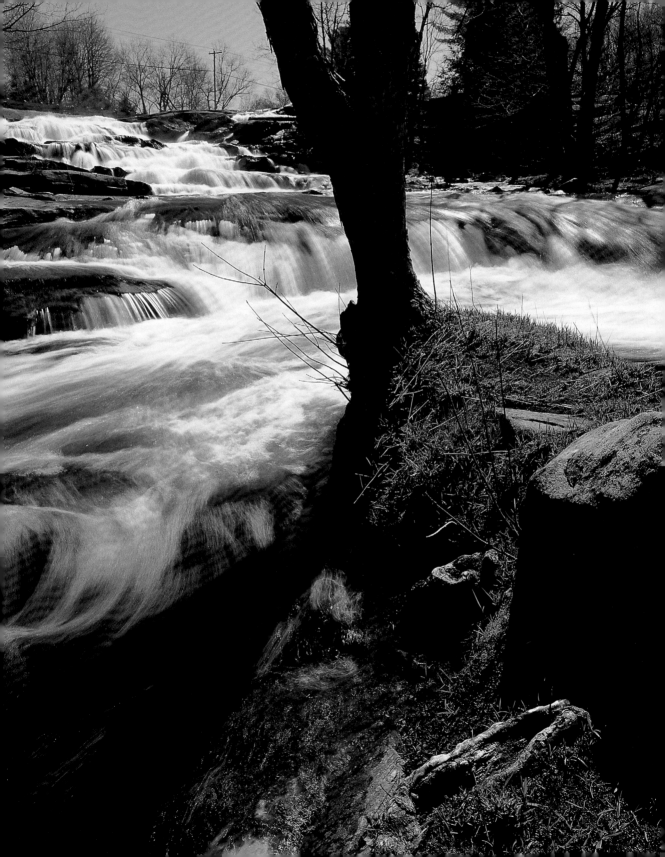

Stubbs Falls

🚗 Follow Hwy. 11 to Huntsville, then exit at Hwy. 60 and go east. After 2.4 km (1.5 mi.), turn left onto Muskoka Rd. 3. Follow this road north for about 5 km (3 mi.) until you reach the entrance to the park. There is an entrance fee of approximately $8 to $10, for which the park will not disappoint. Drive into the park for 1.5 km (0.9 mi.) until you see Mayflower Lake on your left. Turn right at the next intersection, and drive 0.8 km (0.5 mi.) to a parking lot, just before the bridge over the Little East River. Park here and follow the easy, well-worn trail downstream along the lake to the falls.

COUNTY:	Muskoka
NEAREST SETTLEMENT:	Huntsville
RIVER:	Little East River
CLASS:	Cascade
TRAIL CONDITIONS:	Moderate
ACTIVITY:	Moderate
SIZE:	Small
RATING:	Average
NTS MAP SHEET:	31 E/6
UTM COORDINATES:	17T, 640214, 5026832
WALKING TIME:	10 minutes

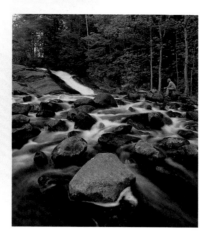

Located in the beautiful 1,237-hectare (3,056 acre) Arrowhead Provincial Park, Stubbs Falls is a charming, unspoiled cascade. At least 10 meters (32 ft.) in height, the falls tumble around a bold gneiss outcrop, the smooth face of which suggests that it probably becomes part of the waterfall when the river floods. This gentle ramp of bedrock serves as a natural viewing platform, and is well used as a picnic spot during summer and autumn by campers staying at the park. If you can get to the falls before the crowds, you can experience one of the most tranquil, peaceful scenes around.

The trails to the falls are excellent, providing a characteristic Muskoka experience through forests of maple and pine, towering over rock outcrops covered by last season's pine needles. The large hills in the woods to the north are well over 70 meters (200 ft.) high. Before leaving the park (you'll want to get your money's worth), be sure to follow some of the spectacular hiking trails. And if you have a canoe, don't miss the canoe trip upstream along Big East River.

Another pretty set of cascades is located about 22 kilometers (14 mi.) further upstream along the Big East River. A 2.5-kilometer (1.5 mi.) canoe trip further downstream will take you to McArthur Chute.

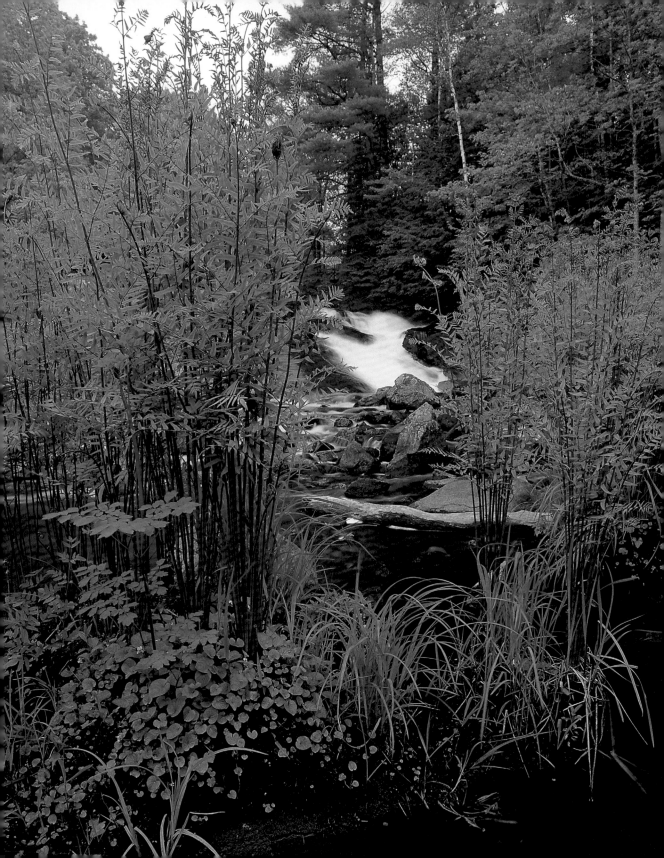

COTTAGE COUNTRY

The Gut

🚗 To visit The Gut, drive east from Peterborough on Hwy. 7 to Hwy. 134. Turn left and follow Hwy. 134 to Hwy. 28. Turn right and drive north for 42 km (26 mi.), past Burleigh Falls to Apsley. Turn right on Peterborough Rd. 504 (watch for the second turn in Apsley) and drive east for 12.5 km (7.7 mi.) to Lasswade at the intersection with Peterborough Rd. 46. Continue east along Lasswade Rd. for 6.3 km (4 mi.) past the town of Lake to The Gut Trail (watch for the signs). Turn right on this road and drive to the parking lot. Be careful, as the road is rocky and not always well maintained. From the parking lot, follow the left trail to the river, and walk upstream along the fence until you reach the main falls.

COUNTY: Hastings	
NEAREST SETTLEMENT: Lake	
RIVER: Crowe River	
CLASS: Cascade	
TRAIL CONDITIONS: Moderate	
ACTIVITY: Quiet	
SIZE: Small	
RATING: Good	
NTS MAP SHEET: 31 C/13	
UTM COORDINATES: 18T, 272042, 4960911	
WALKING TIME: 5 minutes	

The Gut is a unique waterfall hidden away in a remote part of Hastings county. It is not very high, nor very big. But what it lacks in size, it makes up for in raw power! During all but the lowest summer flows, the Crowe River blasts through a narrow, deep chasm producing a train of fierce whitewater several hundred meters long. Frothing down a cedar-lined gorge about 20 meters (65 ft.) high, The Gut is unlike any other waterfall in this collection.

The Gut is clearly visible from a natural rock platform at the upstream end of the gorge. Here, the river bends 90 degrees to the right, narrows from about 10 meters (33 ft.) down to 3 meters (10 ft.), and pours into The Gut over a 2-meter (7 ft.) high horseshoe-shaped bedrock ridge. With care, you can find a way down to the rocks immediately downstream from the falls for a good picture, but watch out for slippery rocks. A cedar rail fence stops visitors from straying too close to the rest of the gorge.

With a closer look at the gorge walls, you will note a vertical trend to the rock that is rarely seen in Ontario waterfalls. The rock is a mix of metasedimentary rocks, including marble and quartzite, that has been folded and tilted by almost 90 degrees.

The waterfall is the jewel of The Gut Conservation Area, formed in 1976 to protect 162 hectares (400 acres) of central Ontario wilderness. Previously, the area was owned by the Pearce Lumber Company and the Armstrong Lumber Company. These companies may have modified the falls to make them less damaging to logs being driven downstream. Arrowheads and other Native artifacts have been found at the site, suggesting that this may have been an important point on a Native route along the Crowe River.

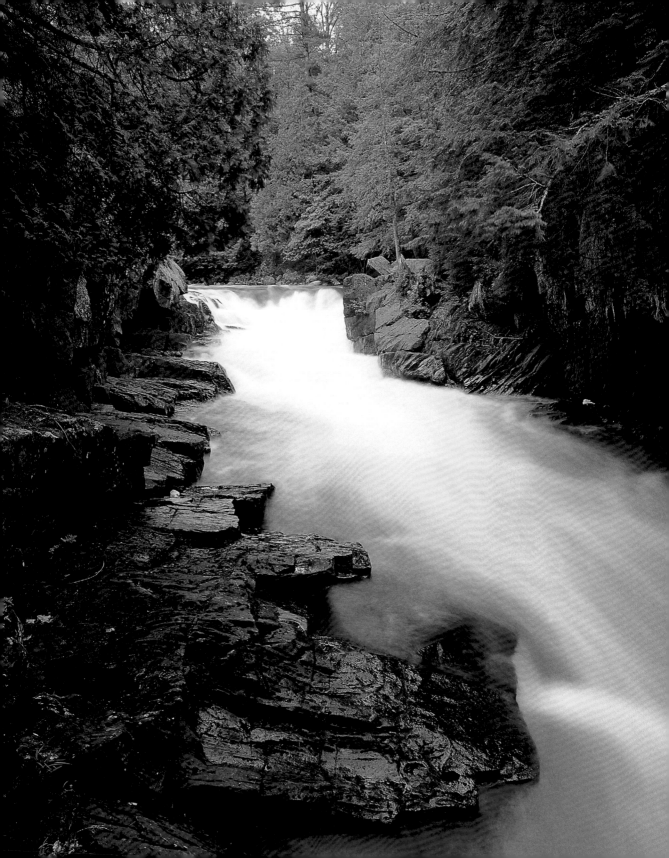

Three Brothers Falls

🚗 **Drive** north on Hwy. 35 to Norland. Turn right onto Kawartha Lakes Rd. 45. Drive for about 10 minutes to Kinmount, then turn left onto Kawartha Lakes Rd. 121, and drive north for 3 km (1.8 mi.) to Howland Junction Rd. Turn right and drive east for 1.2 km (0.7 mi.) to an old rail right-of-way. Park your car here. Walk east along the rail right-of-way, over the abandoned rail trestle and continue for about five minutes around the long bend to the right. As the trail begins to bend to the left, look for a path leading to the right that parallels a pine forest plantation. Take this trail for a few minutes to a clearing, and turn left. Walk across the clearing toward the forest edge and turn right. When you come across an old abandoned truck, follow the path just past it to the upper falls.

COUNTY:	Haliburton
NEAREST SETTLEMENT:	Howland
RIVER:	Burnt River
CLASS:	Cascade
TRAIL CONDITIONS:	Moderate
ACTIVITY:	Quiet
SIZE:	Medium
RATING:	Average
NTS MAP SHEET:	31 D/15
UTM COORDINATES:	17T, 686870, 4964930
WALKING TIME:	20 minutes

Three Brothers Falls is a beautiful set of three low waterfalls that have long been a favorite resting spot for those paddling down the Burnt River or Irondale River routes. Land access to the falls is limited (there is no land access from the south due to extensive private property) so this is one of those waterfalls that is still best explored by canoe.

Each waterfall is a steep cascade about 20 meters (65 ft.) wide, spanning the entire width of the river. The lowest waterfall has the greatest drop – 5 to 6 meters (16 to 20 ft.) – while the middle and upper falls each drop 2 to 3 meters (7 to 10 ft.).

The site is beautiful in winter as the majority of each waterfall freezes almost completely. As pretty as this can be, resist the temptation to walk out onto the falls. The river still flows beneath, carrying frigid waters that would spell disaster for anyone heavy enough to break through the ice.

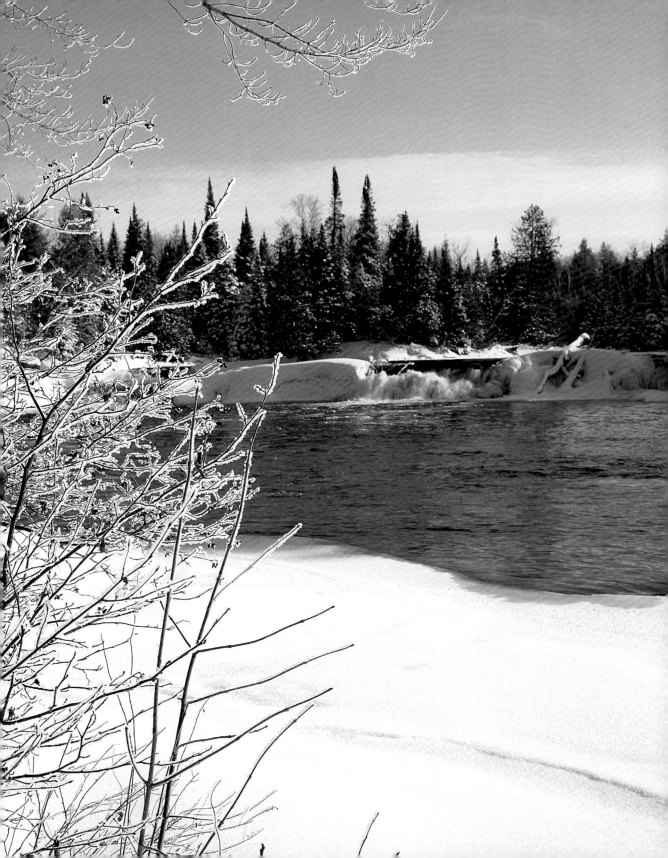

COTTAGE COUNTRY

Wilsons Falls

🚗 **From Hwy. 11, exit at Muskoka Rd. 42 (Taylor Rd.), and go west. Follow Taylor Rd. into town, but immediately after crossing the river, turn right onto River St. By following River St. north to the end you will arrive at the falls. A beautiful trail behind the power building leads to the boardwalk beside the southern falls. The trail also connects to the Trans-Canada Trail.**

COUNTY: Muskoka	
NEAREST SETTLEMENT: Bracebridge	
RIVER: Muskoka River (North Branch)	
CLASS: Cascade	
TRAIL CONDITIONS: Moderate	
ACTIVITY: Quiet	
SIZE: Medium	
RATING: Good	
NTS MAP SHEET: 31 E/3	
UTM COORDINATES: 17T, 633218, 4990970	
WALKING TIME: 3 minutes	

Wilsons Falls is less spectacular than the two nearby big waterfalls on the North Muskoka River: High Falls and Bracebridge Falls. Nevertheless, this is a good example of how a smaller waterfall can be far more interesting to explore. Other than a rather unobtrusive hydroelectric building beside the north falls, the area is mostly undisturbed, and is usually not very busy.

The town of Bracebridge has done an excellent job of developing several kilometers of walking trails around the falls. A fantastic boardwalk guides visitors alongside the rugged bedrock reach of the river above the falls. The main waterfall is formed on a broad expanse of gneiss about 100 meters (325 ft.)

wide. The principal waterfall is about 5 meters (16 ft.) high, with an ever-changing width that depends on the discharge in the river at the time of your visit. A smaller but higher waterfall is located right beside the small red brick building housing the generating station.

The waterfall is believed to be named after Gilman Wilson who, together with William Holditch of Bracebridge, built a sawmill beside the falls in the mid-19th century. For some time, the area was known as Norwood Mills. Some years later, in 1909, the town built the generating station beside the falls. It makes use of the total fall of 12 meters (40 ft.) to develop about 600 kW of electricity.

Wilsons Falls is just one of the many waterfalls that you can visit during the annual "Festival of the Falls" held each year in early May. Bracebridge claims to have the greatest number of waterfalls of any municipality in Ontario, although we suspect the city of Hamilton, as amalgamated in 2000, may contain just as many.

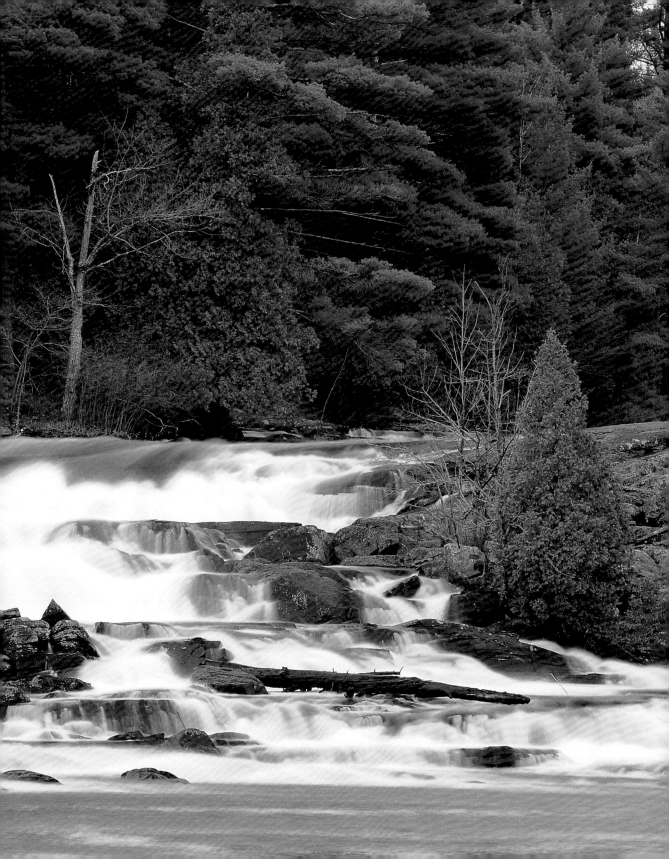

GOLDEN HORSESHOE

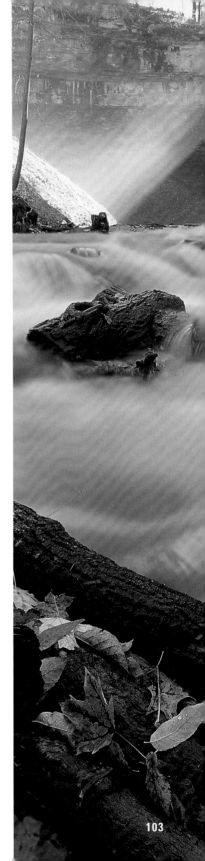

THIS REGION IS HOME to nearly six million people and has been intensively urbanized. Fortunately, however, there are still a large number of natural places where you can temporarily forget the hustle and bustle of city life – including a surprisingly large number of waterfalls. Many of these are well known and have been favorite spots for family outings for years. Others are virtually unknown: small, but pretty and satisfying. Nearly all of the waterfalls are formed by streams crossing the Niagara Escarpment, an unmistakable feature which you can use to guide yourself to the falls.

Recommended tour

Starting at St. Catharines, follow county roads west and visit DeCew, Rockway and Louth Falls, followed by a longer visit to the upper and lower Balls Falls. Alternatively, choose a handful of waterfalls in the greater Hamilton area and "waterfall" till you drop!

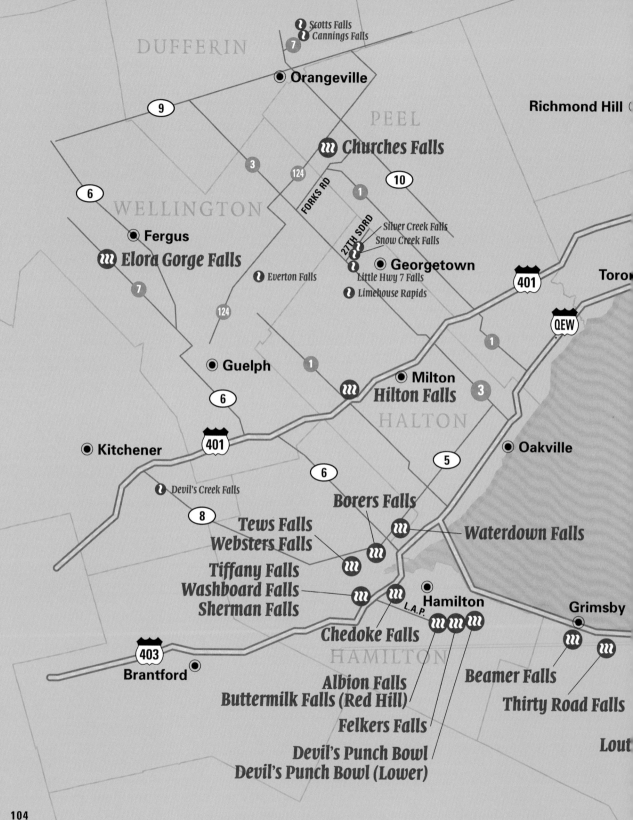

DUFFERIN

Scotts Falls
Cannings Falls
7

● Orangeville

PEEL

Richmond Hill

9

Churches Falls

6

124

10

WELLINGTON

3

FORKS RD

1

● Fergus

27TH SDRD

Silver Creek Falls
Snow Creek Falls

Elora Gorge Falls

Everton Falls

● Georgetown

Little Hwy 7 Falls

401

Toro

7

124

Limehouse Rapids

QEW

1

● Guelph

1

● Milton

● Oakville

6

Hilton Falls

3

HALTON

401

● Kitchener

5

Devil's Creek Falls

6

8

Borers Falls

Tews Falls
Websters Falls

Waterdown Falls

Tiffany Falls
Washboard Falls
Sherman Falls

● Hamilton

Grimsby

L.A.P.

403

Chedoke Falls

HAMILTON

Beamer Falls

● Brantford

Albion Falls
Buttermilk Falls (Red Hill)

Thirty Road Falls

Felkers Falls

Lout

Devil's Punch Bowl
Devil's Punch Bowl (Lower)

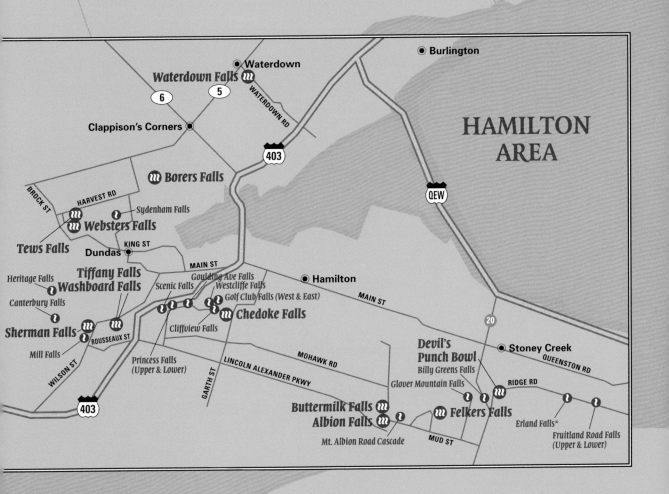

● Burlington

● Waterdown
Waterdown Falls ⑨
⑥ ⑤
WATERDOWN RD

HAMILTON
AREA

Clappison's Corners ●

403

QEW

⑨ Borers Falls

BROCK ST
HARVEST RD
Sydenham Falls
⑨ Websters Falls
Tews Falls
Dundas ● KING ST
MAIN ST

● Hamilton

MAIN ST

Heritage Falls
Tiffany Falls
Washboard Falls
Goulding Ave Falls
Westcliffe Falls
Scenic Falls
Golf Club Falls (West & East)
Canterbury Falls
⑨ Chedoke Falls
Sherman Falls
ROUSSEAUX ST
Cliffview Falls
Mill Falls
WILSON ST
Princess Falls
(Upper & Lower)
MOHAWK RD
LINCOLN ALEXANDER PKWY
GARTH ST

20

● Stoney Creek
QUEENSTON RD

Devil's
Punch Bowl
Billy Greens Falls
Glover Mountain Falls
RIDGE RD

403

Buttermilk Falls ⑨
Albion Falls ⑨
Mt. Albion Road Cascade
MUD ST

⑨ Felkers Falls

Erland Falls✶

Fruitland Road Falls
(Upper & Lower)

⌐ Falls
⌐ Falls (Upper)

QEW

St. Catharines

406

420

⑨
⑨ ⑨ ⑨

● Niagara Falls
⑨ Niagara Falls

DeCew Falls
DeCew Falls (Lower)
⌐way Falls

Swayze Falls

NIAGARA

GOLDEN HORSESHOE

10 0 10 20 30
KILOMETERS

Albion Falls

🚗 Follow Hwy. 403 south past
downtown Hamilton and exit
onto the eastbound Lincoln
Alexander Pkwy. Exit at Dartnell
Rd. and go south to Stone Church
Rd. Turn left (east) on Stone
Church Rd., left at Pritchard St.
and then left again onto Mud St.
There are several parking lots,
but the best is located on the
right side of Mud St., just west of
Pritchard St.

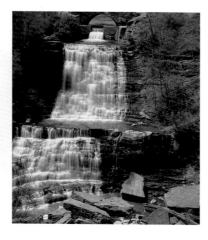

COUNTY: Hamilton	
NEAREST SETTLEMENT: **Albion Falls**	
RIVER: Redhill Creek	
CLASS: Ramp	
TRAIL CONDITIONS: Easy	
ACTIVITY: Moderate	
SIZE: Medium	
RATING: Good	
NTS MAP SHEET: 30 M/4	
UTM COORDINATES: **17T, 595871, 4783736**	
WALKING TIME: 1 minute	

This is one of the largest of the many waterfalls in the Hamilton area, and its site is relatively undisturbed. A large network of trails accessed from Albion Falls leads into King's Forest Park, a significant natural area in the eastern portion of the city. Unfortunately, plans to build an expressway right through this park resurface from time to time, since there is no north-south express route in the eastern edge of the city. Hopefully, an alternate plan will preserve the natural setting of this oasis in one of Ontario's largest cities.

Panoramic views of the waterfall and its gorge are available from the parking lot on the high ground just west of the falls. Be sure to inspect the granite grindstone on display at this parking lot. A gristmill built here by William Davis in 1795 was demolished in 1915. Once owned by John Secord, father of Laura Secord (see DeCew Falls, page 122), the faint remains of the mill site are visible on the east side of the falls.

For a closer experience of the waterfall, cross the Mud Street bridge and take the staircase to a rocky trail on the far side of Red Hill Creek.

At the base of the gorge, carefully survey the rocks exposed along the gorge walls. Note that the horizontal rock formations exposed on one wall of the gorge are essentially continuous around the entire site. On the gorge wall opposite the falls, you can pick off pieces of soft shale and break them in your hands.

The waterfall consists of two steep cascades, each capped by a more resistant rock formation. The upper cap rock is Lockport dolostone, which forms the crest of many falls in the area. While the thinly bedded limestone and shale are quickly pulverized at the base of the falls and carried away by the river, the large blocks of massive limestone cap rock may endure for centuries.

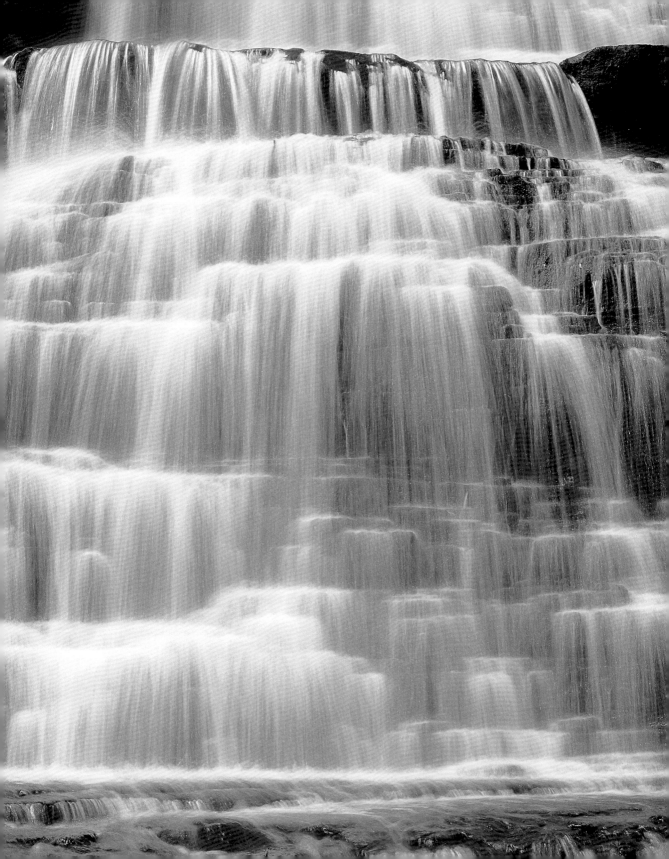

Balls Falls

🚗 **Exit the QEW at Niagara Rd. 24 (Victoria Ave.) and drive south for 5.9 km (3.6 mi.). Watch for the sign for Balls Falls Conservation Area. Turn left on Sixth Ave. and follow it for 0.7 km (0.4 mi.) to the park. There is a small parking fee. As impressive as Balls Falls can be at times, you should be aware that Twenty Mile Creek frequently dries up in summer. The site is still very interesting to visit, but if you're intent on snapping a photograph of these wonderful falls, you could be out of luck!**

COUNTY:	Niagara
NEAREST SETTLEMENT:	Vineland
RIVER:	Twenty Mile Creek
CLASS:	Plunge
TRAIL CONDITIONS:	Wheelchair accessible
ACTIVITY:	Busy
SIZE:	Large
RATING:	Outstanding
NTS MAP SHEET:	30 M/3
UTM COORDINATES:	17T, 631481, 4777089
WALKING TIME:	5 minutes

It's easy to spend most of the day at Balls Falls, so bring the family! In addition to the two beautiful waterfalls, there are several kilometers of rapids, cascades and rockfalls to explore. The well-developed conservation area around the waterfalls has not compromised the natural beauty of the site. Balls Falls is a pretty plunge-class waterfall, dropping about 25 meters (80 ft.) into the plunge pool. There are signs at the viewing area beside the falls that describe the natural landscape.

For a more interesting and challenging meeting with the waterfall, walk across the bridge and through the grassy field along the left bank of the river. Follow the gravel road to the footpath that takes you to the bottom of the valley. From here you can scramble back upstream to the waterfall, or downstream to explore the bedrock streambed. If you follow the trail downstream along the right bank of the river, you can walk all the way to the little tourist village of Jordan.

Balls Falls is formed on a resistant Irondequoit limestone formation. This thin, gray rock layer protects the much weaker rock layers below from erosion by the river and its sediment load. Numerous formations along the rock wall beside the falls each exhibit their own color. From top to bottom (youngest to oldest) they are: Irondequoit limestone, Reynales dolostone, Neahga shale (green layers), Thorold sandstone and Grimsby shale (red layers).

The falls are named after John and George Ball, who settled along the creek around 1784. Between 1807 and 1812 they constructed a large gristmill at the falls. At one point, this mill supplied flour to the British 104th regiment, which was stationed nearby during the War of 1812. Today, the gristmill and the old Ball homestead still stand as the centerpieces of a small pioneer village beside the falls.

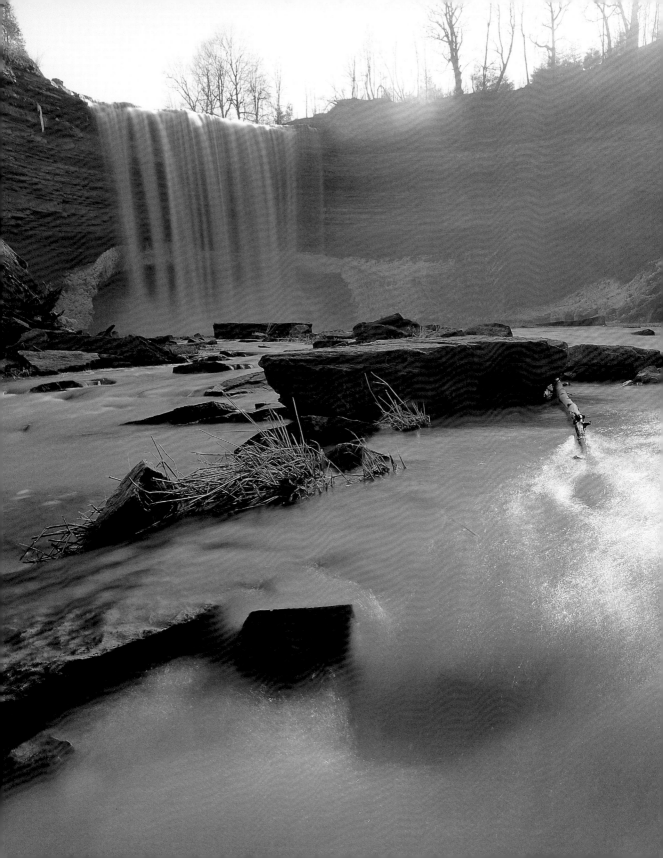

Balls Falls (Upper)

🚗 Follow the directions to Balls Falls (page 108). From here, walk upstream along the path on the west side of the river for about 10 to 15 minutes to a viewing platform. After visiting Balls Falls, follow 6th Ave. E. to the end and turn left. Follow this road to 19th St., turn right, and drive south for 0.5 km (0.3 mi.) to the base of the escarpment. Park well off the side of the road on the gravel shoulder and walk up the hill along the road. Near the top of the hill, a path leads into the woods on the left side. A short walk takes you to West Eighteen Mile Creek Falls, a small plunge waterfall about 5 m (16 ft.) high, that only runs during wetter periods of the year.

COUNTY:	Niagara
NEAREST SETTLEMENT:	Vineland
RIVER:	Twenty Mile Creek
CLASS:	Plunge
TRAIL CONDITIONS:	Moderate
ACTIVITY:	Moderate
SIZE:	Medium
RATING:	Good
NTS MAP SHEET:	30 M/3
UTM COORDINATES:	17T, 631413, 4776383
WALKING TIME:	15 minutes

Many visitors to the Balls Falls Conservation Area are pleasantly surprised when they make the 1-kilometer (0.6 mi.) hike upstream from the main falls. An undisturbed waterfall about 11 meters (36 ft.) in height, it does not exhibit the nice, clean lines of its downstream neighbor. In addition, since it lacks the manicured lawns and "tourist appeal" of the lower falls, some argue that it is actually the prettier of the two.

The crest of the waterfall is Lockport dolostone, which forms the upper rock face of the Niagara Escarpment throughout much of the area. Like the lower Balls Falls (and many of the smaller falls in the Niagara Peninsula), stream discharge at the upper falls can dry up to a trickle during summer. Fortunately, this will not ruin your visit to this splendid conservation area.

Oddly, water usually appears to pour out of cracks partway up the far gorge wall beside the falls. Somewhere upstream of the falls, river water has found its way into joints between layers of dolostone. Gravity pulls the water downward until it meets the underlying Rochester shale. Since the shale is impermeable, the water begins to move horizontally, and discharges on the gorge wall at the contact between the dolostone and shale. This phenomenon is quite rare among waterfalls in Ontario, although it also occurs to a much smaller degree at Minniehill Falls, near Walters Falls in Grey County.

By walking upstream along the bedrock streambed during low summer flows, you can observe hundreds of small potholes in the riverbed. Unlike the giant specimens at Niagara Glen or at the Warsaw Caves, you can't climb into these potholes. Here, they are perhaps 15 centimeters (6 in.) across and 10 to 15 centimeters (4 to 6 in.) deep. Although the exact process of their formation is unknown, geomorphologists believe that concentrated, eddylike flows within the river hurtle sand and pebbles at the bedrock, acting like a swirling, natural drill.

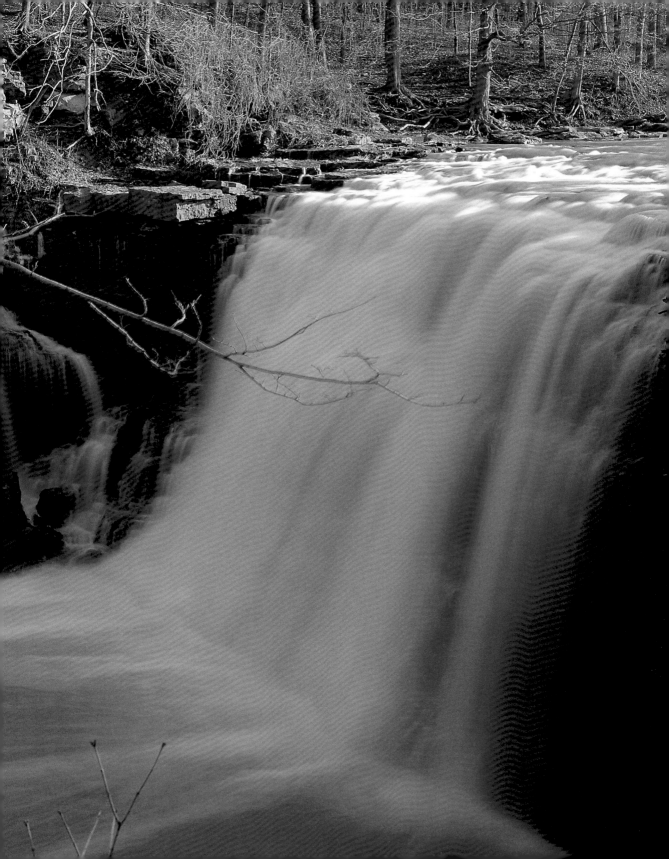

Beamer Falls

🚗 Exit the QEW at Niagara Rd. 12 (Christie St.) in Grimsby and head south. Follow this road up the Niagara Escarpment and turn right on Ridge Rd. Drive for 1.2 km (0.7 mi.) to the small parking area on the right just after the bend in the road. The falls are only steps from the parking area. Since the west side of the river is private property, you can only descend to the base of the falls by means of a weak path in the woods on the east side of the river. For the lower falls, continue east on Ridge Rd. to the first street on the right. A short drive takes you to the conservation area parking lot. Follow the paths down to river level and make your way upstream.

COUNTY: **Niagara**

NEAREST SETTLEMENT: **Grimsby**

RIVER: **Forty Mile Creek**

CLASS: **Ramp**

TRAIL CONDITIONS: **Moderate**

ACTIVITY: **Moderate**

SIZE: **Medium**

RATING: **Good**

NTS MAP SHEET: **30 M/4**

UTM COORDINATES: **17T, 615896, 4782160**

WALKING TIME: **2 minutes**

There are two main waterfalls at Beamer Memorial Conservation Area, as well as a few little ones on small tributaries flowing into the gorge. The upper waterfall is a very interesting ramp waterfall about 9 meters (30 ft.) in height. Only 3 meters (10 ft.) wide at the top, it broadens to perhaps 20 meters (65 ft.) at its base. Much of the waterfall spreads over a wide exposure of Rochester shale, where the thin, bedded nature of the shale gives the waterfall innumerable tiny steps. This is one waterfall that looks so much better when flows are lower.

The lower waterfall is rarely mentioned in guidebooks, probably because it is less accessible than the upper falls. When you reach river level, most of the established trails bend to the south. Thus, to see the lower falls, you'll have to walk upstream, carefully stepping over boulders and ducking under fallen trees. This waterfall is a very steep cascade, about 7 meters (23 ft.) high and 3 to 4 meters (10 to 13 ft.) wide.

Beamer Memorial Conservation Area is well known for more than just its waterfalls. This is one of the best locations in southern Ontario for watching the springtime migration of raptors. Taking advantage of rising air currents along the escarpment edge, hundreds of birds of prey have been observed flying over the site between mid-March and May. An information board and lookout tower enhance the birding experience.

For birders and non-birders alike, the views from the Grimsby Point Bluffs at the northern edge of the park are magnificent. Excellent panoramic views of both the Forty Mile Creek valley and the town of Grimsby are possible. On a clear day, even the Toronto skyline can be seen poking above the lake.

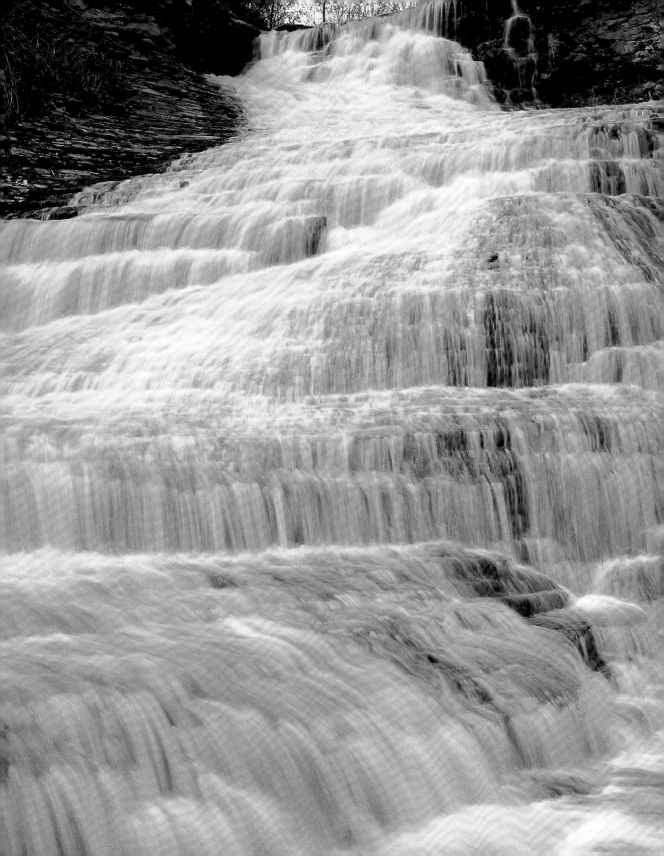

Borers Falls

🚗 Take the QEW west to Hwy. 403. Follow Hwy. 403 to Hwy. 6 and go north. Turn left onto Hwy. 5 (Dundas St.) and then turn left again onto Rock Chapel Rd. Follow this road for 1.6 km (1 mi.) and park in the lot on the left side of the road. You will have just passed a sharp curve in the road; the waterfall is located below it. From the parking lot, backtrack along Rock Chapel Rd. past Borers Creek and turn right onto the trail leading along the edge of the woods. A short walk leads to a clearing with a guardrail and a good view.

COUNTY:	Hamilton
NEAREST SETTLEMENT:	Clappison's Corners
RIVER:	Borers Creek
CLASS:	Plunge
TRAIL CONDITIONS:	Easy
ACTIVITY:	Moderate
SIZE:	Medium
RATING:	Average
NTS MAP SHEET:	30 M/5
UTM COORDINATES:	17T, 586250, 4793987
WALKING TIME:	5 minutes

This is a nice plunge-class waterfall that should be included in any waterfall trip to the Hamilton area. Since Borers Falls is significantly smaller than nearby Websters and Tews falls, it is often overlooked in the tourism literature, and is rarely busy.

Borers Falls was once the site of a sawmill, but it now enjoys one of the most natural settings of all the falls in the Hamilton region. At places, there are no fences or railings to keep you from walking right out onto the crest of this 16-meter (52 ft.) high waterfall, so be very careful!

Some visitors may be comfortable descending into the gorge via the muddy access point along the right (west) gorge wall, fairly close to the waterfall. At this spot, the escarpment face is only about 2 meters (7 ft.) high, and visitors have carefully lowered themselves onto the huge talus slope below. From here, you can make your way down to the riverbed for an excellent view. This is also one of the select few locations in Ontario where you can actually walk behind the waterfall.

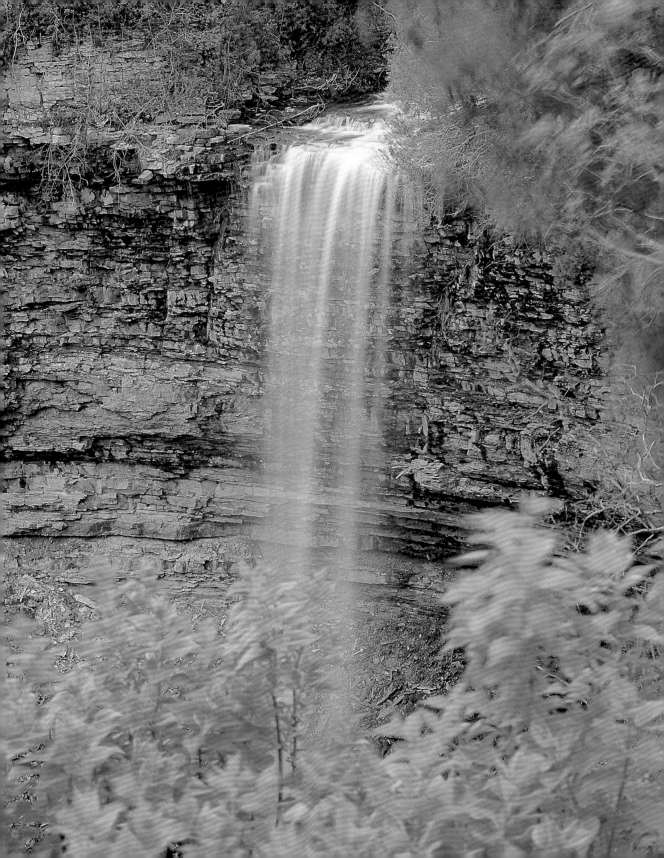

Buttermilk Falls

🚗 Follow Hwy. 403 south past downtown Hamilton and exit onto the eastbound Lincoln Alexander Pkwy. Exit at Dartnell Rd. and go south to Stone Church Rd. Turn left on Stone Church Rd., left at Pritchard St. and then left again onto Mud St. Park here and follow the trail leading north into the woods for about 10 minutes.

COUNTY: Hamilton

NEAREST SETTLEMENT: Albion Falls

RIVER: Red Hill Creek (Tributary)

CLASS: Plunge

TRAIL CONDITIONS: Moderate

ACTIVITY: Moderate

SIZE: Small

RATING: Mediocre

NTS MAP SHEET: 30 M/4

UTM COORDINATES: 17T, 595882, 4784294

WALKING TIME: 10 minutes

As with many falls in the Hamilton area, Buttermilk Falls is topped by a large concrete culvert carrying the creek under a road. Many people complain that such structures have ruined the appearance of many of the falls in Hamilton, like Chedoke or Albion Falls. Indeed, their pristine natural setting is gone forever, and they are being identified more and more as integral parts of the urban landscape.

Buttermilk Falls can be disappointing. Since the watershed upstream of the waterfall is almost entirely urbanized, the flow is no more than a mere trickle for much of the year. In urbanized areas, rainwater runs off asphalt and concrete and is quickly carried downstream by concrete-lined ditches and covered storm sewers. In the study of hydrology, flows from urban watersheds are often termed "flashy": the creek only comes to life after intense rain events or extended periods of snow melt in spring. Getting a good picture at this waterfall is thus hit-or-miss, and you are well advised to pay careful attention to recent weather conditions.

Even though this creek is very often dry, a visit is still recommended, especially after a visit to nearby Albion Falls. The gorge associated with this creek is quite deep, with steep walls and a well-shaded bottom. How could such a tiny creek have eroded so much rock? It probably didn't. As at the Devil's Punch Bowl to the east, the creek flowing through this gorge was likely much fuller at one time.

The safest way to reach the base of the falls is to take the trail south to the base of Albion Falls. If flows are low enough, you should be able to scramble along the base of Red Hill Creek. Walk downstream for 300 to 400 meters (1,000 to 1,300 ft.) and watch for a small creek joining Red Hill Creek on the west side. Walk up this creek to the falls.

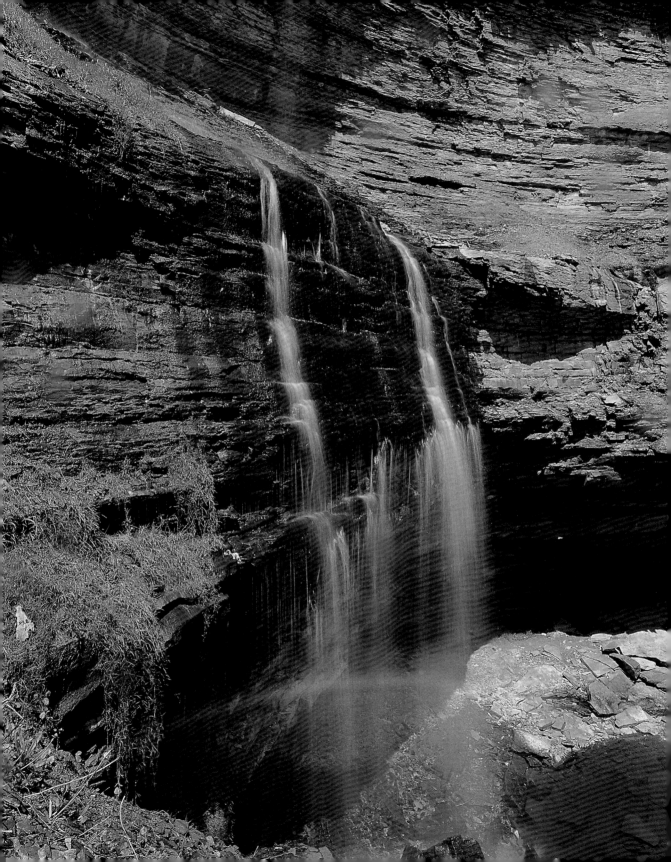

Chedoke Falls

🚗 **Exit Hwy. 403 at the Lincoln Alexander Parkway and go east to Garth St. Go north on Garth St. for 2.2 km (1.4 mi.) and turn left on Denlow Ave. Follow it to the end at Scenic Dr., and find a place to park on a nearby side street. Walk to the concrete railing along Scenic Dr. and find the falls. The view from the base of the falls is much better; unfortunately, the route to the bottom is very challenging. You need to walk along the road to the right of the falls and look for a break in the fence. Carefully descend the narrow break in the gorge wall, then slowly make your way down the steep, bouldery slope. If you cannot find a safe way to the bottom, enjoy this waterfall from the top.**

COUNTY:	Hamilton
NEAREST SETTLEMENT:	Hamilton
RIVER:	Chedoke Creek
CLASS:	Plunge
TRAIL CONDITIONS:	Difficult
ACTIVITY:	Quiet
SIZE:	Medium
RATING:	Average
NTS MAP SHEET:	30 M/4
UTM COORDINATES:	17T, 589256, 4788255
WALKING TIME:	5 minutes

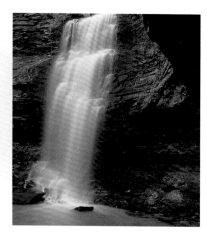

What a surprise! Chedoke Falls is bigger and much prettier than one would expect for a waterfall that few people visit. There are no signs or viewing platforms, and it is not marked on topographic maps. The difficult hiking required to see this waterfall is probably why it remains one of Hamilton's best kept natural secrets.

Chedoke Creek is buried under the city for much of its journey toward Lake Ontario. At the falls, the creek suddenly appears from a concrete culvert beneath Scenic Drive, and then promptly falls about 18 meters (60 ft.) into a pretty little plunge pool. At times, the plunge pool shines with a bright turquoise blue color. Following a large rainstorm or snow melt, however, urban runoff turns the pool and the river a stale, ugly brown color.

Two smaller waterfalls are also located in this gorge. Just 50 meters (165 ft.) downstream, a small creek trickles down the right side of the valley. Unlike most tiny streams along the Niagara Escarpment, this creek has not eroded even a small gorge. This little waterfall is probably very young and is perhaps simply an urban drainage project developed within the last hundred years or so.

A few hundred meters downstream, Chedoke Creek falls over a somewhat uninspiring plunge waterfall about 5 meters (16 ft.) in height. The crest is composed of hard Whirlpool sandstone, while the undercut Queenston shale is easily visible due to its bright rusty red color.

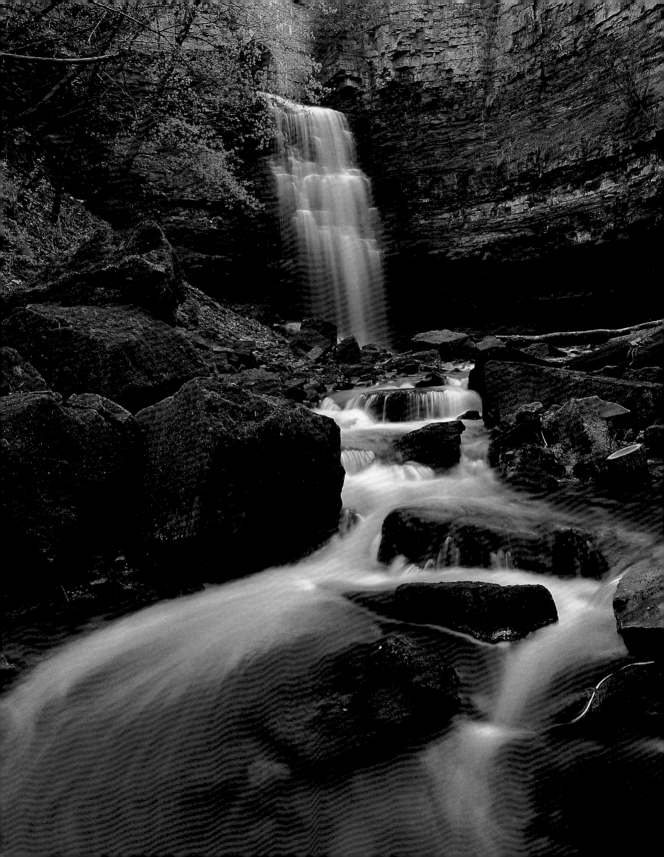

Churches Falls

🚗 From Hwy. 401, drive north on Meadowvale Rd. (Peel Rd. 1) for about 30 km (18 mi.) until you reach the intersection with Forks of the Credit Rd. Turn right and follow this very scenic road for about 7 km (4 mi.) to Hwy. 10 (Hurontario St.). Turn left onto Hwy. 10 and follow the highway for 4.5 km (2.8 mi.) to Peel Rd. 24. Turn left on this road and follow to McLaren Rd. Watch for the signs. Go left on McLaren Rd. and after a short drive, park in the lot provided for the conservation area. From here, you will need to walk about 40 minutes to the falls. There are a few places where you can park closer to the falls (try Cataract Rd. to the west), but pay attention to the "No Parking" signs.

COUNTY:	**Peel**
NEAREST SETTLEMENT:	**Cataract**
RIVER:	**Credit River**
CLASS:	**Plunge**
TRAIL CONDITIONS:	**Moderate**
ACTIVITY:	**Moderate**
SIZE:	**Large**
RATING:	**Average**
NTS MAP SHEET:	**40 P/16**
UTM COORDINATES:	**17T, 578614, 4852490**
WALKING TIME:	**40 minutes**

Churches Falls is located immediately east of the small village of Cataract, in the Forks of the Credit Park. This park provides a mix of forest, wide open fields and a smattering of small ponds. The trail to the waterfall is relatively well-signed and winds through the varied landscape, but you should be prepared to walk for about 40 minutes.

You are treated to a fair view of the falls from a large steel viewing platform perched on the side of the Credit River's steep valley. It is far too dangerous to descend to the riverbed from the lookout platform. This is unfortunate because photos of the waterfall are best taken from the bed of the river 30 to 40 meters (100 to 130 ft.) below. And in order to get to the other side, you would need to cross private property (like the CP rail line running along the far side of the river).

Unfortunately, the natural beauty of this plunge-class waterfall has been seriously compromised. The waterfall itself is formed where resistant sandstones and limestones of the Cataract formation have been undercut by the underlying Queenston shale. Immediately above the falls, however, a giant concrete retaining wall built along the right bank of the river protects the railway bed from erosion. This has ruined the natural approach of the creek to the falls. The remains of an old power plant (one of the first in Canada) sit precariously at the edge of the waterfall. Its dull gray concrete form blends somewhat into the natural surroundings, but a pleasant walkway to the edge of the falls would be preferable.

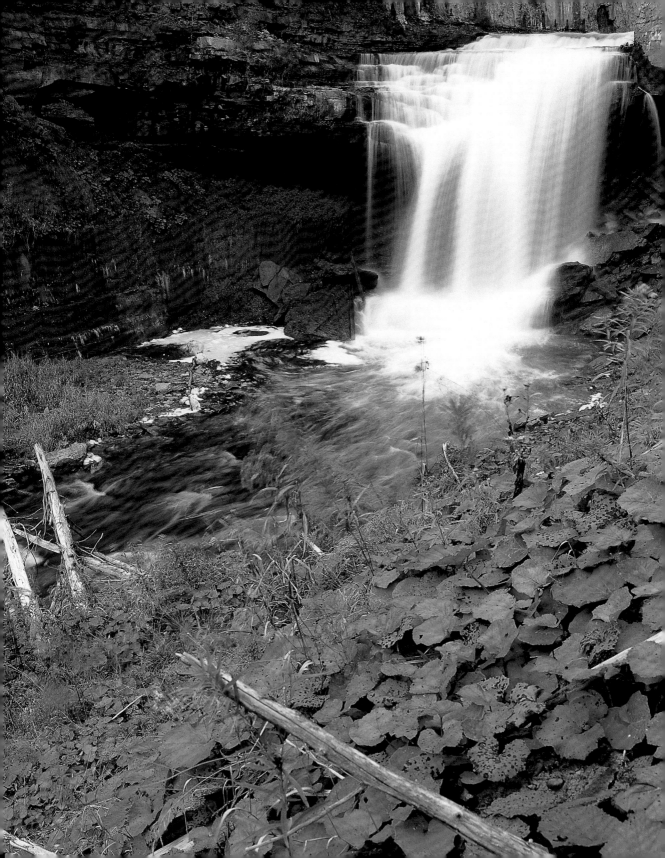

DeCew Falls

🚗 **To get to DeCew Falls, exit Hwy. 406 at St. David's Rd. Turn left (south) onto the Merrittville Hwy. and drive for a few minutes to DeCew Rd. Turn right onto DeCew Rd., and follow it 1.8 km (1.1 mi.) to the gravel parking lot for Morningstar Mills on the right.**

COUNTY:	Niagara
NEAREST SETTLEMENT:	Power Glen
RIVER:	Twelve Mile Creek
CLASS:	Plunge
TRAIL CONDITIONS:	Easy
ACTIVITY:	Moderate
SIZE:	Large
RATING:	Good
NTS MAP SHEET:	30 M/3
UTM COORDINATES:	17T, 641210, 4774549
WALKING TIME:	3 minutes

This well-visited, classy waterfall is a favorite of many. Good to visit just about any time of the year, its flow is maintained somewhat by the municipal reservoir located upstream.

DeCew Falls is a beautiful example of the plunge form: water falls over a dolostone ledge and does not touch bedrock until it hits the plunge pool some 22 meters (72 ft.) below. Even the nongeologist will note a number of well-exposed horizontal rock formations in the gorge walls beside the waterfall. A 3 to 4 meter (10 to 13 ft.) thick layer of gray Lockport dolostone dominates the upper portion of the rock stratigraphy. This rock formation is considered to be "massive" by geologists, since it does not contain many horizontal beds. Contrast this with the thinly bedded lighter gray layers of shale and sandstone below. Since the dolostone is more resistant to erosion, it overhangs the weaker shale and sandstone layers.

The Morningstar Mill, originally built in 1872 and again in 1895 after a fire, is located adjacent to the falls. On summer weekends, you can visit the mill building and take a look at some of the 19th-century rural artifacts that have been collected. As a special treat, you can walk downstairs into the turbine shed and look right over the edge of the waterfall. Drop a donation in the box to help keep the mill museum running. East along DeCew Road you can visit the stone foundations of the house built by Captain John DeCou in 1812. It was to this home that a young Laura Secord came running to warn of the advancing American Forces during the War of 1812.

The best view of the waterfall is from the bottom of the gorge, but getting there is not easy. Active adults should be able to detect the safe routes used to enter the gorge. The view from the riverbed below the falls is arguably one of the most picturesque at any waterfall in the Golden Horseshoe region. The clean, curtainlike nature of the falls, bright red color of the mill and fine spray from the falling water combine to make the trip an unforgettable experience.

In addition to Lower DeCew Falls, there are other smaller waterfalls at this site. While by no means spectacular, readers are still encouraged to hunt them down.

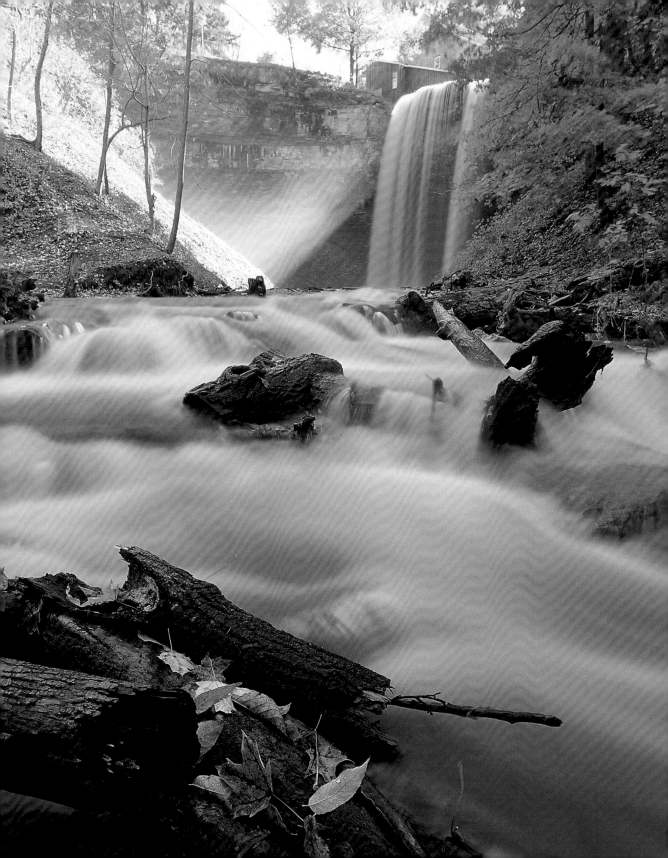

DeCew Falls (Lower)

🚗 Follow the directions to DeCew Falls (page 122). Continue past Morningstar Mill, the main falls and the other buildings. After passing through the gate, turn left and walk along the gravel trail. You should soon be able to hear the waterfall. Look for spots that previous visitors have used to descend down the side of the gorge. Use caution! Unless you can find a safe place to climb down, it is better to enjoy this waterfall from above. For safety reasons (and to double the fun), it is a good idea to visit this waterfall with a friend. There are two other small waterfalls to be found at DeCew: Faucet Falls and a small, unnamed waterfall hidden behind a chain-link fence.

COUNTY:	Niagara
NEAREST SETTLEMENT:	Power Glen
RIVER:	Twelve Mile Creek
CLASS:	Cascade (Steep)
TRAIL CONDITIONS:	Difficult
ACTIVITY:	Quiet
SIZE:	Medium
RATING:	Average
NTS MAP SHEET:	30 M/3
UTM COORDINATES:	17T, 640989, 4774548
WALKING TIME:	10 minutes

Most visitors to DeCew are probably completely unaware of this significant waterfall downstream of the main falls. There are no viewing platforms beside these falls nor is there an established path to its edge. As it is located in the middle of the 20-meter (65 ft.) deep gorge cut by the upper falls, you should only access Lower DeCew Falls if you are physically fit, and very, very careful.

Getting a good view of the waterfall is worth the trouble. It is not a true plunge waterfall, but a near-vertical cascade about 8 meters (26 ft.) high. The crest of the falls is formed by Irondequoit limestone, which also forms the crest of the lower falls at Rockway, Balls Falls and Beamers Falls. Unlike almost all of the gorges in the Niagara Peninsula, the DeCew Gorge trends in an east-west direction. This results in slightly warmer conditions on its northern sun-facing slope – botanists will note slightly different vegetation on either side of the valley.

After you've finished visiting the waterfalls at DeCew, be sure to take the scenic drive west along DeCew Road. If you turn right at Pelham Road (Niagara Region No. 69), you will be able to see the impressive penstocks of two large hydroelectric power stations located less than 1 kilometer (0.6 mi.) from DeCew Falls. The entire DeCew area has been altered in order to feed water to these generating stations. A system of canals delivers water to the generating station from the Welland Canal, via nearby Lake Moodie and Lake Gibson.

Utilizing the total head drop of 79 meters (260 ft.), the two generating stations are rated at a total of 174 MW. The older of the two plants was built in 1898, and remains the oldest generating station in Niagara. The two large concrete penstocks feed the newer power plant, which was built in 1943.

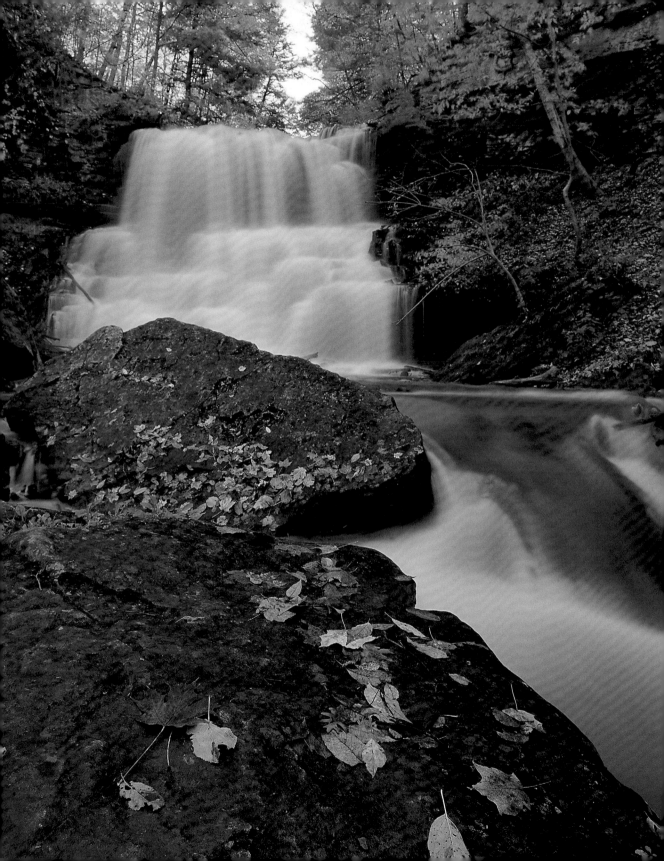

Devil's Punch Bowl

From the QEW in Stoney Creek, exit south onto Centennial Pkwy. Follow Centennial Pkwy. south through Stoney Creek and up the escarpment. As you are climbing the escarpment, the road curves to the left and then back to the right. At the top of the hill, turn left onto Ridge Rd. Follow this road for a few minutes, go around the bend, and park in the lot on the left (north) side of the road. Be sure to look for Billy Greens Falls on the right side of Centennial Pkwy. as you climb the escarpment. Be careful as no stopping is allowed on this busy four-lane road.

COUNTY:	Hamilton
NEAREST SETTLEMENT:	Stoney Creek
RIVER:	Stoney Creek
CLASS:	Plunge
TRAIL CONDITIONS:	Easy
ACTIVITY:	Moderate
SIZE:	Medium
RATING:	Average
NTS MAP SHEET:	30 M/4
UTM COORDINATES:	17T, 601066, 4784921
WALKING TIME:	1 minute

This is a spectacular site, yet probably doesn't get the publicity it deserves. It doesn't take a geologist to notice that something here just isn't right. Compared to the little brook that is Stoney Creek, this gorge is enormous! How could this little trickle have eroded away tons and tons of bedrock? Chances are, it didn't. About 10,000 to 15,000 years ago, the drainage patterns in southern Ontario were different from today due to melt-water from retreating glaciers. Only a significantly sized stream would have sufficient erosive power to carve out the Devil's Punch Bowl, which is about 39 meters (128 ft.) deep and probably 100 meters (325 ft.) wide.

The punch bowl itself is a slice through several tens of millions of years of the Silurian era of geologic history. All of the major bedrock formations found throughout the southern portion of the Niagara Escarpment outcrop along the gorge walls. From top to bottom (youngest to oldest), the primary rock formations are: Lockport dolostone, DeCew limestone, Rochester shale, Irondequoit limestone, Reynales shale, Thorold sandstone, Grimsby sandstone and Cabot Head shale. This site marks the furthest south that the Cabot Head shale unit is observed: it is not seen anywhere further east along the escarpment.

Descending into the deep gorge is not safe from this location, but it may be done with ease by visiting the lower falls (see page 128). Before leaving for the lower falls however, be sure to take in the spectacular view of Stoney Creek and eastern Hamilton. Good views of the Burlington Skyway and the steel mills of Hamilton are provided, although most of the buildings of Hamilton's downtown are hidden by the escarpment edge. The large cross was erected in 1966 and, when lit at night, can be viewed from a distance of many kilometers.

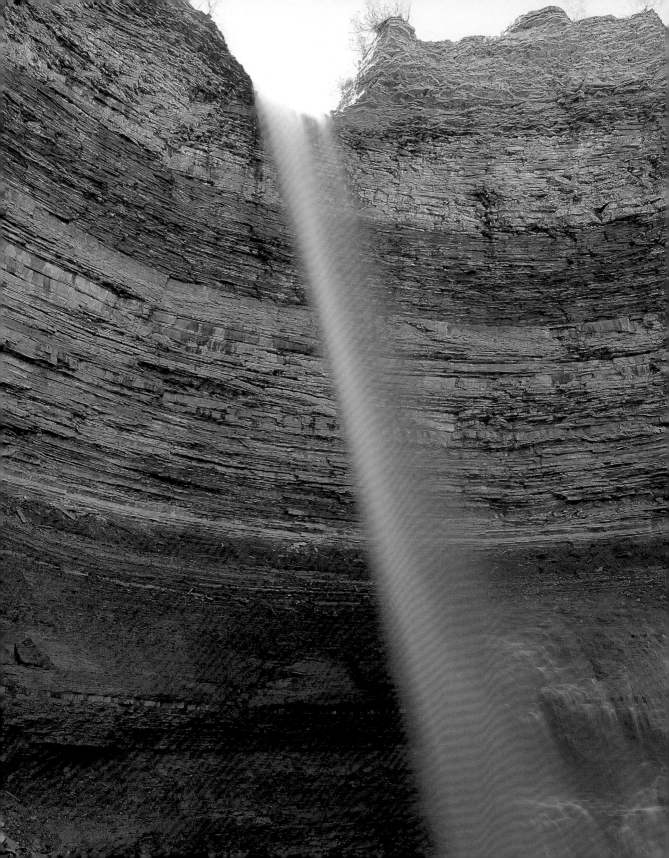

Devil's Punch Bowl (Lower)

🚗 Go south from the QEW along Centennial Pkwy. (or north from Ridge Rd. if you are visiting the upper falls). Go east on King St. to Mountain Rd. Turn right on Mountain Rd., and follow it to a small parking lot at its end. Take the dirt path across the railway tracks to the lower falls. There are no major waterfalls along the escarpment between these falls and those at Beamer Park in Grimsby, but there are other tiny falls in this area (at the west end of Glover Mountain Rd.; along the escarpment south of Fruitland Rd.; where Dewitt Rd. meets Ridge Rd.; and at the south end of Centennial Park in Grimsby).

COUNTY:	Hamilton
NEAREST SETTLEMENT:	Stoney Creek
RIVER:	Stoney Creek
CLASS:	Plunge
TRAIL CONDITIONS:	Moderate
ACTIVITY:	Quiet
SIZE:	Small
RATING:	Average
NTS MAP SHEET:	30 M/4
UTM COORDINATES:	17T, 600908, 4785098
WALKING TIME:	5 minutes

Often an afterthought to the main falls at the Devil's Punch Bowl, the lower waterfall is still worth a visit. As a small plunge-class waterfall, it is an excellent example of the process of differential erosion.

The crest is formed of resistant Manitoulin and Whirlpool sandstones, while the rest of the face of the falls is composed of reddish-colored Queenston shale. The shale is very weak structurally, and erodes quite quickly by the cycles of freezing-thawing, wetting-drying and heating-cooling. Conversely, the sandstone is much more resistant to erosion, and forms a strong rock ledge that overhangs the face of the shale. From time to time, large pieces of sandstone do break off, and many of these can be seen immediately beneath the waterfall. When the sandstone breaks off, it does so in a more irregular shape than do dolostone and limestone, which tend to be more blocky.

After visiting the waterfall, be sure to continue along the rocky trail up to the main falls. You can approach the base of the main falls relatively easily in a few minutes. The near-vertical high walls of the punch bowl are awesome! This vantage point leaves an impression of the upper falls that is completely different from that available from Ridge Road above. If you visit the base of the upper falls on a windy day, you may see one of Ontario's only "bending" waterfalls.

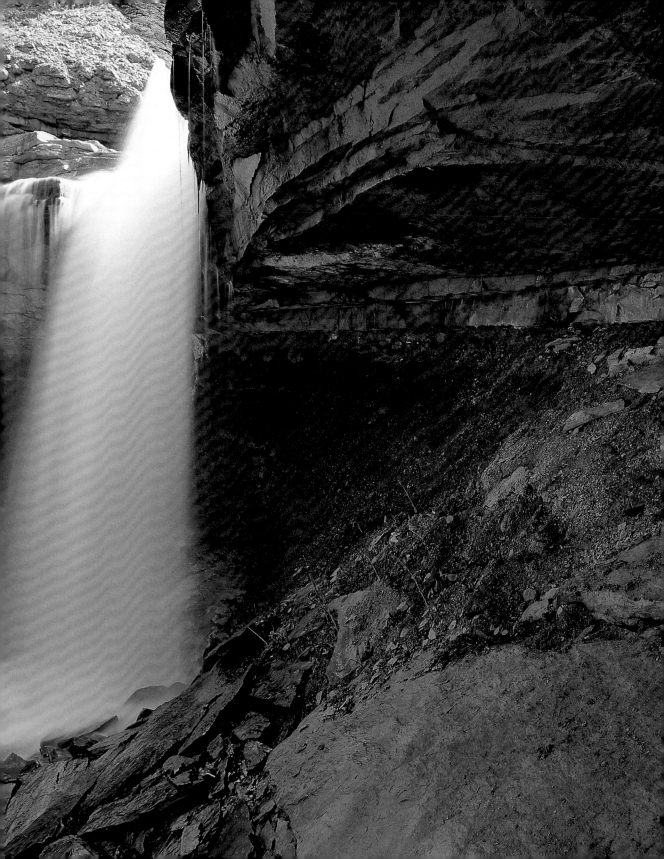

Elora Gorge Falls

🚗 From Hwy. 401, exit onto Hwy. 6 north (Hanlon Expressway), which speeds you past most of Guelph. At the end of the expressway, turn right on Woodlawn Rd. and watch for the sign for Hwy. 6 north. Go north on Hwy. 6, and turn left onto Wellington Rd. 7. Drive through the countryside for 14 km (9 mi.) until you reach the town of Elora. Turn right at McNab St., and then left at Metcalfe St. Your best bet for parking is to use the municipal lot on the left side of Metcalfe St., immediately before crossing over the Grand River. A wooden footbridge over the river takes you to Mill St., which is the heart of the old town.

COUNTY: Wellington	
NEAREST SETTLEMENT: Elora	
RIVER: Grand River	
CLASS: Ramp	
TRAIL CONDITIONS: Wheelchair accessible	
ACTIVITY: Busy	
SIZE: Medium	
RATING: Outstanding	
NTS MAP SHEET: 40 P/9	
UTM COORDINATES: 17T, 545836, 4836543	
WALKING TIME: 5 minutes	

A trip to Elora can easily fill an entire day, and this quaint town and its spectacular gorge have long been a magnet for day-trippers. After exploring the falls and gorge, visitors can spend a long afternoon in the gift shops, pubs and art studios in this tourist town. In addition to the main falls, there are numerous small caves, river chutes, cliffs and occasional fossils.

Elora Gorge Falls is an example of the ramp form. As at other ramp falls, no one rock formation is more resistant than the rest. Instead, the river appears to "slide" down over thinly bedded rocks of uniform resistance to erosion. More resistant Guelph dolostone forms the massive, vertical cliffs up to 15 meters (50 ft.) high and the tiny island precariously set in the middle of the falls, often called the "Tooth of Time."

Although excellent hiking trails encircle the entire gorge, a unique view can be had in summer by floating down the river in an inner tube. Tubes can be rented at the Elora Gorge Conservation Area and a bus shuttles "tubers" from the conservation area to a point near the top of the gorge.

The gorge is also a favorite of the white-water paddling crowd. River flows vary widely throughout the year, ranging from as low as 3 cubic meters (105 cu. ft.) per second in summer to highs of 100 cubic meters (3,500 cu. ft.) per second during spring melts.

Due to the absense of any signs reading "To the Falls," many visitors have undoubtedly missed the excellent walking trails. From Mill Street in downtown Elora, walk up the hill on Price Street and then turn left onto Church Street. Church Street soon narrows to a gravel trail leading to a lovely walk along the top of the gorge. A panoramic view is available at "Lover's Leap," a high promontory between the gorge and Irvine Creek. Still further along the trail is a stone staircase that gives access to the riverbed at Irvine Creek. In summer, water levels are so low that you can walk across the bedrock creek bottom to explore tiny caves, rapids and massive limestone blocks. For more trails, cross the downtown footbridge and walk to the right along Ross Street. A clearing between small factories leads to several kilometers of trails.

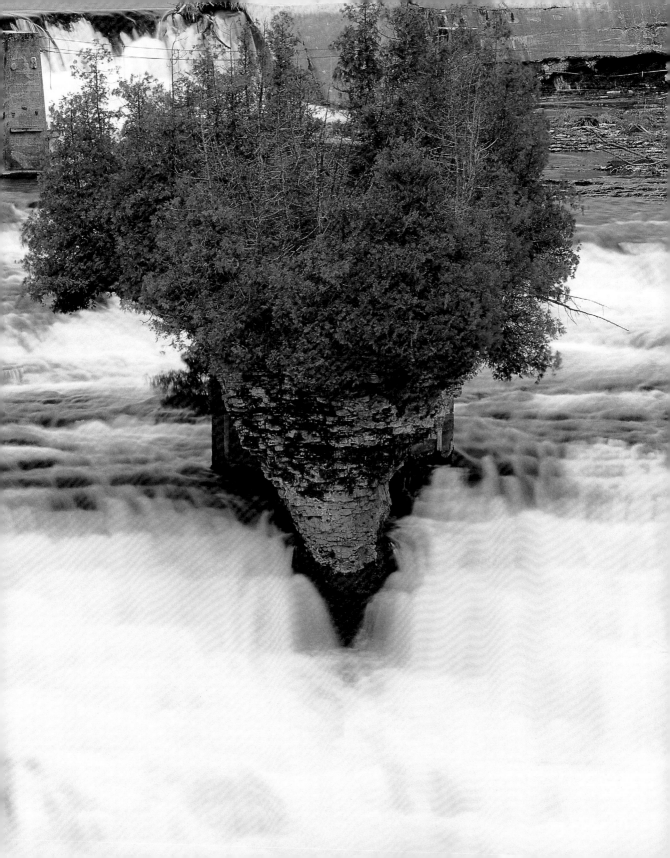

Felkers Falls

🚗 Exit the QEW at Centennial Pkwy. and go south. Drive through Stoney Creek and up the escarpment. Turn right onto Mud St., and then turn right at Paramount Dr. From Paramount Dr., turn right onto Ackland Rd. Follow the road around the bend and park in the small lot provided for the city park. Walk across the field to the wooden fence – the falls are right behind it.

COUNTY:	Hamilton
NEAREST SETTLEMENT:	Elfrida
RIVER:	Red Hill Creek (East Branch)
CLASS:	Plunge
TRAIL CONDITIONS:	Wheelchair accessible
ACTIVITY:	Moderate
SIZE:	Medium
RATING:	Average
NTS MAP SHEET:	30 M/4
UTM COORDINATES:	17T, 598280, 4784120
WALKING TIME:	3 minutes

This is a pretty waterfall nestled right in the heart of suburbia! Situated at one end of a grassy field barely 200 meters (650 ft.) from surrounding homes, Felkers Falls is part of a bigger city park. The Bruce Trail and the wheelchair-accessible Peter Street Trail allow you to walk both upstream and downstream through the forests along the creek. A few hundred meters upstream of the waterfall is a footbridge that allows you to walk back downstream along the far side of the waterfall.

Felkers Falls is a plunge waterfall, with two main drops of about 10 meters (33 ft.) each. The gorge walls are steep, and you are well advised to stay on the safe side of the wooden fence. In summer, it can be difficult to get a good view of the waterfall due to the heavy foliage. Some of the cedars and hemlocks along the cliff edge just don't seem to want to give up – their trunks bend nearly 90 degrees in order to ensure that the tree stays vertical. Also note that the cedars and hemlocks dominating the cliff edges are gradually replaced by American beech, sugar maple and white oak.

An interesting feature of Felkers Falls is the narrow bedrock gorge leading upstream from the waterfall site. In places, the creek bed here can be bare bedrock with very little silt, stream detritus or boulders. While this gives the impression of a natural "paved" streambed, people have unfortunately reversed this effect with every imaginable kind of litter, including an old bicycle frame. At times, the cleanliness (or lack thereof) of this whole site is an unfortunate reminder of what can happen to a waterfall when it is situated in such close proximity to so many people.

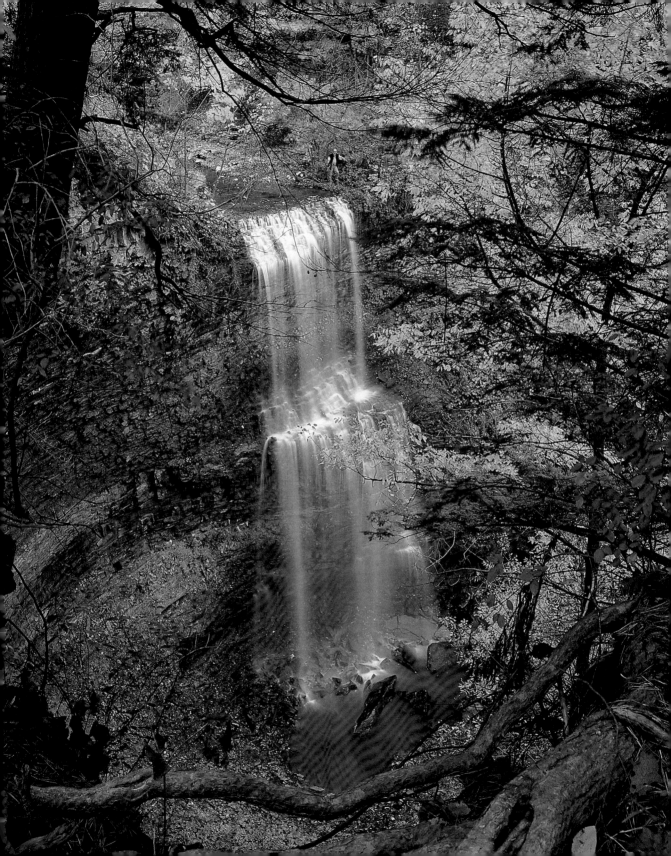

Hilton Falls

🚗 Exit Hwy. 401 at Halton Rd. 1 (Guelph Line) and go north to Campbellville Rd. Turn right and drive for 3.2 km (2 mi.) to the park driveway on the left. There is a small admission fee, and the walk to the waterfall takes about 20 minutes.

For Silver Creek and Snow Creek Falls, drive north from Hwy. 401 along Halton Rd. 3 (Trafalgar Rd.) for 17.5 km (10.9 mi.) to Halton Hills Side Rd. 27. Turn right and drive east to the intersection with 8th Line. Snow Creek Falls is located on the southeast corner. Continue east for 0.9 km (0.6 mi.) for Silver Creek Falls. The waterfall is very small, but an interesting hiking trail heads off from either side of the road.

COUNTY:	Halton
NEAREST SETTLEMENT:	Campbellville
RIVER:	Sixteen Mile Creek
CLASS:	Plunge
TRAIL CONDITIONS:	Moderate
ACTIVITY:	Busy
SIZE:	Small
RATING:	Good
NTS MAP SHEET:	30 M/12
UTM COORDINATES:	17T, 582507, 4817941
WALKING TIME:	20 minutes

This charming waterfall is found in an oasis of nature, not far from Ontario's most infamous expressway. Hilton Falls is the centerpiece of a large conservation area that hosts hundreds of visitors every weekend. Sixteen Mile Creek plunges 10 meters (33 ft.) into a beautiful gorge lined by cedars. A staircase descends to a viewing platform at the base of the falls, and signs explain the valley's history and geology.

The falls are named after Edward Hilton, who constructed a mill here circa 1835. The stone foundations of the mill are visible in the gorge and serve to remind visitors of the importance that even little falls like these once had to the early settlers of the province. Photographers will love this site (particularly in autumn) as the picture is almost perfect.

Detailed topographic maps suggest that another small waterfall may be found downstream on the west side of the gorge. There are very likely no waterfalls between Hilton Falls and Waterdown Falls at Waterdown. Many guidebooks list Churches Falls as the next significant waterfall north along the Niagara Escarpment. This is true, but there are no fewer than five small sites on public land along this stretch. The largest is Snow Creek Falls, a 2-meter (7 ft.) high plunge waterfall with a narrow, but defined gorge. The quaintest is tiny Silver Creek Falls, which is nicely framed by a stone bridge.

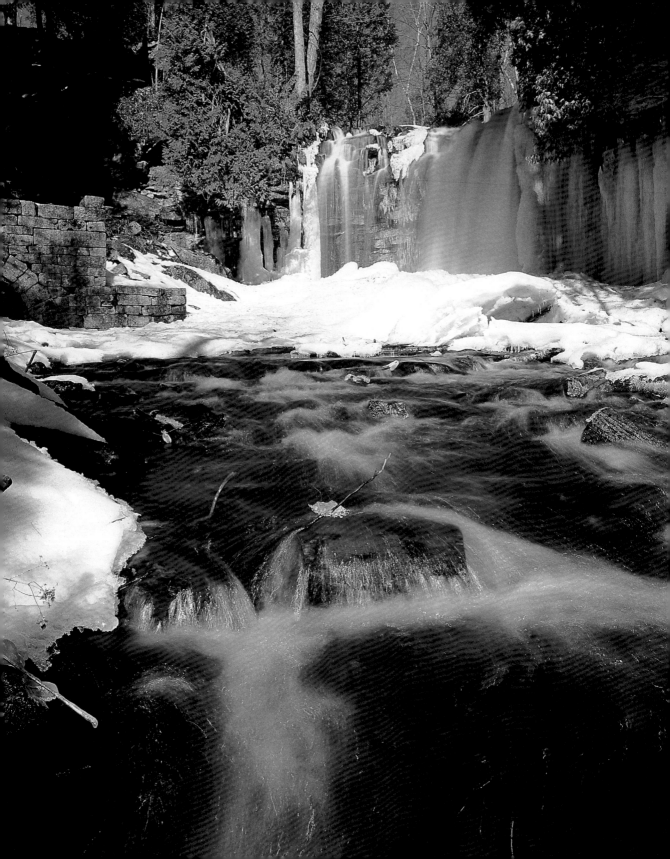

Louth Falls

🚗 **Exit the QEW at Niagara Rd. 26 (Jordan Rd.) and head south. Follow this road to the end and turn left on Niagara Rd. 81 (Old Hwy. 8). Note the small hill running parallel to Niagara Rd. 81 – this is the old shoreline of glacial Lake Iroquois. Turn right onto 17th St., and then left on Staff Ave. Proceed to the tiny parking lot for the conservation area on the left. Follow the walking trail until you've descended down the escarpment. Turn left and follow this trail to the falls. Three very small waterfalls are nearby on three small tributaries of Eighteen Mile Creek. Two can be accessed where the escarpment crosses 17th St., and the other can be reached via the Bruce Trail on the east side of 19th St.**

COUNTY: Niagara	
NEAREST SETTLEMENT: Jordan	
RIVER: Sixteen Mile Creek	
CLASS: Plunge	
TRAIL CONDITIONS: Moderate	
ACTIVITY: Quiet	
SIZE: Small	
RATING: Good	
NTS MAP SHEET: 30 M/3	
UTM COORDINATES: 17T, 634179, 4775967	
WALKING TIME: 10 minutes	

Louth Falls is arguably the best waterfall surprise in the Niagara Peninsula. It isn't very big, isn't well known or signed, and isn't even marked on maps. But this is one of those special places where you feel you've found something secret that you want to keep to yourself. The waterfall is about 8 meters (26 ft.) high and belongs to the plunge class, with a nice little pool at its base. Accessing the lower gorge is a little difficult. For a more interesting walk, carefully trek up the creek above the waterfall. Be sure to be mindful of the sensitive ecological habitat in small streams like this.

If you continue south toward the road, you will see the dried-up ramp waterfall beside Staff Avenue (also visible from the road). The river now crosses the road at a point closer to the conservation area entrance, flowing through a broken quasi-waterfall.

The 10-minute walk to the waterfall is interesting in itself. The woods in the Niagara Peninsula belong to the Carolinan forest: an assemblage of species more at home in the mid-Atlantic states than in Canada. Shagbark hickory and sassafras are two tree species found in this zone, which is confined to southwestern Ontario, more or less south of Highway 401. On the left side of the trail, you should be able to see deep, polished fissures in the rock. This is a mild example of karst topography, a name given to landscapes where limestone bedrock is slowly dissolved by the weak carbonic acid present in rainwater.

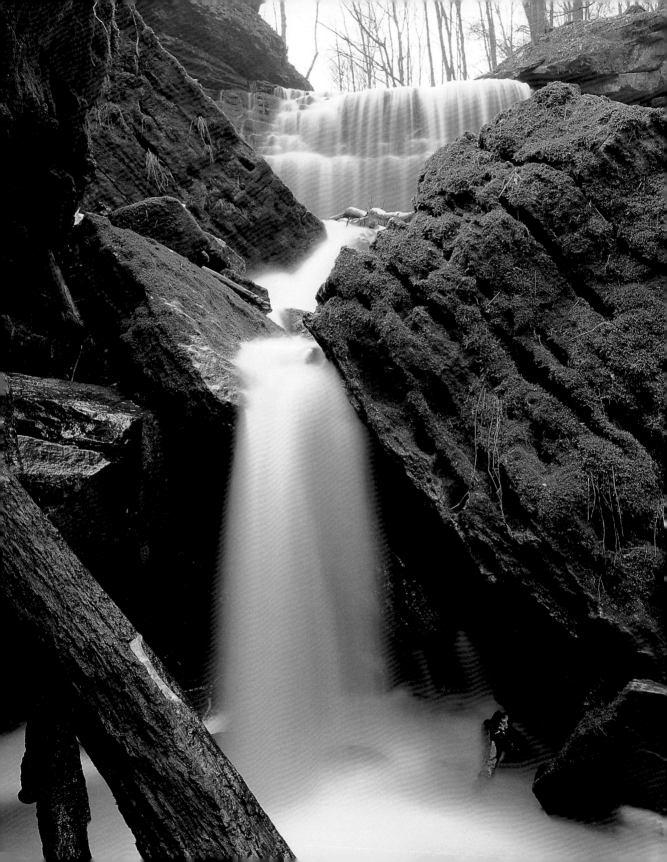

Niagara Falls

🚗 Follow the QEW to the city of Niagara Falls, and exit east at Hwy. 420, which soon becomes Roberts Rd. Turn right at Falls Ave., and continue south until this road merges with the Niagara River Pkwy. Drive along the river until you see the falls. There are pay parking lots in the area, including a large one on the right side of the road, almost directly opposite the falls. If ever in doubt, watch for signs reading "To the Falls," which are scattered throughout the town on all major thoroughfares. To reach Wintergreen Flats, drive downstream along the Niagara River Pkwy. (also signed as River Rd.) for about 8 km (5 mi.). Parking is available between the road and the river.

COUNTY:	Niagara
NEAREST SETTLEMENT:	Niagara Falls
RIVER:	Niagara River
CLASS:	Plunge
TRAIL CONDITIONS:	Wheelchair accessible
ACTIVITY:	Very busy
SIZE:	Very large
RATING:	Outstanding
NTS MAP SHEET:	30 M/3
UTM COORDINATES:	17T, 656615, 4771456
WALKING TIME:	0 minutes

Visited by millions of tourists every year, Niagara Falls is the best known waterfall in the province, and probably the most famous in the world. So much has been written about the falls, that it is impossible to adequately explain all the interesting facts, figures and folklore in this book. One thing is certain however: If you have not been to the falls, go! Some people complain about the rampant commercialism of the lands around Niagara Falls, but don't let this stop you. The money-making exploitation of the falls is certain, but no amount of circus and cheesy glitz can diminish the breathtaking sight of the waterfalls.

There are three waterfalls at Niagara. The American Falls and the small, narrow Bridal Veil Falls are entirely in New York State. Horseshoe Falls, also known as the Canadian Falls, is entirely in Ontario. Each waterfall is fed by the Niagara River, through which all the water draining from the Great Lakes watershed – approximately 436,000 square kilometers (168,000 sq. mi.) – flows, except for that water draining to Lake Ontario. Prior to the 20th century, this amounted to an average discharge of about 5,720 cubic meters (202,000 cu. ft.) per second in total over all three falls. Since some of the river's water is now diverted for hydroelectric power generation on both sides of the border, the river's average discharge is now closer to 2,832 cubic meters (100,000 cu. ft.) per second. These values are maintained by the Niagara Water Diversion Treaty agreed upon by Canada and the United States in 1950. Approximately 90 percent of the flow spills over Horseshoe Falls.

The American Falls is 56 meters (183 ft.) high, although over half of the bedrock face of the waterfall is hidden by enormous blocks of dolostone eroded from the crest of the falls through the millennia. Horseshoe Falls is 53 meters (174 ft.) high and approximately 671 meters (2,200 ft.) along its crest. The water is roughly 3 meters (10 ft.) deep as it plunges over the falls at speeds of up to 32 kilometers per hour (20 mph). The plunge pool below Horseshoe Falls is estimated to be nearly 52 meters (172 ft.) deep, a testament to the enormous erosive power of the falls.

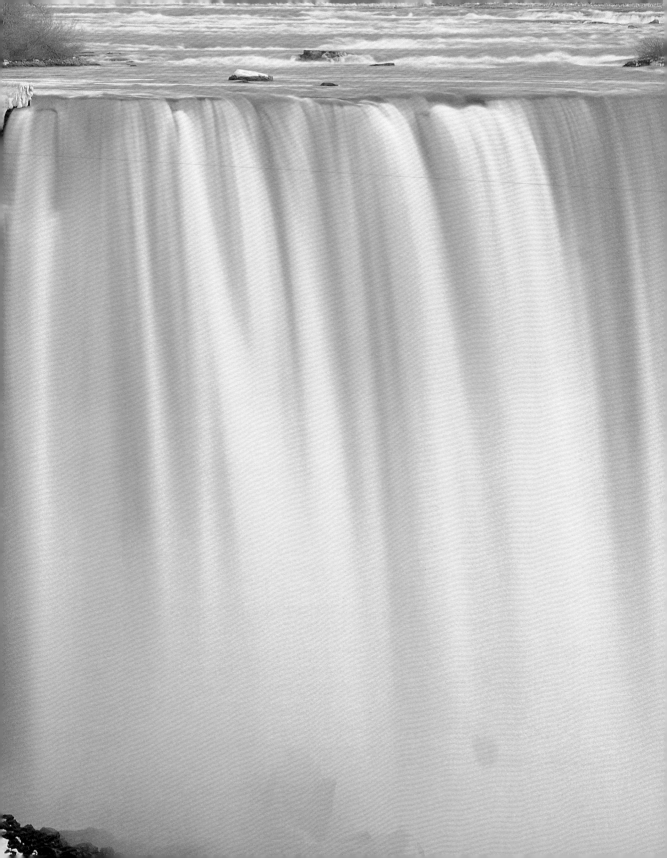

Niagara Falls (continued)

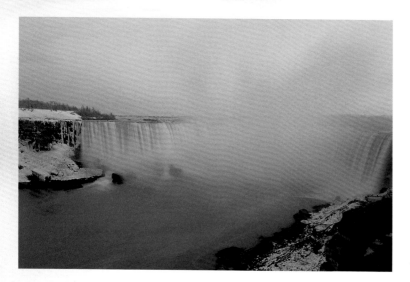

There are enough tourist attractions around Niagara Falls to keep visitors on either side of the border busy for a week. We will leave the wax museums and souvenir shops to another guide, and focus instead on exploration of the more natural aspects of Niagara. For obvious safety reasons, you are not able to wander around the base of the falls.

The best place to explore the area on foot is at the less crowded, yet no less interesting Niagara Glen. Visitors can access the Glen at Wintergreen Flats, on the Niagara River Parkway, a few kilometers north of the Whirlpool and Spanish Aero Car. From the air, the Glen forms a well-forested bulge along the Canadian shore of the river. Park your car and walk down the 80-step staircase at the edge of the gorge. You can wander around here for hours. An excellent network of rocky paths lead past enormous dolostone blocks and wide potholes, and then onto the edge of the river, where the water speeds by at close to 40 kilometers per hour (25 mph).

Niagara Falls is not the biggest waterfall in the world. Angel Falls in Venezuela is the highest, with an incredible drop of 979 meters (3,212 ft.)! The waterfall with the largest discharge is either Boyoma Falls (formerly Stanley Falls) in the Congo, with a discharge up to 17,000 cubic meters (600,000 cu. ft.) per second during floods; or Khone Falls in Laos, which is reported to have an average discharge of 11,610 cubic meters (410,000 cu. ft.) per second. Still, even after comparing the numbers, there is no other major waterfall in the world that is as easily accessed, as well studied and as well known as Niagara.

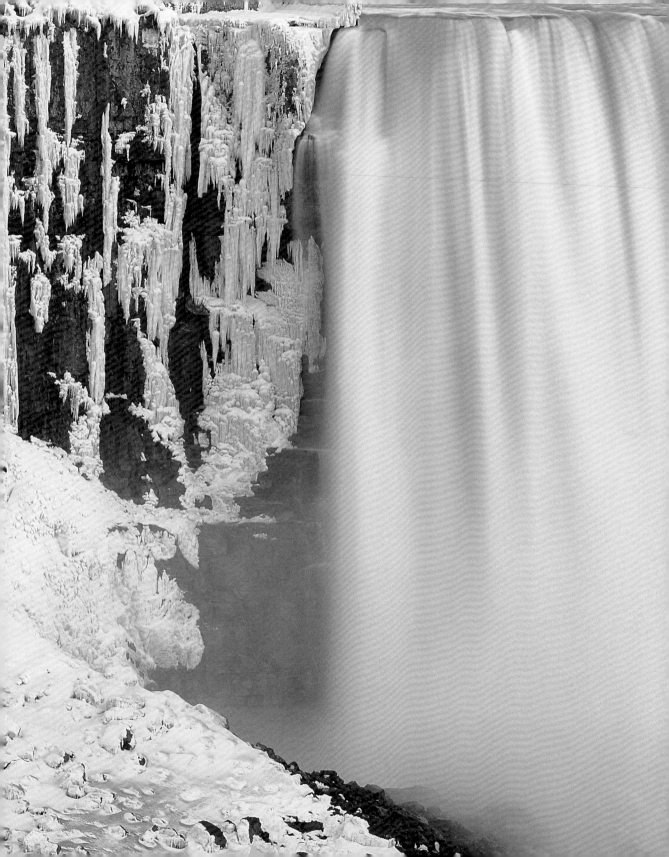

Rockway Falls

🚗 **Exit the QEW at Victoria Ave. and go south through Vineland. Go past the road to Balls Falls, but turn left on the second side road (8th Ave.). Follow this road for about 5.7 km (3.5 mi.) to the tiny community of Rockway. Park in the gravel parking lot at the little community center on the left side of the road, immediately after crossing Fifteen Mile Creek. Exercise caution when exploring this site as there are few fences or guardrails. Another small waterfall (Martins Falls) is located on a small creek crossing the escarpment just past the east end of the parking lot.**

COUNTY: Niagara	
NEAREST SETTLEMENT: Rockway	
RIVER: Fifteen Mile Creek	
CLASS: Ramp	
TRAIL CONDITIONS: Moderate	
ACTIVITY: Moderate	
SIZE: Medium	
RATING: Outstanding	
NTS MAP SHEET: 30 M/3	
UTM COORDINATES: 17T, 636420, 4774521	
WALKING TIME: 1 minute	

Rockway Falls is a surprisingly rewarding waterfall, one of the most underrated in the Golden Horseshoe region. Yet even many locals are unaware of this gem. While the gorge is at least as deep as that of nearby Balls Falls, the waterfall itself is admittedly less spectacular. Rockway Falls is a ramp waterfall, and thus the waters of Fifteen Mile Creek never really leave the rock face during the descent. Nevertheless, stream flows during spring snow melt events are powerful enough to have moved two old vans abandoned at the base of the waterfall several hundred meters downstream.

In addition to the main falls, there is an upper falls and a lower falls, each about 2 to 3 meters (7 to 10 ft.) in height. The upper waterfall is on private property, but can be viewed from the bridge. The lower is 100 meters (325 ft.) downstream of the main falls, and forms a low, but convincing plunge waterfall where the river crosses a layer of resistant Irondequoit limestone.

The base of the falls may be accessed by a trail that leads behind the community center. The trail follows along the east edge of the gorge, but then splits into two. The left branch terminates at an interesting narrow rock outcrop further along the edge of the gorge. The right branch leads temporarily away from Fifteen Mile Creek, and follows a more gentle course down the escarpment edge. The trail then cuts back toward the creek, and by walking upstream along the water's edge (during lower flows), you can reach the base of the falls.

At the falls, an impressive ledge of Lockport dolostone overhangs the gorge by at least 20 meters (65 ft.) along the west wall. Beneath the dolostone the gorge wall is composed of Rochester shale, which is much less resistant to erosion than the overhanging dolostone. This is all relative, of course – a study at Brock University estimated that the rock face of the shale erodes by just a few millimeters per year.

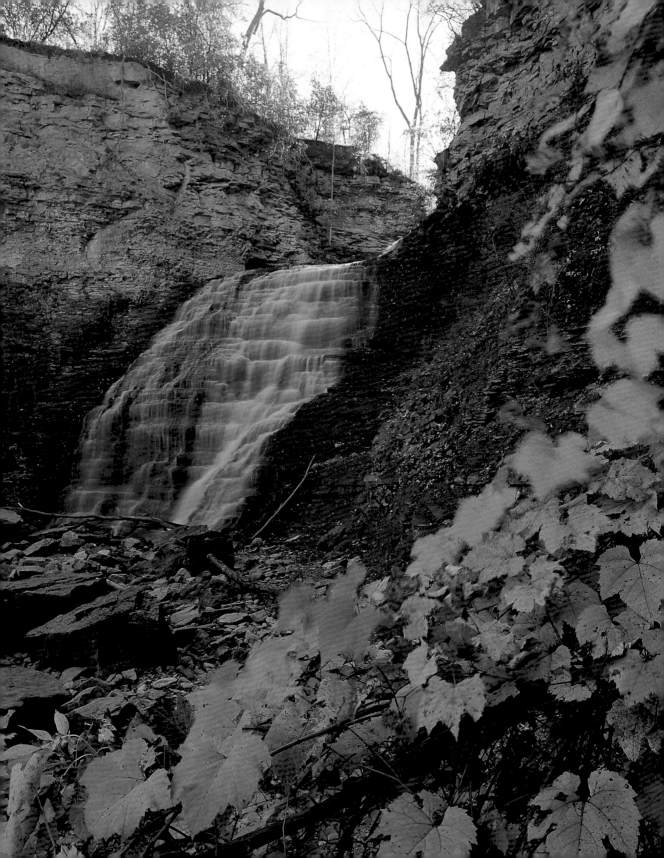

Sherman Falls

🚗 Exit Hwy. 403 in Hamilton at Mohawk Rd., and go west. Follow this road (which turns into Rosseaux St.) to the end and turn right onto Wilson St. Turn left at the next street, which is Montgomery Dr., and then turn right on Old Dundas Rd. Follow the road to the next intersection and find a place to park. Two short trails lead off into the woods on the left toward the waterfall. This waterfall is located on private property, but access is granted due to the presence of the Bruce Trail. If you continue west along Lions Club Rd. for about 1 km (0.6 mi.) you will cross a little creek, on which tiny Canterbury Falls may be found (with some effort) to the south.

COUNTY:	Hamilton
NEAREST SETTLEMENT:	Dundas
RIVER:	Ancaster Creek
CLASS:	Ramp
TRAIL CONDITIONS:	Moderate
ACTIVITY:	Moderate
SIZE:	Medium
RATING:	Average
NTS MAP SHEET:	30 M/4
UTM COORDINATES:	17T, 583354, 4787861
WALKING TIME:	3 minutes

Sherman Falls is a simple waterfall with an almost symmetrical appearance. Some argue that its simplicity makes it a little boring, but nonetheless this is one of the few waterfalls that invites you to reach out and touch it.

Unlike at many other sites, visitors can follow the established walking trail right to the base of the falls with few safety concerns. A nice little wooden footbridge crosses the creek about 50 meters (165 ft.) downstream, and provides a great place to survey the small forested valley. At the waterfall, water slides over bedrock at an angle of about 80 degrees, dropping a total of 12 meters (40 ft.) in height. Its descent is temporarily interrupted by a prominent, more resistant formation of limestone. This is Irondequoit limestone, which in the Niagara Peninsula forms the lower of two falls on many creeks (see Balls Falls, page 109, and DeCew Falls, page 123).

Like many of the waterfalls along the Niagara Escarpment, Sherman Falls is located along the Bruce Trail. This well-known footpath winds 800 km (500 mi.) through mid-western Ontario, and is free for all to enjoy. There are hundreds of access points: just find a road crossing and a place to park your car, and away you go!

Established in 1963, The Bruce Trail Association publishes a trail guide each year, with detailed color maps and documentation explaining the many points of natural and human history found along the route. They also maintain a website at www.brucetrail.org. Additional information about the trail can be obtained from the Niagara Escarpment Commission's website at www.escarpment.org.

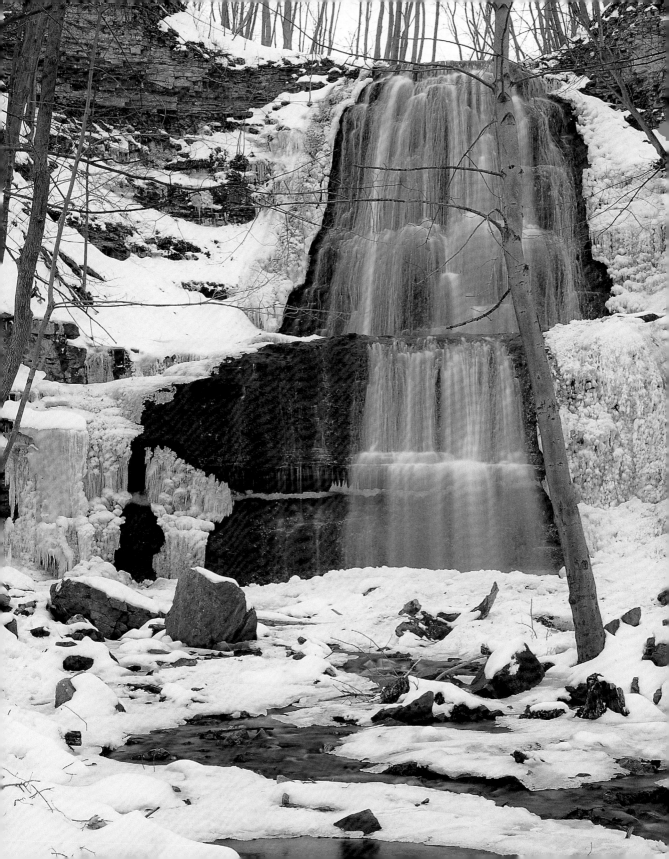

Swayze Falls

🚗 **Follow the directions to DeCew Falls (page 122), but continue west along DeCew Rd. Follow the road around the bend to the right, and then turn left at Pelham Rd. (Niagara Rd. 69). Follow Pelham Rd. for 2.2 km (1.4 mi.) and turn left onto Effing-ham Rd. Follow this road for 2.9 km (1.8 mi.) and turn left onto Roland Rd. The parking lot is located on the north side of Roland Rd., 0.8 km (0.5 mi.) east of Effingham Rd.**

COUNTY: Niagara	
NEAREST SETTLEMENT: St. John's	
RIVER: Twelve Mile Creek	
CLASS: Ramp	
TRAIL CONDITIONS: Wheelchair accessible	
ACTIVITY: Quiet	
SIZE: Small	
RATING: Good	
NTS MAP SHEET: 30 M/3	
UTM COORDINATES: 17T, 638093, 4772537	
WALKING TIME: 10 minutes	

Not powerful, and often dry, this waterfall still forms the focal point of a pleasant walk in the Short Hills Provincial Park. Also known as "Dry Falls," Swayze Falls is located midway along the Paleozoic Path, which is a wheelchair-accessible gravel trail leading from the small parking lot on Roland Road. The round trip is about 800 meters (0.5 mi.) and is marked by 13 different points of interest along the way. Since the watershed feeding this waterfall is quite small, the best time to view the falls is in the spring, when soils are still saturated by recently melted snow. And though the waterfall usually lives up to its alternate name the rest of the year, the area is interesting to visit at any time. This includes

winter, when the site is used for ice climbing when conditions are right.

The viewing platform on the side of the gorge gives an excellent view of the falls. However, an interesting area to explore is around the crest of the falls. Walk west from the platform to the short dirt path that leads right to the waterfall. The gorge walls are surprisingly high and nearly vertical, so proceed with caution. A large "erratic" boulder sits in the middle of Swayze Creek, near the crest of the falls. This term describes a rock that is unlike the surrounding bedrock. A close look at the boulder reveals that it is a metamorphic rock, formed of parallel bands of mineral crystals. Glaciers carried this rock from somewhere on the Canadian Shield, hundreds of kilometers to the north.

Swayze Falls is but one of the waterfalls in Short Hills Provincial Park. Terrace Creek Falls, on the east side of the park, is the next largest and is marked on some maps. Perhaps a dozen other tiny falls are scattered around the park awaiting discovery. Most of them are dry for much of the year, however.

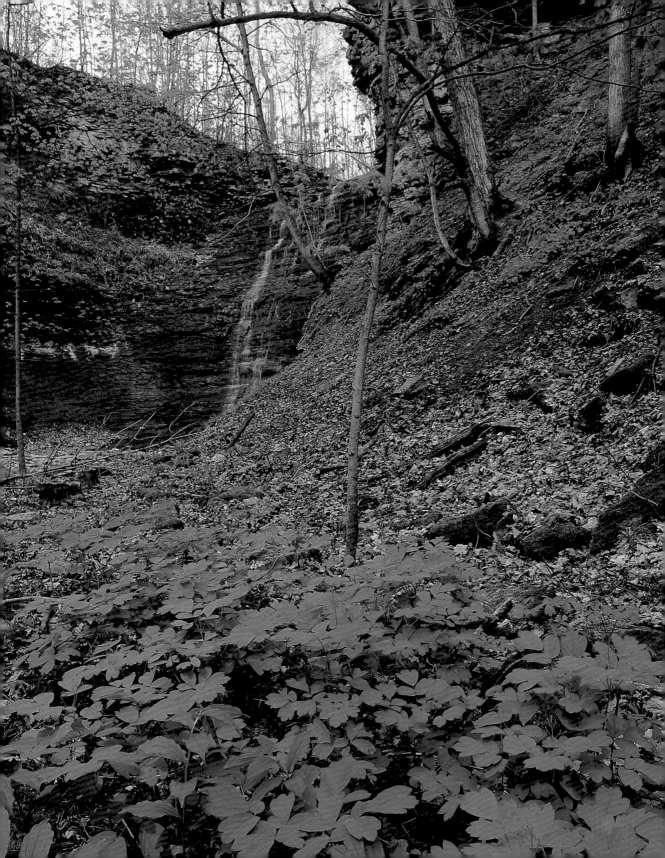

Tews Falls

🚗 **To reach Tews Falls, follow the directions to Websters Falls (page 158), but instead of turning on Short Rd., continue east on Harvest Rd. for another 0.6 km (0.4 mi.). Park in the lot and please pay the small parking fee. A short trail leads to two visitors' platforms. Access to the lower gorge is very difficult.**

COUNTY: Hamilton	
NEAREST SETTLEMENT: Greensville	
RIVER: Logie's Creek	
CLASS: Plunge	
TRAIL CONDITIONS: Easy	
ACTIVITY: Busy	
SIZE: Large	
RATING: Mediocre	
NTS MAP SHEET: 30 M/5	
UTM COORDINATES: 17T, 582889, 4792502	
WALKING TIME: 3 minutes	

At 42 meters (138 ft.), Tews Falls has the distinction of being the highest waterfall in all of southern Ontario except, of course, for Niagara. Logie's Creek, however, is one of the smallest to feed the waterfalls listed in this collection. Its watershed is 9 square kilometers (3.5 sq. mi.) and, thus, even under wet conditions, the waterfall is at most graceful if never thundering. How, then, could this waterfall have formed such an impressive, deep gorge?

Geomorphologists believe that many thousands of years ago much more water flowed over the falls. The tremendous erosive energy needed to carve the gorge most likely came from glacial meltwater blasting over the falls some 10,000 to 12,000 years ago. As the 2-kilometer (1.2 mi.) thick ice sheet melted, enormous quantities of water were available to carry out catastrophic feats of erosion. Some researchers even believe that prehistoric Tews Falls may have rivaled Niagara, if for only a brief period.

Tews Falls is located only about a 15-minute walk from Websters Falls. The hike between the two is well worth the trip, and will save you from having to pay a second parking fee. The trail along the edge of the Niagara Escarpment is recommended, and gives spectacular views of the Spencer Gorge. This is some of the best scenery in the Golden Horseshoe region.

Access to the bottom of the falls takes some effort, but may be achieved by following the trail from the bottom of Websters Falls downstream to the confluence with Logie's Creek. From here, you can walk upstream along Logie's Creek to the base of Tews Falls. Along the way you will pass Lower Tews Falls, which is a very small plunge waterfall about 2 meters (7 ft.) in height, formed on an outcrop of Whirlpool sandstone.

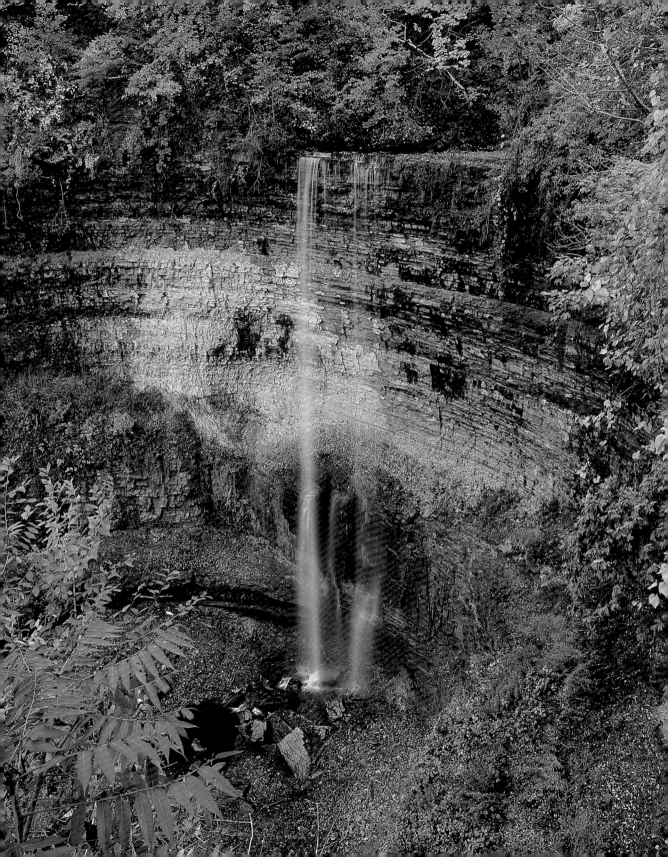

Thirty Road Falls

🚗 Exit the QEW at Bartlett Rd. and go south. The road bends to the right to become Park Rd. before climbing the Niagara Escarpment. Continue south to Ridge Rd., and turn left. Follow Ridge Rd. to Thirty Rd., and turn left. Partway down the hill, look for the tiny sandy parking area on the left side of the road. There is only room for one or two small cars. The Bruce Trail leads from here to the creek, less than a five-minute walk away. To our knowledge, there are no other waterfalls between Thirty Road Falls and Balls Falls to the east, save for one tiny trickle less than 1 m (3 ft.) high at Aberdeen Rd. and Hillside Dr.

COUNTY:	Niagara
NEAREST SETTLEMENT:	Beamsville
RIVER:	Thirty Mile Creek
CLASS:	Cascade
TRAIL CONDITIONS:	Moderate
ACTIVITY:	Quiet
SIZE:	Small
RATING:	Mediocre
NTS MAP SHEET:	30 M/4
UTM COORDINATES:	17T, 620852, 4780535
WALKING TIME:	5 minutes

Of the waterfalls in the Niagara Peninsula that are included in this collection, Thirty Road Falls is one of the smallest. The site is actually broken into several smaller waterfalls, none of which are overly beautiful, but the overall scene is pretty in autumn, and is rarely visited by anyone else.

Jacob Beam built a sawmill and later a gristmill at the falls in 1790. Soon after, however, as the land upstream of the falls was cleared for farming, the stream flow in the little creek became unreliable. As is common across much of southern Ontario, the removal of forest cover and the draining of swamps greatly reduced the natural water holding capacity of the landscape. An unreliable stream flow was a hindrance that no mill could afford, and milling operations did not flourish here.

Since the watershed (the area of land from which the stream obtains its water) feeding Thirty Mile Creek is barely 9 square kilometers (3.5 sq. mi.), the creek never builds the powerful flows seen at some of the larger creeks nearby. For comparison, the watershed for Fifteen Mile Creek upstream of

Rockway is about 56 square kilometers (21 sq. mi). If each of these watersheds received 2.5 centimeters (1 in.) of rain, Thirty Mile Creek might receive 225 million liters (60 million U.S. gallons) of water, whereas Fifteen Mile Creek might receive 1.4 billion liters (370 million U.S. gallons) of water. Granted, a good portion (greater than 50 percent) of that water would evaporate, be used by plants or infiltrate into the soil to become groundwater, but the remainder is allowed to "run off" over the landscape to become stream flow. It is the job of the professional hydrologist to understand the "water budget" of a watershed, and determine the ecological and socioeconomic impacts of human changes to the water budget. If only Jacob Beam could have hired a hydrologist!

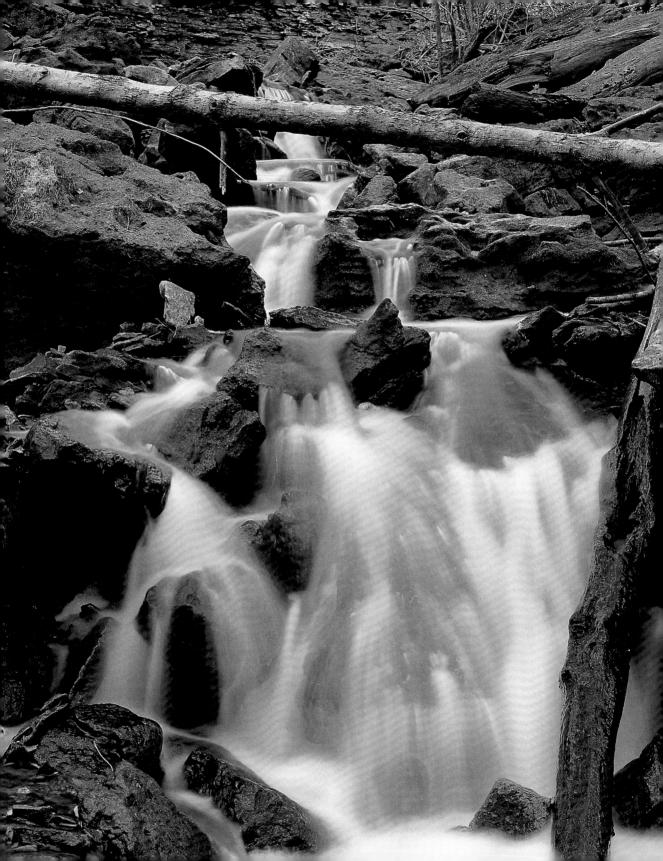

Tiffany Falls

🚗 Take Hwy. 403 west to the Mohawk Rd. exit and go west. Follow Mohawk Rd. (which becomes Rosseaux St.) and turn right on to Wilson St. E. Follow this street and turn off into the little car park on the right side of the road at the Tiffany Falls Conservation Area. A rocky trail leads up the steep wooded valley to the waterfall. The walk is less than 10 minutes, but is fairly strenuous, so be sure to wear solid footwear. If you are careful, you can climb up the left side of the waterfall gorge to the crest of the waterfall. Washboard Falls (see page 154) is just 100 m (330 ft.) further upstream.

COUNTY:	Hamilton
NEAREST SETTLEMENT:	Dundas
RIVER:	Tiffany Creek
CLASS:	Cascade (Steep)
TRAIL CONDITIONS:	Difficult
ACTIVITY:	Quiet
SIZE:	Medium
RATING:	Good
NTS MAP SHEET:	30 M/4
UTM COORDINATES:	17T, 584581, 4787870
WALKING TIME:	7 minutes

A nice waterfall situated in the greater Hamilton urban area, the rocky, somewhat treacherous main trail to this waterfall minimizes the number of visitors as compared to other nearby falls. Most people should be able to make the hike, provided that they are careful.

Tiffany Creek does not drain a large watershed, so stream flows over the falls can be quite low during summer and fall. But even when flows are low, this is a pretty waterfall. Water trickles over the rock in the upper portion of the falls, and then drops freely for the lower 8 meters (26 ft.). Green mosses that sometimes carpet the rock beside the falls during summer give the site an almost tropical appearance.

Winter ice climbing is practiced at Tiffany Falls, but you must have all the appropriate gear and secure a permit from the Hamilton Region Conservation Authority. Even if you aren't enthusiastic about climbing a frozen wall of ice during freezing temperatures, a trip to Tiffany Falls in winter can be just as interesting as in summer. In addition to the creek, which freezes against the face of the waterfall, frozen columns of ice appear along the gorge walls to either side of the falls. Unlike the icicles on your roof, these columns suddenly appear midway up the rock wall. The source of the icicles is, of course, groundwater. Groundwater seeps through fractures in the bedrock all year, since the freezing air temperatures do not penetrate past the upper few meters of bedrock. When water flowing through one of the fractures meets the rock face, it freezes on contact with the cold air.

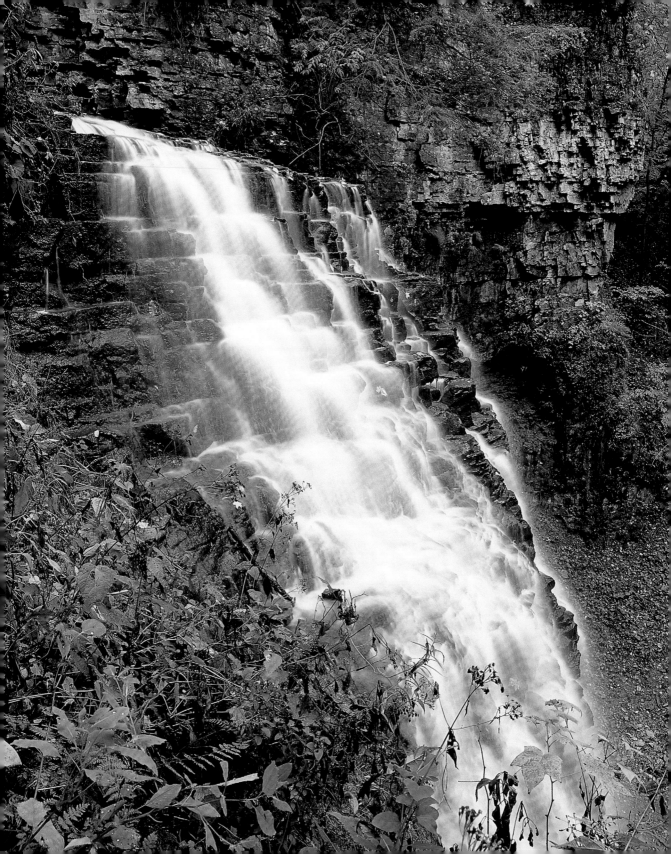

Washboard Falls

🚗 **Take Hwy. 403 west to the Mohawk Rd. exit and go west. Follow Mohawk Rd. (which becomes Rosseaux St.) and turn right on to Wilson St. E. Follow this road for 800 m (0.5 mi.) and turn right onto Montgomery Dr. Follow this residential road to the very end (keep left). Walk through the break in the fence and follow the trail toward the woods. About 50 m (165 ft.) along the trail there is a small path on the left leading downslope beside an old wire fence. The falls are only a minute's walk along this path. Washboard Falls can also be accessed from the base of Tiffany Falls by scrambling up the gorge to the left of the falls. The climb should only be attempted if you are physically fit. As always, be careful!**

COUNTY:	Hamilton
NEAREST SETTLEMENT:	Dundas
RIVER:	Tiffany Creek
CLASS:	Ramp
TRAIL CONDITIONS:	Moderate
ACTIVITY:	Quiet
SIZE:	Small
RATING:	Average
NTS MAP SHEET:	30 M/4
UTM COORDINATES:	17T, 584594, 4787808
WALKING TIME:	3 minutes

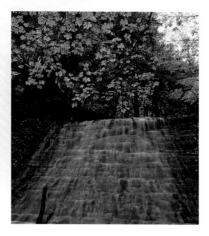

Located immediately upstream of Tiffany Falls, this spot is sometimes referred to simply as "Upper Tiffany Falls." While clearly much smaller, the unique shape of Washboard Falls makes it worthy of its own name.

Tiffany Creek slides over a steeply inclined "washboard" formed of dozens of thin dolostone layers. Unlike plunge waterfalls, or even many of the other nearby ramp-type waterfalls like Sherman Falls or Albion Falls, there is no single resistant layer of rock to dominate the profile of this waterfall. Since each of the thin rock layers is equally resistant to erosion, the waterfall takes on the relatively rare ramp form as water spills over the waterfall face without ever losing contact with the rock.

Immediately downstream of the falls along the right bank of the creek is an impressive 6-meter (20 ft.) high sheer dolostone rock face. Curiously, however, the rock wall is absent on the left bank of the river.

This is a beautiful waterfall to visit at any time of the year. The abundance of eastern hemlock, cedar, and other coniferous trees at this site keep things green even during the middle of winter. While at Washboard Falls, however, remember that you are only about 100 meters (325 ft.) upstream from the sheer 20-meter (65 ft.) drop at Tiffany Falls. Children should be supervised at all times.

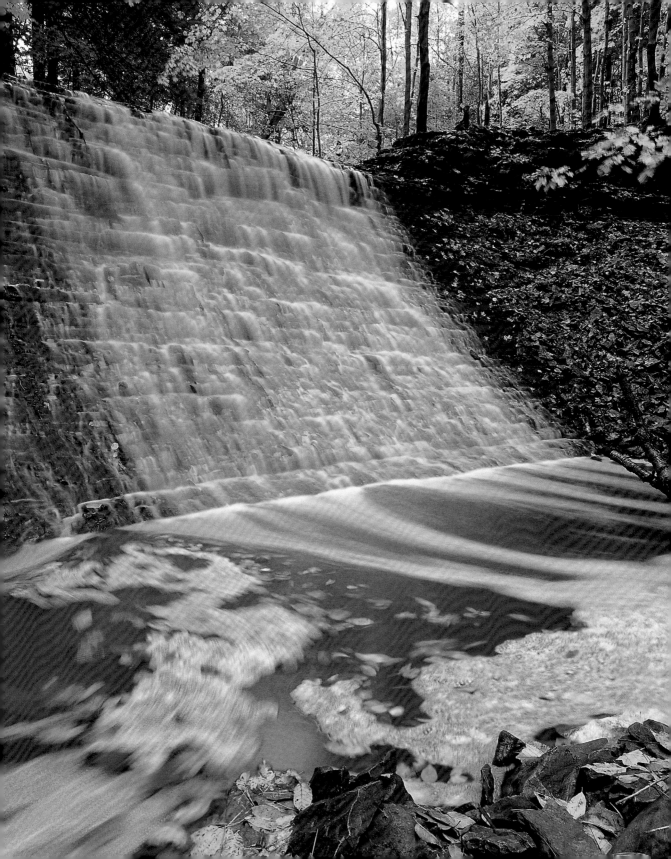

Waterdown Falls

🚗 From the QEW, continue west along Hwy. 403 to Hwy. 6. Take Hwy. 6 north up the big hill over the Niagara Escarpment and turn right at Hamilton Rd. 5 (Dundas St.). Drive 3.2 km (2 mi.) along this road to Mill St., and turn right. Follow Mill St. down the hill, and soon after the road bends to the left look for the small parking lot on the right side of the road. The falls are behind the wooden viewing platform and the trail downstream leads away from the platform.

COUNTY: Hamilton	
NEAREST SETTLEMENT: Waterdown	
RIVER: Grindstone Creek	
CLASS: Plunge	
TRAIL CONDITIONS: Wheelchair accessible	
ACTIVITY: Moderate	
SIZE: Medium	
RATING: Good	
NTS MAP SHEET: 30 M/5	
UTM COORDINATES: 17T, 590210, 4798118	
WALKING TIME: 1 minute	

Of all the waterfall sites in the greater Hamilton area, Waterdown Falls and the Grindstone Creek valley may be the most pleasant. The site is quite undisturbed, save for an excellent viewing platform. Signs explain the interesting history of this location.

Alexander Brown built a sawmill beside these falls in 1805, spurring settlement at nearby Waterdown. By the turn of the century, power from Grindstone Creek was used to run several mills and foundries. Some operations were also steam-powered, and as the valley became thick with industrial smoke, the area was nicknamed "Smokey Hollow." Mill production ceased by about 1912, and signs of this bygone era have now all but disappeared.

The falls are perhaps 7 to 8 meters (23 to 26 ft.) high, the width depending on the discharge of the creek. Several thin strata of Whirlpool sandstone have been undercut by the much weaker Queenston shale. Undercutting is significant enough that younger visitors have worn a weak footpath into the red shales behind the water jet, but not enough to allow adults to walk behind the falls, however. Larger visitors who try this path should expect to get very wet and very muddy! Large sandstone slabs litter the floor of the gorge at the base of the falls (unfortunately, sandstone isn't the only litter to be found at this site).

After you've had your fill of the falls, don't miss the excellent walk down the forested valley of Grindstone Creek. The Bruce Trail follows the fast-moving brook downstream before heading west across a footbridge to parallel the base of the Niagara Escarpment. Depending on the season, you may see a few small tributaries pouring over the west side of the valley, although none of them form waterfalls of any significance.

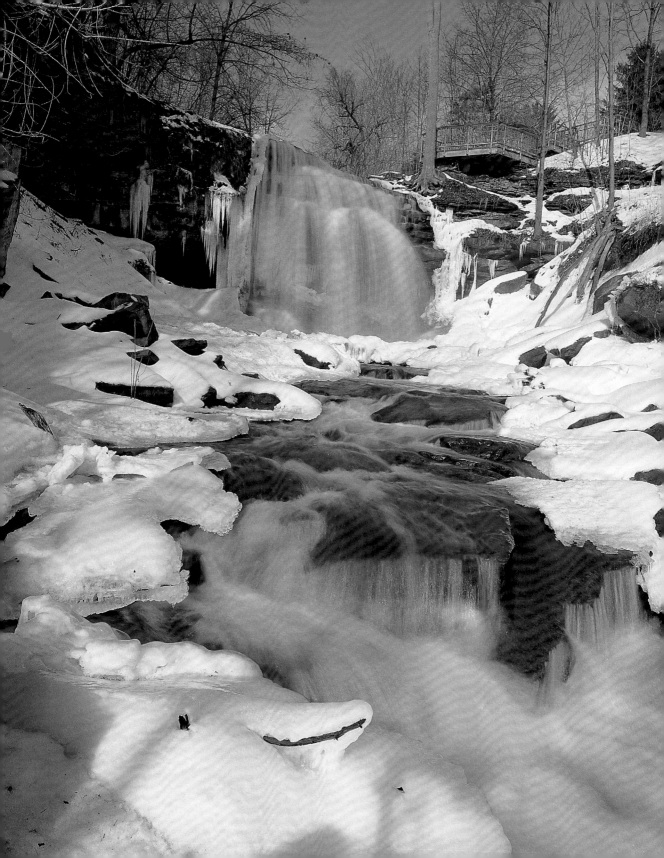

Websters Falls

🚗 Follow Hwy. 403 to Hwy. 6 and exit north. Follow the highway as it climbs up the Niagara Escarpment, and turn left onto Hwy. 5. Drive for 7.2 km (4.5 mi.) to Brock Rd. and turn left. Turn left again at Harvest Rd. and then right at Short Rd. Follow this road to the conservation area parking lot. Walk to the fence at the west end of the parking lot, follow the path down the hill and cross over the stone footbridge. An excellent viewing area beside the falls contains signs that explain the physical and human aspects of the landscape. A staircase beside the viewing area leads to the base of the falls.

COUNTY:	Hamilton
NEAREST SETTLEMENT:	Greensville
RIVER:	Spencer Creek
CLASS:	Plunge
TRAIL CONDITIONS:	Wheelchair accessible
ACTIVITY:	Very busy
SIZE:	Large
RATING:	Good
NTS MAP SHEET:	30 M/5
UTM COORDINATES:	17T, 582692, 4792000
WALKING TIME:	5 minutes

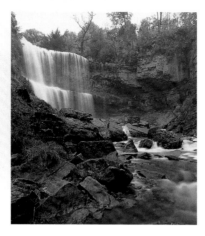

This is the most visited and best known waterfall in the Hamilton area. Sunny summer afternoons attract hundreds of people to the area. The Spencer Gorge Wilderness Area has long been a venue for family picnics, church gatherings and day-trippers.

Websters Falls is the centerpiece of this park. At 22 meters (72 ft.) it isn't as high as nearby Tews Falls, but always has a much greater discharge, helped by the Christie Reservoir just upstream. A splendid panoramic view of the site can be had from the stone wall near the parking lot, but for a better view of the falls, walk down the 120-odd steps to the bottom of the gorge. The size and rugged beauty of the waterfall are best enjoyed from here.

On your way down, watch for Little Websters Falls on the right. Although about 10 meters (33 ft.) high, due to its small watershed – about 2 square kilometers (0.75 sq. mi.) – it only flows during the wettest seasons. A trail along the right bank of the river continues south for over a kilometer to King Street.

The cap rock of the waterfall is Lockport dolostone, a strong rock formation found at the crest of many falls in the Niagara-Hamilton area. The lower 12 meters (40 ft.) of the waterfall face are a variety of Silurian aged sandstones, shales and limestones. Away from the falls, the lower portions of the gorge walls are buried by fallen rock – huge blocks fallen from the resistant dolostone, and smaller pieces from the weaker shale formations.

The waterfall is named after Joseph Webster, who bought property around the falls in 1819. Numerous industries sprang up near the falls, including a short-lived power station that supplied electricity to the town of Dundas.

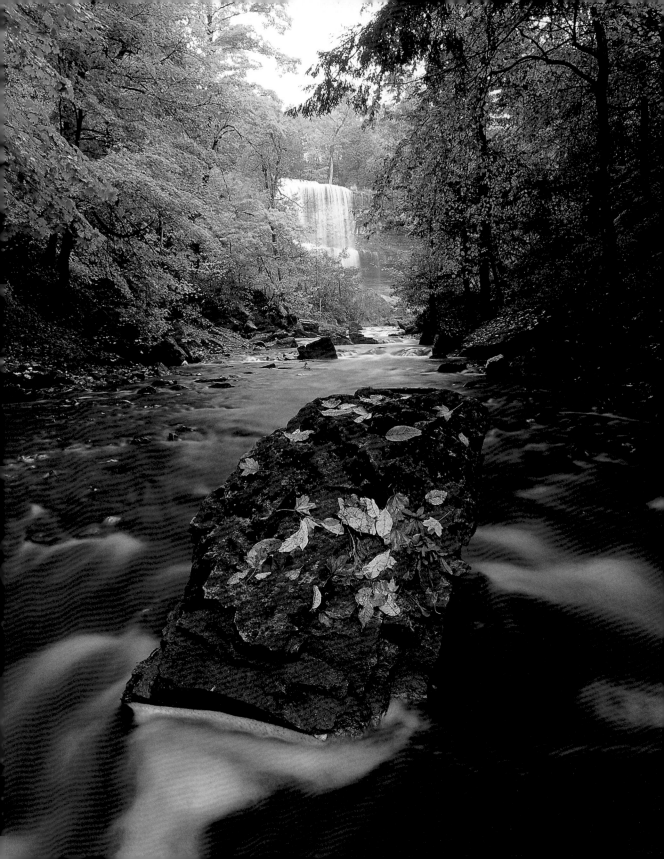

LAKE HURON

FOR LARGE, CLASSIC PLUNGE WATERFALLS in a relatively tranquil setting, look no further than the Lake Huron region. While one of the smallest regions in terms of the number of falls, it nevertheless boasts some of the prettiest waterfalls in the province. Most of the sites are found along the Niagara Escarpment, with a good number clustered near the town of Owen Sound.

The region's road network is excellent, but most towns are small and provide only basic services for travelers. Owen Sound is the largest town and offers all required services.

It is recommended that you avoid some of the more remote waterfalls in winter, since the back roads can become difficult for light cars traveling after poor weather.

Recommended tour

Take advantage of the high concentration of waterfalls around Owen Sound. Visit Inglis, Jones, Indian and then Keefer Falls. If time permits, drive south to Hoggs Falls and Eugenia Falls, which are only a five-minute drive apart.

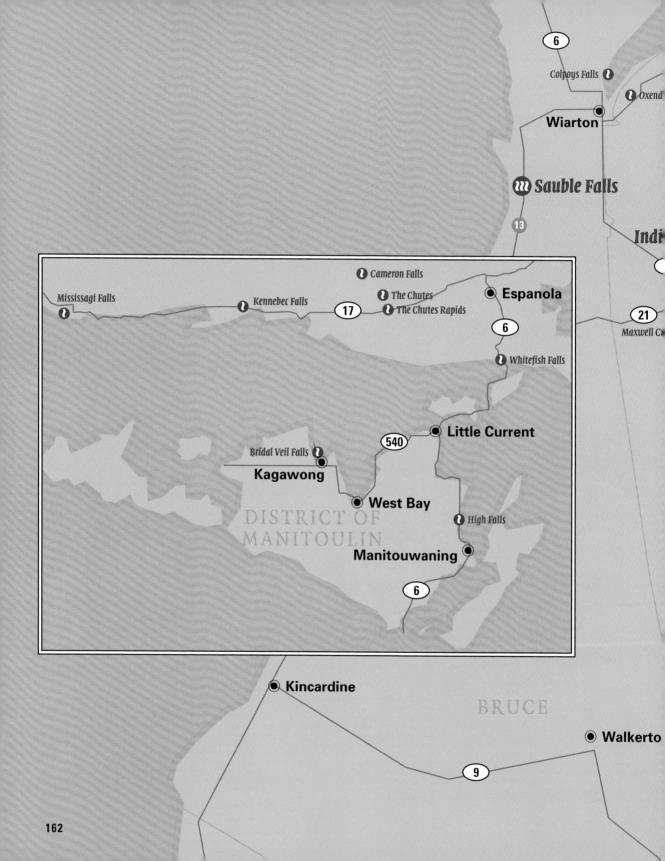

6

Colpoys Falls ♆

♆ Oxend

Wiarton

♒ **Sauble Falls**

Indi

13

♆ Cameron Falls

♆ The Chutes

● **Espanola**

Mississagi Falls Kennebec Falls ♆ The Chutes Rapids

♆ 17

21

6

Maxwell C

♆ Whitefish Falls

● **Little Current**

540

Bridal Veil Falls ♆

Kagawong

● **West Bay**

DISTRICT OF
MANITOULIN ♆ High Falls

● **Manitouwaning**

6

● **Kincardine**

BRUCE

● **Walkerto**

9

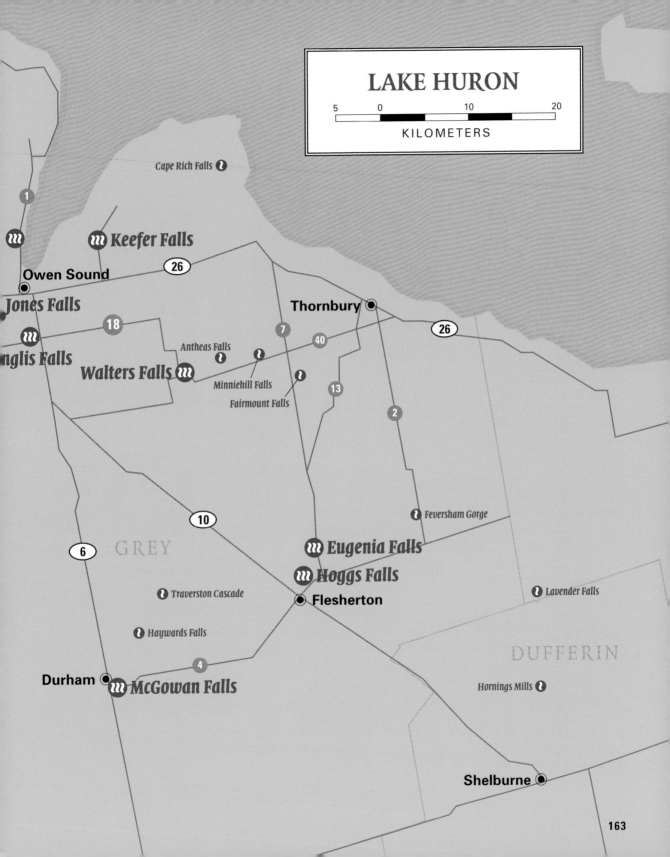

LAKE HURON

KILOMETERS

5 0 10 20

Cape Rich Falls

1

Keefer Falls

26

Owen Sound

Jones Falls

Thornbury

18

7

26

Antheas Falls

40

Minniehill Falls

Walters Falls

Fairmount Falls

13

nglis Falls

2

Feversham Gorge

10

Eugenia Falls

GREY

Hoggs Falls

6

Lavender Falls

Traverston Cascade

Flesherton

Haywards Falls

DUFFERIN

4

Durham

Hornings Mills

McGowan Falls

Shelburne

Eugenia Falls

🚗 From Owen Sound, go south on Hwy. 6 and turn left onto Hwy. 10 at Chatsworth. Proceed southwest on Hwy. 10 for about 36 km (22 mi.) and then turn left onto Grey Rd. 4 at Flesherton. Follow the road for 3.6 km (2.2 mi.) and turn left on Grey Rd. 13. Follow this road north to the village of Eugenia, and watch for the signs. The waterfall is to the left at the end of Pellisier St. It is quite possible that there are dozens of other, much smaller waterfalls along the edges of the Beaver Valley. Very few of the creeks crossing the escarpment extend onto the tablelands above, however, and many of the likely sites are on private property. One such waterfall is Fairmount Falls, which, unfortunately, is just barely visible from the road.

COUNTY:	Grey
NEAREST SETTLEMENT:	Eugenia
RIVER:	Beaver River
CLASS:	Plunge
TRAIL CONDITIONS:	Wheelchair accessible
ACTIVITY:	Moderate
SIZE:	Large
RATING:	Average
NTS MAP SHEET:	41 A/7
UTM COORDINATES:	17T, 537754, 4906775
WALKING TIME:	5 minutes

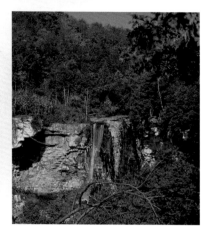

One of the highlights of the scenic Beaver Valley area, Eugenia Falls is arguably one of the most beautiful waterfalls in Ontario. The development of a small, passive park at the site has not ruined the stunning natural setting of this waterfall. Vertical dolostone cliffs at least 15 meters (50 ft.) high frame the falls within a beautiful forested valley. From behind a stone safety wall, you can watch the water plunge 25 meters (80 ft.) vertically over the dolostone crest of the falls into an impressive gorge below.

For a more complete view of the waterfall, walk along the stone wall to a point about 150 meters (500 ft.) downstream where there is a break in the woods. From here you can photograph this absolute jewel of a falls, with no evidence of human development. You can continue to walk along the trail for quite a ways, but be careful. The stone wall ends after a few hundred meters. Beyond this, the trail runs along the edge of the gorge, just inches from a 30-meter (100 ft.) vertical drop!

Eugenia Falls was named by early surveyors in honor of Empress Eugénie, wife of Napoleon III and friend of Queen Victoria. Perhaps a more suitable name would have been "Pyrite Falls." When the waterfall was discovered by settlers, a glint of gold was noted in the rocks of the gorge. After some initial excitement, it was soon determined to be the mineral pyrite, more popularly known as "fool's gold."

Like many of the larger waterfalls in Ontario, the natural flow over Eugenia Falls has been reduced by the development of hydroelectric power. Fortunately, at Eugenia the generating station was built about 3 kilometers (2 mi.) to the north in order to utilize the greater drop in elevation found there. As a result, other than the stone safety walls, this jewel of a waterfall remains relatively unspoiled, beautifully placed within a white cedar grove.

Hoggs Falls

🚗 From Owen Sound, go south on Hwy. 6 and turn left onto Hwy. 10 at Chatsworth. Proceed southwest on Hwy. 10 for about 36 km (22 mi.) and then turn left onto Grey Rd. 4 at Flesherton. Follow the road for 1.6 km (1 mi.) and turn left on East Back Line. Turn right onto Lower Valley Rd. After 0.8 km (0.5 mi.) there are two very small parking areas on the left side of the road, each marked with yellow steel posts. Park at either of these two spots and walk into the forest along the well-marked trail. The river is visible almost immediately, and the falls are just another minute or two along the trail.

COUNTY:	Grey
NEAREST SETTLEMENT:	Flesherton
RIVER:	Boyne River
CLASS:	Plunge
TRAIL CONDITIONS:	Moderate
ACTIVITY:	Quiet
SIZE:	Small
RATING:	Average
NTS MAP SHEET:	41 A/7
UTM COORDINATES:	17T, 536538, 4904036
WALKING TIME:	2 minutes

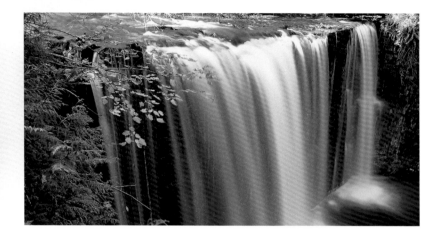

If you visit Eugenia Falls, be sure not to miss Beaver Valley's best kept secret. Hoggs Falls is just a few kilometers from its much more popular neighbor and is well worth the detour. Even the drive to the falls along Lower Valley Road through the cedar forest is enough of a reward to make the trip.

While Hoggs Falls is much smaller than Eugenia Falls, it is located in about as natural a setting as any of the waterfalls in southern Ontario. You can walk right to the crest of the waterfall, and there are no safety walls or signs to distract your view. The only sign of human intervention here is the concrete remains of a dam built during the early years of the 20th century.

Note that there are very few (if any) large dolostone blocks littering the base of this waterfall. Unlike many other waterfalls along the Niagara Escarpment, there is only one major exposed rock formation at Hoggs Falls. For this reason, the upper cap rock of the falls is not significantly undercut, and thus, large blocks do not break off and park themselves for centuries at the base of the falls.

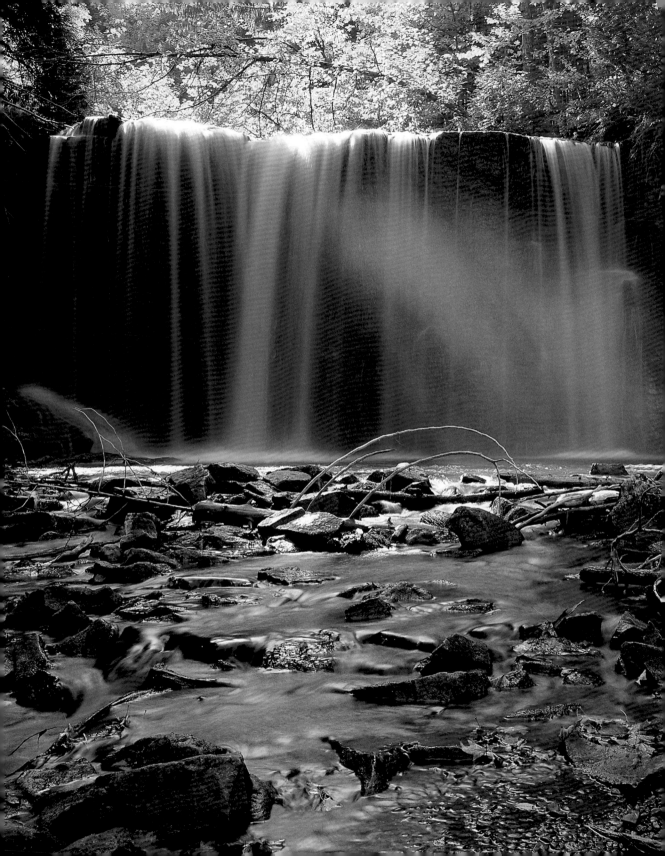

Indian Falls

🚗 **Follow Third Ave. W., north from Owen Sound, and watch for the sign for Indian Falls Conservation Area. Look for the trail that leads beyond the gate at the end of the parking lot, and take note of the nearby plaque that describes the geology of the area. A rocky trail follows the river's edge for the first portion of the journey, but then climbs a wooden staircase and follows the upper edge of the gorge toward the waterfall. Be careful! The trail takes you right to the edge of the waterfall, at which point there is no safety fence.**

COUNTY: Grey

NEAREST SETTLEMENT: Balmy Beach

RIVER: Indian Creek

CLASS: Plunge

TRAIL CONDITIONS: Moderate

ACTIVITY: Quiet

SIZE: Medium

RATING: Good

NTS MAP SHEET: 41 A/10

UTM COORDINATES: 17T, 503636, 4940885

WALKING TIME: 10 minutes

This waterfall typically dries up to a trickle during the summer months. In spring or fall, however, when Indian Creek has a good head of water, it is one of the prettier waterfalls in the province.

This is a true plunge waterfall: water does not contact rock until crashing into the plunge pool some 15 meters (50 ft.) below. Such waterfalls typically form when the hard cap rock forming the edge of the waterfall is underlaid by various softer rocks. This is indeed the case at Indian Falls, where about 6 meters (20 ft.) of gray Manitoulin dolostone lies on top of light gray shales and red sandstones. The gorge also displays the classic "amphitheater" shape common in many of the larger waterfalls along the southern portion of the Niagara Escarpment (see Balls Falls, page 109). It is about 75 meters (250 ft.) wide, and exhibits very steep cliffs.

The 10-minute walk to the waterfall is just long enough to drown out the sounds of civilization, as well as ensure that, more often than not, you will have the falls to yourself. Above the waterfall, a short trail along the left bank of the creek leads out of the white cedar forest and abruptly into a rural setting, complete with sheep grazing in pastures. Here, the lazy, still appearance of Indian Creek is in strong contrast with the chaotic boulder-strewn reaches below the falls. The land around Indian Creek was once part of a Native reserve known as Newash, and later became part of Sarawak township, once one of the smallest townships in Ontario.

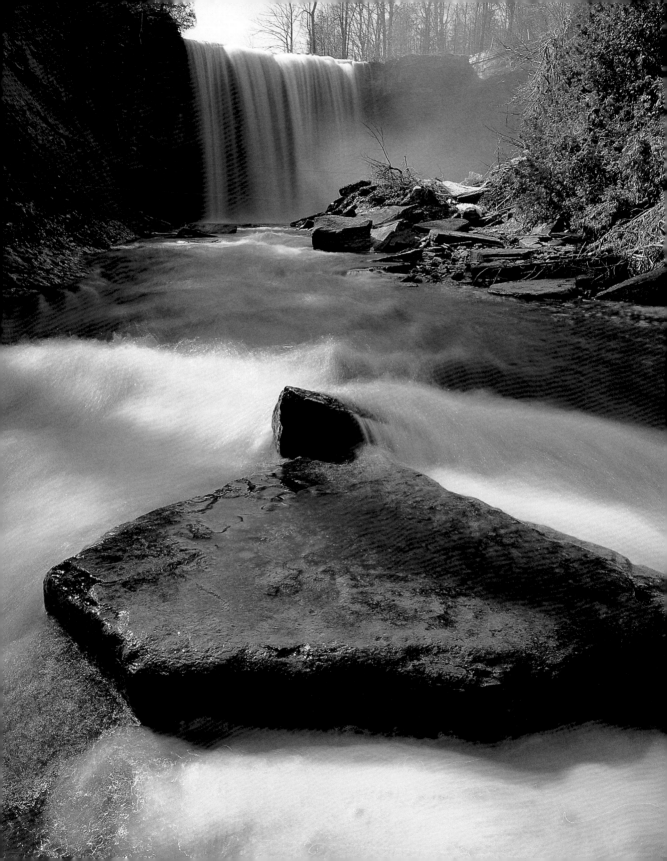

Inglis Falls

🚗 You can find the falls by traveling south from Owen Sound on Hwy. 6/10 and turning right on Grey Rd. 18 at Rockford. Follow this road over the Sydenham River, and then turn right onto Inglis Falls Rd. Follow the signs to the parking lot. This site is well developed and includes ample parking, picnic tables, flower gardens and a small gift shop. The mill, however, burned in 1945 and was not restored.

COUNTY:	Grey
NEAREST SETTLEMENT:	Inglis Falls
RIVER:	Sydenham River
CLASS:	Cascade
TRAIL CONDITIONS:	Wheelchair accessible
ACTIVITY:	Busy
SIZE:	Large
RATING:	Good
NTS MAP SHEET:	41 A/10
UTM COORDINATES:	17T, 505223, 4930345
WALKING TIME:	1 minute

Named after Peter Inglis, a Scottish immigrant who built a sawmill at this site around 1845, Inglis Falls is probably the best known and most visited waterfall in the Lake Huron region. Approximately 18 meters (60 ft.) in height, it is the falls' irregular shape that also makes it one of the most interesting in the area. The river seems to burst from its narrow confines above the falls, expanding into a broad, fan-shaped structure composed of a thousand small rock ledges. Large blocks of limestone up to 5 meters (16 ft.) in size have fallen from upper strata into the gorge below, only to be slowly worn away over centuries by the erosive power of the Sydenham River and its load.

Trails of pavement, soil and rock lead visitors to a large number of safe vantage points from which to view the waterfall. None, however, are as interesting as the "trail" to the river gorge. Following the trail along the left side (looking downstream) of the waterfall, you will pass a wooden lookout platform. About 150 meters (500 ft.) along this poorly marked trail, a short break in the woods exposes Inglis Falls Road. Literally a few steps further along the trail, a narrow "chasm" between two massive limestone blocks provides a natural ramp of earth and stone by which you can gain entry to the river gorge. From this point on, you can carefully explore the gorge by making your own trail amongst the boulders and fallen trees.

A visit to Inglis Falls is rewarding in any season. The relatively large size of the Sydenham River watershed – roughly 212 square kilometers (81 sq. mi.) upstream of the falls – as well as its abundant wetlands, ensure that even during dry summers the waterfall is always alive.

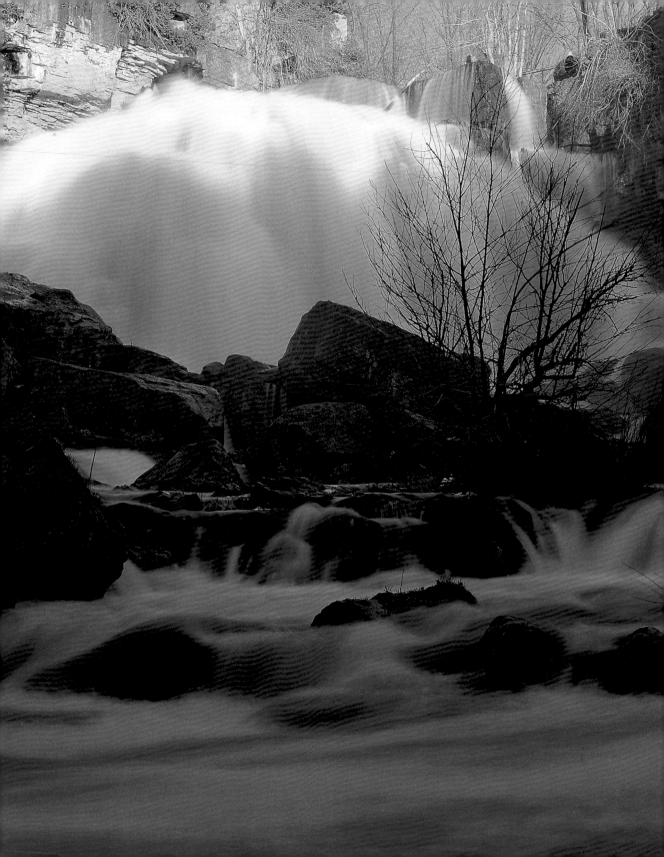

Jones Falls

🚗 Go north on Hwy. 6/10 to Owen Sound. Follow Hwy. 6/10 west through the town until the road begins to climb the big hill up the Niagara Escarpment. Towards the top of the hill, there is a wide gravel shoulder on the right (north) side of the road. Park here and look for the path leading into the forest. Once in the forest, turn right beside the steel footbridge and make your way through the open woods to the small rock promontory beside the falls. For a different view, continue over the bridge and follow the rocky trail to the right to the higher viewing area.

COUNTY:	Grey
NEAREST SETTLEMENT:	Springmount
RIVER:	Pottawatomi River
CLASS:	Cascade (Steep)
TRAIL CONDITIONS:	Moderate
ACTIVITY:	Busy
SIZE:	Medium
RATING:	Average
NTS MAP SHEET:	41 A/10
UTM COORDINATES:	17T, 501150, 4933982
WALKING TIME:	3 minutes

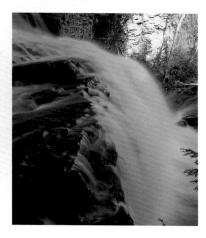

Jones Falls is the third of a trio of well-publicized waterfalls within minutes of Owen Sound. It is not as big as Inglis Falls, nor as pretty as Indian Falls, but nevertheless gets its fair share of visitors. Whereas Inglis Falls has been somewhat "improved" into a tourist attraction, Jones Falls is all natural. And while the trail to Indian Falls involves a rigorous 10-minute hike up some steep hills, you can see Jones Falls within minutes of parking your car.

Situated in the Pottawatomi Conservation Area, the entire site is fun to explore as you scramble through the cedar woods over bare bedrock and scattered boulders. If you find a safe footing, it is even possible to descend to the bottom of the falls through crevices in the rock. The upper formations of the bedrock are Amabel dolostone, which forms the cap rock of the Niagara Escarpment throughout most of the Grey-Bruce area.

Jones Falls is named after Samuel Ayres Jones, who was one of the first Europeans to settle at this property. Below the waterfall, in about 1850, he built a sawmill that didn't close until 1910. At its peak, the mill could saw 1,200 meters (6,000 ft.) of lumber in a day (its staff were paid $1 for a 10-hour workday). The mill is gone now, and the site has reverted to its natural state, offering up to several hours of exploring.

An interesting trail leads away from the falls to a tourist information center and a parking lot on Highway 6. A 4-kilometer (2.5 mi.) hiking trail leads through forests north to the Derby-Sarawak townline road.

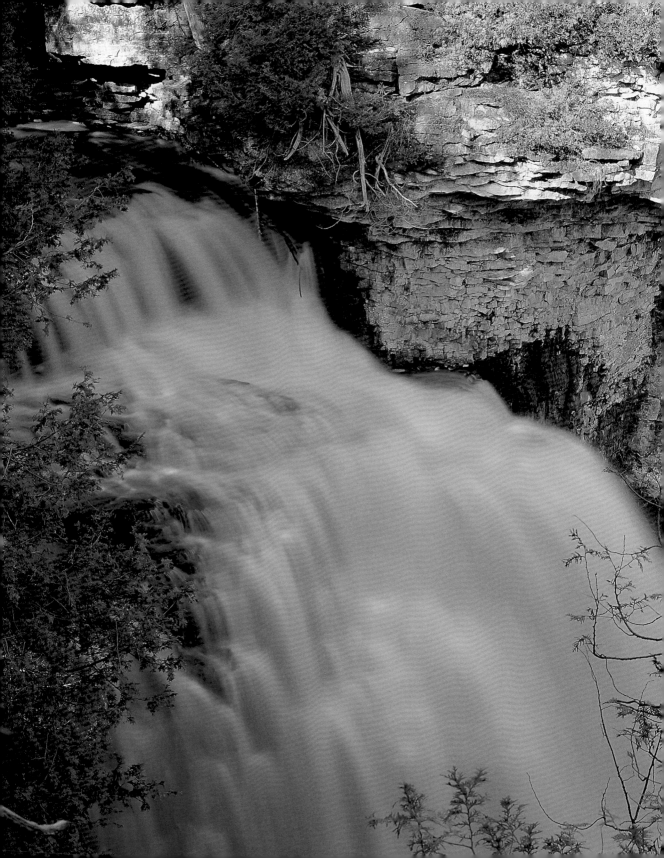

Keefer Falls

🚗 **Follow Hwy. 26 east from Owen Sound to the Sydenham Township 6th Concession Rd. Turn left and drive north for about 3.8 km (2.4 mi.) to the intersection with the 24th Side Rd. Continue straight through the intersection and park where the road bends to the right. A straight trail on the left side of the road continues north from the bend in the road. Walk along this forested trail to the waterfall. It is an easy walk of about five to six minutes, but can be muddy.**

COUNTY: Grey	
NEAREST SETTLEMENT: Annan	
RIVER: Keefer Creek	
CLASS: Plunge	
TRAIL CONDITIONS: Moderate	
ACTIVITY: Quiet	
SIZE: Medium	
RATING: Average	
NTS MAP SHEET: 41 A/10	
UTM COORDINATES: 17T, 512976, 4941095	
WALKING TIME: 6 minutes	

This is a rather little-known waterfall that plays "fourth fiddle" to the three big falls in the Owen Sound area (Inglis Falls, Indian Falls and Jones Falls). The short drive out of town is well worth your time, however, since unlike its three bigger neighbors, you'll probably have Keefer Falls all to yourself.

This is a nice, 7-meter (23 ft.) high plunge-class waterfall set amidst a quiet, clean landscape of forests and old fields. The remains of an old concrete dam are good evidence that an early milling industry may have developed here. These falls have also been called Slattery Mills Falls on some maps, further suggesting that the site was once a little more bustling than it is today. However, the highly variable stream flow would have been far too unreliable for any large-scale industry.

The reach of Keefer Creek below the falls and out to Owen Sound is a fish sanctuary. Waterfalls can represent major obstacles to the upstream movement of fish. This is particularly true in the Owen Sound area, where large falls create impassable barriers on Indian Creek, Keefer Creek, Pottawatomi River and Sydenham River. Unfortunately, many of the best areas for spawning are located above the escarpment, in small, cold water streams that feed the more significant rivers. Realizing this problem, the Sydenham Sportsmen's Association has been active in conserving spawning areas in the lower reaches of area streams, and have successfully constructed artificial spawning channels along the lower reaches of the Sydenham River.

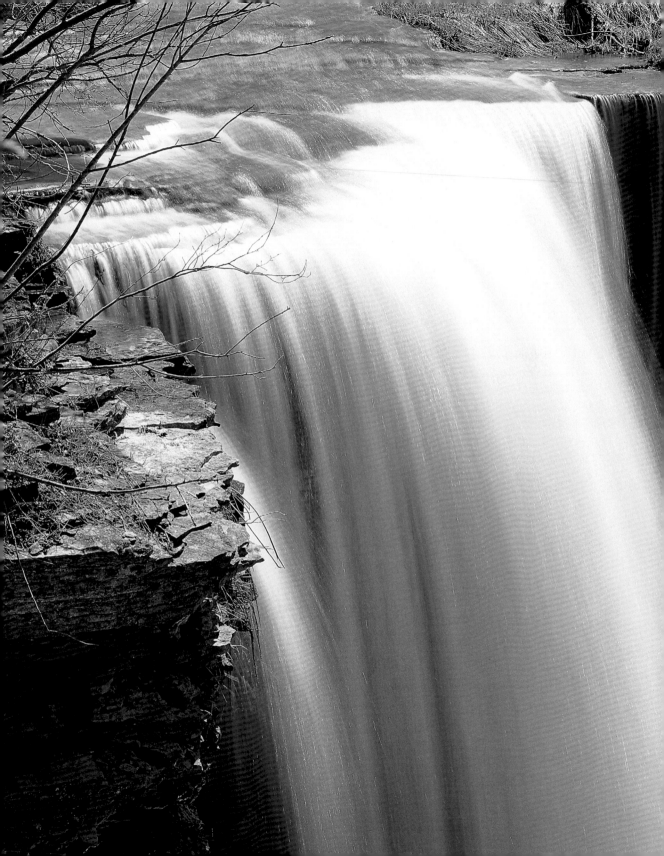

McGowan Falls

🚗 Follow Hwy. 6 south from Owen Sound to the town of Durham. Turn left onto Grey Rd. 4 (Lambton St. E.). Drive for 0.9 km (0.6 mi.) and then turn left onto George St. Just a few hundred meters along George St. there is a gravel parking area on the right side of the road. Park here as the falls are just behind the small utility building. A very small waterfall and old mill building are located to the northeast on the Rocky Saugeen River at Traverston. Topographic maps show Hayward Falls, further downstream, but it is currently located on private property and should not be visited.

McGowan Falls isn't a spectacular waterfall, but nevertheless makes for an interesting place to get out for a stretch. The river cascades over a 2 to 3 meter (7 to 10 ft.) high outcrop of thinly bedded Guelph dolostone.

Immediately upstream of the falls, a dam operated by the Saugeen Valley Conservation Authority maintains water levels in a small swimming pond. A walkway across the dam leads to a short but interesting trail to the west through the cedar woods on the far side of the river.

Unlike the steep, dangerous gorge walls at Elora, the rock face here is much lower and is not continuous. At some points the dolostone forms vertical walls a few meters high, whereas at others you can walk right down to the river's edge.

Arthur McGowan built a mill here around 1847, and also built a dam used to supply the first electricity to the town of Durham in 1890. Today, a light maintained by the local chapter of the Royal Canadian Legion directs its golden beam toward the falls at night.

COUNTY:	Grey
NEAREST SETTLEMENT:	Durham
RIVER:	Saugeen River
CLASS:	Cascade
TRAIL CONDITIONS:	Easy
ACTIVITY:	Moderate
SIZE:	Small
RATING:	Mediocre
NTS MAP SHEET:	41 A/2
UTM COORDINATES:	17T, 515220, 4891763
WALKING TIME:	1 minute

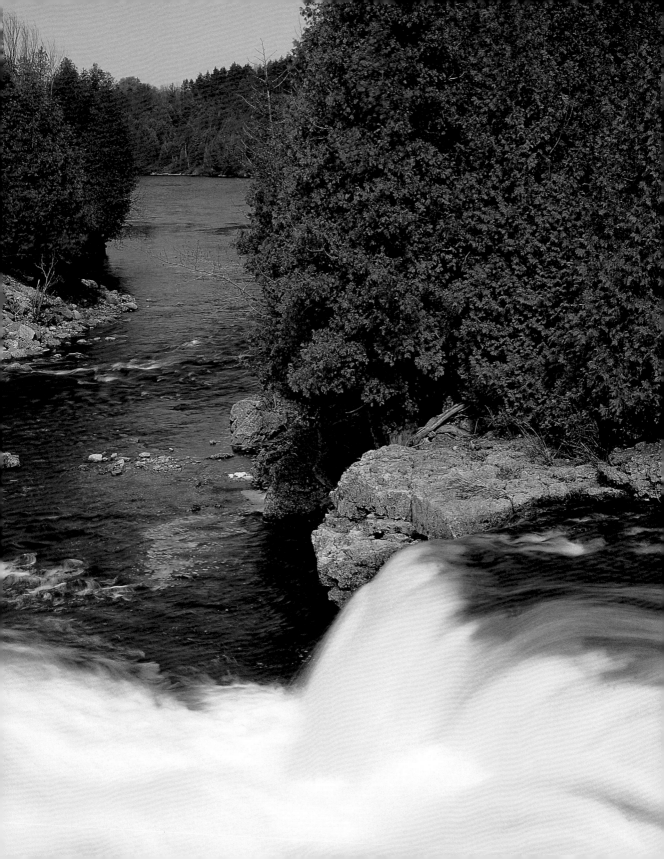

Rock Glen Falls (Fuller Falls)

🚗 **Exit Hwy. 402 at Lambton Rd. 79 and go north. Turn right at Lambton Rd. 22/79, go east for about 4 km (2.5 mi.), and then turn left onto Lambton Rd. 79 (Arkona Rd.). Drive north for 9 km (5.5 mi.) to Rock Glen Rd., which is just past the small village of Arkona. Turn right on this road, and drive to the conservation area. Please pay the small admission fee to help maintain the site.**

COUNTY: Lambton

NEAREST SETTLEMENT: Arkona

RIVER: Bear Creek

CLASS: Plunge

TRAIL CONDITIONS: Easy

ACTIVITY: Moderate

SIZE: Small

RATING: Good

NTS MAP SHEET: 40 P/4

UTM COORDINATES: 17T, 433201, 4770598

WALKING TIME: 3 minutes

At Rock Glen Conservation Area, a small but beautiful waterfall is the focal point of a very interesting few hours of exploration. The 10-meter (33 ft.) high waterfall is also known as Fuller Falls and has eroded a narrow gorge into the hard Widder limestone cap rock and underlying softer shale formations.

The falls may be viewed from a sturdy visitor's platform on the side of the gorge, but to get the most out of Rock Glen, you need to explore more than just the falls. You can walk downstream along the rocky bed of Bear Creek to the Ausable River. A more civilized route follows the road to a long wooden staircase to the base of the gorge. At the Ausable River, the concrete remains of a hydroelectric development built here in 1907 by the Rock Glen Power Company can be seen. A second staircase on the far side of the gorge makes a round trip back to the parking lot.

If you walk along the bed of Bear Creek or the Ausable River, be sure to watch where you step – the conservation area is well known as an excellent spot to find fossils. Geologists have collected the stony casts of a variety of early life forms that lived during the Devonian period, some 350 million years ago. Trilobites, blastoids and brachiopods have been recorded, although visitors are more likely to find small cone-shaped corals and short tube-like crinoid stems. Good specimens can easily be found lying loose in the streambed below the falls, and along the banks of the Ausable River. Visitors may collect their own fossils, but are limited to one specimen per species, and should remember that digging is prohibited. The Arkona Lions Museum is located behind the waterfall and contains a good exhibit of fossils found in the region.

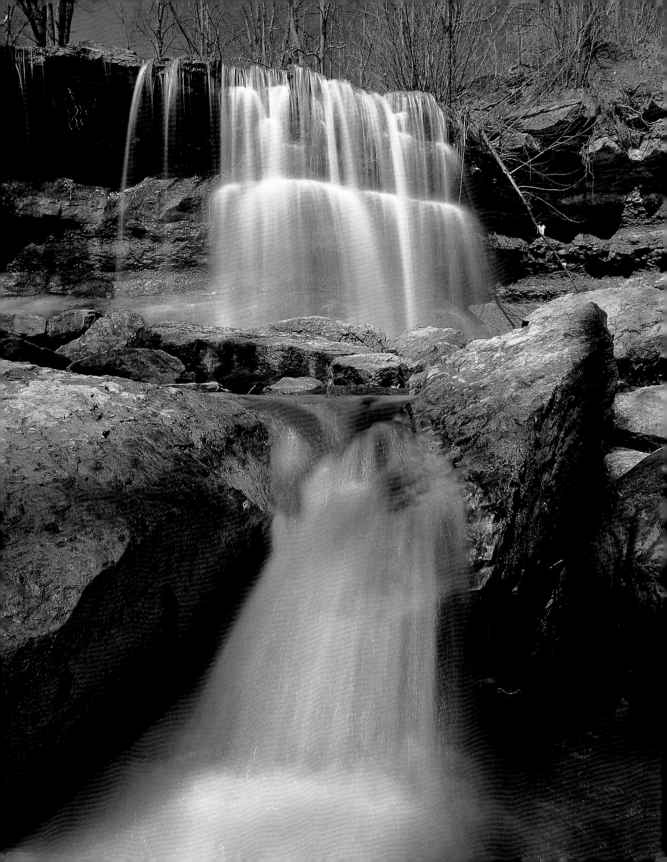

Sauble Falls

🚗 From Owen Sound, drive north on Hwy. 6 to Hepworth. Turn left on Bruce Rd. 8, and follow this road to Sauble Beach. Turn right onto Bruce Rd. 13 (Sauble Falls Rd.) and drive about 5 km (3 mi.) to the falls. There is a large parking lot on the left side of the road. Please pay the small parking fee to help maintain this site. About 15 km (9 mi.) away, just a few minutes' drive northeast of Wiarton, a tiny, yet beautiful waterfall is hidden on the north side of Bruce Rd. 26 at Oxenden.

COUNTY:	Bruce
NEAREST SETTLEMENT:	Sauble Falls
RIVER:	Sauble River
CLASS:	Step
TRAIL CONDITIONS:	Easy
ACTIVITY:	Busy
SIZE:	Medium
RATING:	Good
NTS MAP SHEET:	41 A/11
UTM COORDINATES:	17T, 479740, 4947008
WALKING TIME:	3 minutes

Sauble Falls is one of the rare locations in Ontario where even the mildest adventurer can actually walk across a waterfall. Unfortunately, during summer, you may be joined by dozens of other vacationers. The Sauble River is about 25 meters (80 ft.) wide and falls over a series of low, broad steps composed of Guelph dolostone. The largest step is along the right bank (looking downstream) and is less than 2 meters (7 ft.) high.

The shape of this waterfall is in sharp contrast to the falls further east along the Niagara Escarpment, which usually have a far more vertical "personality." A small plunge pool is barely deep enough to cushion brave visitors who jump off the rim of the waterfall during low flow. Elsewhere, when flows are low enough, you can carefully wade across the shin-deep water to the left bank, where trails lead to a series of signs. If you prefer to stay dry, cross the river on the concrete footbridge.

The falls are positioned at the north end of Sauble Falls Provincial Park. Fishing between the falls and the river's mouth at Lake Huron is reported to be excellent, and the falls are an excellent spot to watch the migration of rainbow trout and chinook salmon during spring and fall. Camping and canoeing are permitted, and the area is heavily used for day-use activities including picnicking and hiking.

Before the development of the park, the falls supported the largest sawmill in the Bruce Peninsula. In 1897, the mill employed about 20 men (paid about $1.20 a day), and put out about 6,000 meters (20,000 ft.) of lumber a day. Later, in 1908, a hydroelectric station at the falls generated about 167 kW for the nearby town of Wiarton. This plant was demolished in 1939, but the concrete foundations can still be seen.

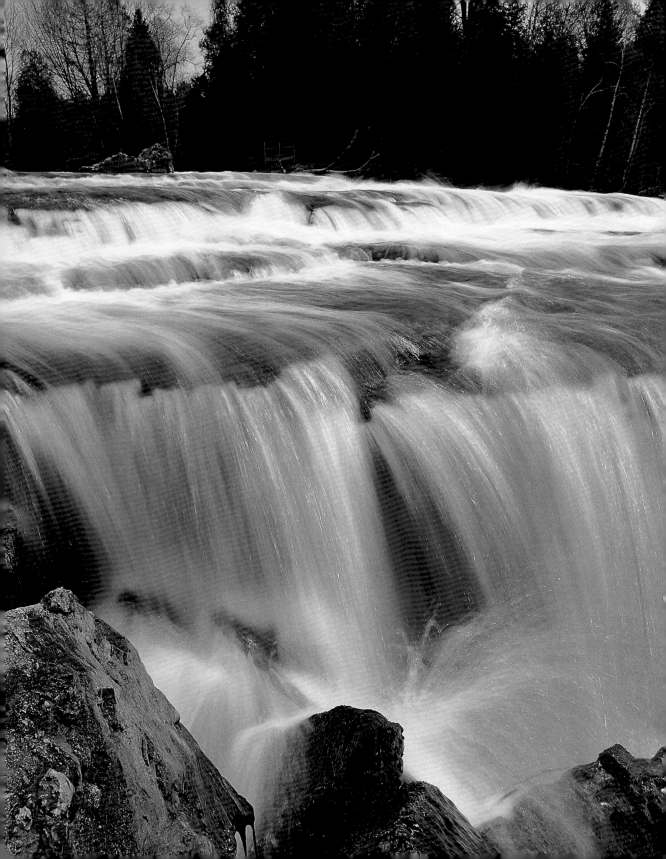

LAKE HURON
Walters Falls

🚗 **More than one tourist has been lost at Walters Falls! Follow Hwy. 10 to Chatsworth, which is about 15 km (9 mi.) south of Owen Sound. Turn east on Grey Rd. 40 and drive east for 12 km (7.5 mi.). Grey Rd. 40 bends to the left, and then after 2.8 km (1.7 mi.) bends back to the right. Before entering the village, the road also becomes Grey Rd. 29. Once you enter the village, turn left onto Front St. Drive to the end of this road, and park in the concrete area in front of the old wooden barn. To see the falls, walk to the red wooden railing beside the river. A path along the side of the river leads into the woods, where you can find a safe point to descend to the base of the falls.**

COUNTY: Grey	
NEAREST SETTLEMENT: Walters Falls	
RIVER: Walters Creek	
CLASS: Plunge	
TRAIL CONDITIONS: Easy	
ACTIVITY: Moderate	
SIZE: Medium	
RATING: Average	
NTS MAP SHEET: 41 A/7	
UTM COORDINATES: 17T, 522921, 4926231	
WALKING TIME: 1 minute	

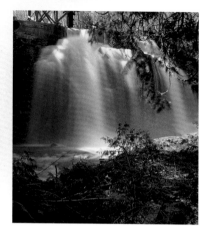

Walters Falls is one of Ontario's only twin falls. Two beautiful waterfalls about 14 meters (46 ft.) high stand side by side, separated by a tall pillar of bedrock. A wooden walkway has been constructed right out over the top of the falls, just below the remains of long-forgotten industry. Some say that the walkway ruins the appearance of the falls, but it does provide for a unique bird's eye view of the plunging waters.

The falls and the surrounding village are named after John Walter, who settled on 120 hectares (300 acres) in the area in 1852. Walter built a sawmill here in 1853, followed by a gristmill and a fulling and carding mill just a few years later. The little village soon blos-

somed into an important center for nearby farmers. Fire destroyed the mill in 1984, but some of the foundations and metalwork can still be found near the falls. John Walter died in 1867 and was buried in the cemetery for St. Philip's Church in the village.

A few other small, lesser-known waterfalls can be visited in the area. Minniehill Falls is a tiny little waterfall, part of which flows out of a fracture midway down the gorge wall between the limestone and underlying shale. It is located about a 15-minute walk on the Bruce Trail west from 7th Line Euphrasia Township, north of Grey Road 40. Further west, about 700 meters (0.4 mi.) east of Grey Road 12 is tiny Antheas Falls, named after the daughter of one of the former presidents of the Bruce Trail Association. Still further west, where Rocklyn Creek crosses the Bruce Trail, the topographic map shows contour lines converging in a V-shape, the telltale sign that another little waterfall might just be hidden there. Finally, Lavender Falls is marked on some topographic maps, but is located on private property.

OTTAWA VALLEY

NOT BLESSED with as many well-known waterfalls as the other four regions, the Ottawa Valley still has a number of sites worth visiting. Some require a canoe trip to the quiet central Ontario wilderness, while others are found in the middle of the nation's capital. Geographers will note that a few of the waterfalls in this region aren't actually on streams that drain to the Ottawa River. They have instead been grouped here for convenience.

Recommended tour

Drive west from Ottawa to Carleton Place, and then north along the Mississippi River. Visit Mill and Grand Falls at Almonte, followed by the little falls at Blakeney and Pakenham. Continue to Arnprior and follow Renfrew Road 1 along the Ottawa River to Bonnechere Falls. If time permits, swing west along Highway 60 to Second Chute and Fourth Chute. Another group of waterfalls is clustered around the Bancroft area, making for an interesting alternate tour.

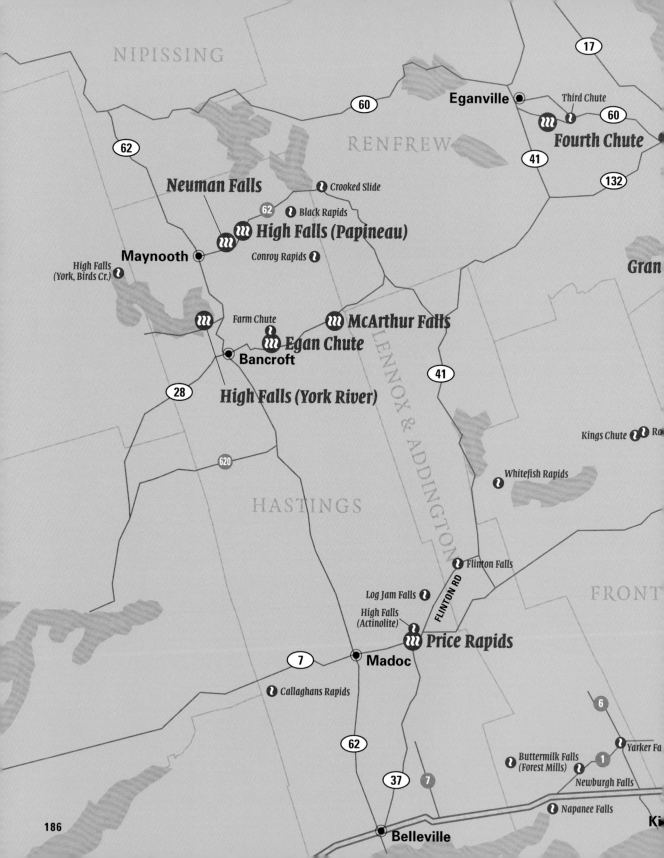

NIPISSING

RENFREW

17

60

Eganville

Third Chute

60

Fourth Chute

41

132

62

Crooked Slide

Neuman Falls

62 Black Rapids

Gran

High Falls (Papineau)

Maynooth

Conroy Rapids

High Falls
(York, Birds Cr.)

Farm Chute

McArthur Falls

Egan Chute

Bancroft

28

High Falls (York River)

LENNOX & ADDINGTON

41

Kings Chute Ra

620

Whitefish Rapids

HASTINGS

FRONT

Flinton Falls

FLINTON RD

Log Jam Falls

High Falls
(Actinolite)

Price Rapids

7 Madoc

Callaghans Rapids

6

62

Yarker Fa

37 7

Buttermilk Falls
(Forest Mills)

1

Newburgh Falls

Napanee Falls

186

Belleville

Ki

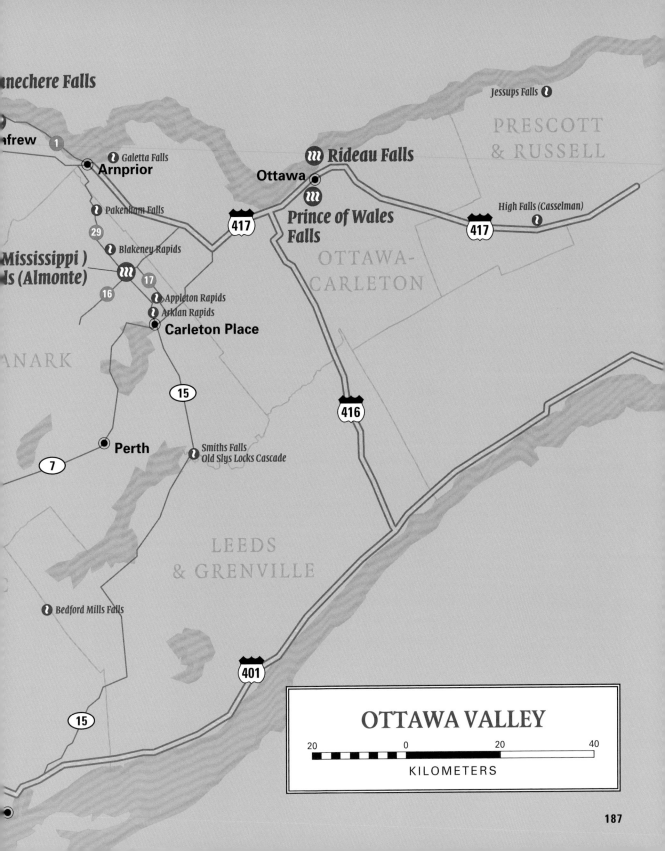

nechere Falls

frew ⑴

② Galetta Falls

Arnprior

② Pakenham Falls

㉙

② Blakeney Rapids

Mississippi)
ls (Almonte)

⑰

⑯

② Appleton Rapids

② Arklan Rapids

Carleton Place

Rideau Falls

Ottawa

Prince of Wales
Falls

Jessups Falls ②

PRESCOTT
& RUSSELL

High Falls (Casselman)
②

417

417

OTTAWA-
CARLETON

⑮

ANARK

⑦

Perth

② Smiths Falls
② Old Slys Locks Cascade

416

LEEDS
& GRENVILLE

② Bedford Mills Falls

401

⑮

OTTAWA VALLEY

20 0 20 40

KILOMETERS

Bonnechere Falls

🚗 Follow Hwy. 417 west from Ottawa, and continue west as the road becomes Hwy. 17. As you approach Renfrew, turn right on Renfrew Rd 6. Follow this road for a few kilometers, but when the regional road makes a 90-degree turn to the right, continue straight along what becomes Thompson Rd. Follow Thompson Rd. for about 4 km (2.5 mi.) until you see a small parking lot on the left side of the road. On the left side of the lot there is a path that leads down the hill to the Bonnechere River. From here, a short path leads to the base of the falls, while another goes uphill to the crest of the waterfall.

COUNTY:	Renfrew
NEAREST SETTLEMENT:	Castleford Station
RIVER:	Bonnechere River
CLASS:	Cascade
TRAIL CONDITIONS:	Moderate
ACTIVITY:	Quiet
SIZE:	Medium
RATING:	Good
NTS MAP SHEET:	31 F/7
UTM COORDINATES:	18T, 378049, 5039573
WALKING TIME:	5 minutes

Bonnechere Falls is a beautifully rugged waterfall hidden just 6 kilometers (4 mi.) from the Trans-Canada Highway. At the falls, the river erodes into tilted layers of dolomitic marble of varying resistance, giving the riverbed a linear, jagged texture. The river braids into a dozen little channels at the lower falls, each flowing along a linear notch between more resistant layers of rock. Potholes up to 1 meter (3 ft.) in diameter are found on some of the wider rock formations.

Like most rivers, the Bonnechere varies greatly in flow. The average daily discharge is about 19 cubic meters (670 cu. ft.) per second, but since the nearby stream gauge was installed in 1921, the flow has ranged from a raging 286 cubic meters (10,000 cu. ft.) per second to a little over 0.3 cubic meters (10 cu. ft.) per second. When flows are high enough, kayakers use the river below the falls. The falls themselves are certainly a class-V rapids, and should be attempted only by expert paddlers.

Bonnechere Falls is also called the First Chute. Traveling upstream along the Bonnechere River, early loggers met five waterfalls that hindered their log drives. Eventually, log chutes were built at these falls to prevent the logs from being pulverized by heavy spring waters. The first timber slide was built here by Christopher James Bell in 1829. At Second Chute in Renfrew, a dam has erased much of the falls. The upper part is still a low, rugged waterfall over crystalline limestone. At low flow, you can explore this bedrock reach, immediately below the historic McDougall Mill Museum. The Third Chute is at Douglas and the Fourth is at Bonnechere Caves (see Fourth Chute, page 192). The Fifth Chute was in the deep, wide gorge that passes through Eganville.

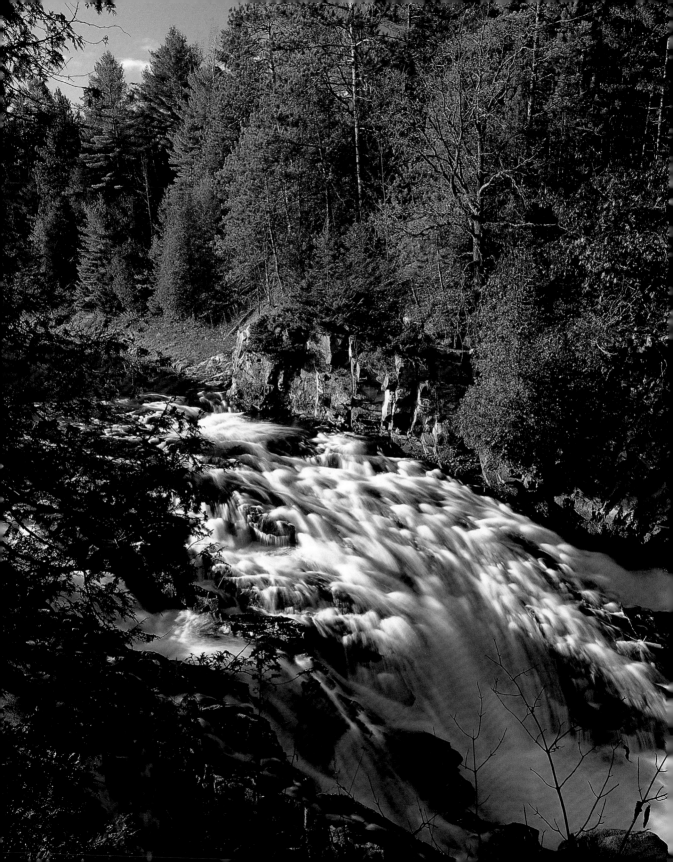

Egan Chute

🚗 Follow Hwy. 28 north to Bancroft and continue along the highway as it turns east past the town. Watch for the sign for the Egan Chute provincial park, which is on the north side of the road, about 10 km (6 mi.) east of Bancroft. The access road is located about 100 m (325 ft.) west of the bridge over the York River. The access road starts off paved, but turns first to a sandy surface, and then eventually deteriorates to an uneven rock surface. Unless you have a vehicle with four-wheel drive, it is best to park at the end of the paved section. From there, a trail leads along the edge of the river for about 500 m (1,600 ft.) to a beautiful secluded spot beside the chute.

COUNTY: Hastings
NEAREST SETTLEMENT: Bowen Corner
RIVER: York River
CLASS: Cascade
TRAIL CONDITIONS: Moderate
ACTIVITY: Quiet
SIZE: Medium
RATING: Good
NTS MAP SHEET: 31 F/4
UTM COORDINATES: 18T, 284514, 4995229
WALKING TIME: 15 minutes

This waterfall forms the center of the recently developed Egan Chutes Provincial Nature Reserve. The chute isn't as big as many visitors first expect, but the York River can really put on a good show as it spills over one side of a long, V-shaped notch in tilted layers of gneiss and marble. The site is surrounded by pines and rocky cliffs and is quite picturesque.

The chute is located in the heart of "mineral collecting country" and you are likely to encounter a few rockhounds during your visit. Every year during the Civic Holiday weekend, thousands of enthusiasts visit the Bancroft area to take part in the annual "Rockhound Gemboree." Here, mineral buffs can buy, sell and trade with other rockhounds.

The Bancroft Chamber of Commerce maintains a small rock and mineral museum in the old railway station beside the York River in Bancroft. The museum is open seven days a week in the summer, and Monday to Saturday during the fall, winter and spring. Admission is by donation. You can purchase a mineral collecting guidebook here that lists mineral localities and old abandoned mines you can visit. One such site, the Goulding-Keene Quarry, is located right along the trail to Egan Chute and is quite safe to explore. The open face quarry was worked for nepheline syenite between 1937 and 1939. If you are lucky, you may be able to find small exposures of the blue mineral sodalite, for which the Bancroft area is famous.

While you are in the area, you may also want to visit Farm Chute, which is located 3.2 kilometers (2 mi.) downstream from Egan Chute. It can be reached by canoe, or by a long trail on the far side of the York River.

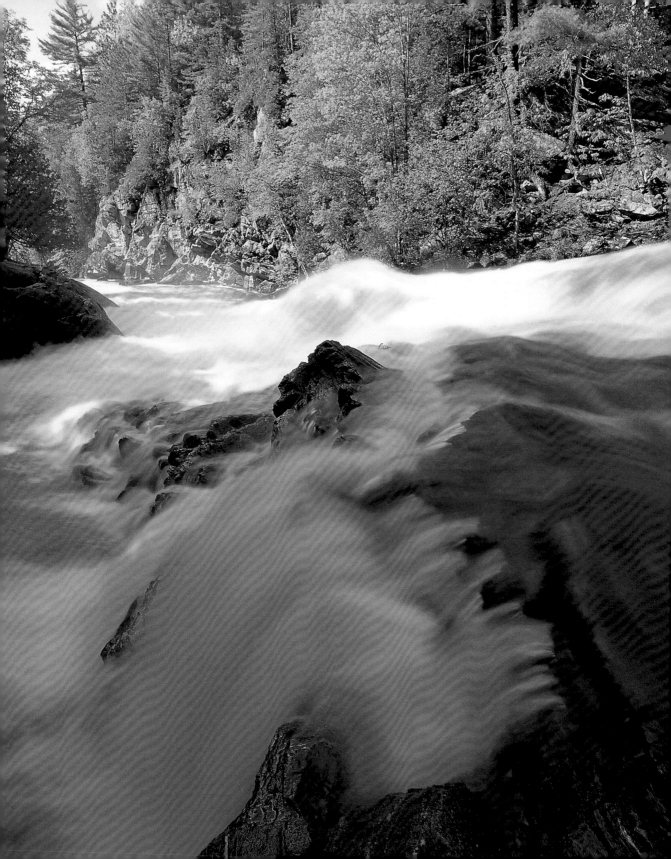

Fourth Chute

🚗 Follow Hwy. 417 west from Ottawa, and continue west along Hwy. 17. Turn left on Hwy. 60 and drive through the town of Renfrew, where it is known as O'Brien Rd., Coumbes St., Raglan St., Bridge St. and Stewart St., but is always the main road. Continue west along Hwy. 60 for about 21 km (13 mi.) to Douglas. Follow the highway as it bends to the right, but then make a quick left turn onto Fourth Chute Rd. Follow this road for 6.3 km (3.9 mi.) to the gravel parking lots beside the Bonnechere River. If you don't plan to visit the caves, park in the small lot on the right side of the river. Walk across the road to the old field beside the river and follow the path along the top of the gorge. There are a few safe places where you can scramble down to the river edge.

COUNTY:	Renfrew
NEAREST SETTLEMENT:	Fourth Chute
RIVER:	Bonnechere River
CLASS:	Step
TRAIL CONDITIONS:	Moderate
ACTIVITY:	Moderate
SIZE:	Medium
RATING:	Good
NTS MAP SHEET:	31 F/11
UTM COORDINATES:	18T, 343127, 5040856
WALKING TIME:	3 minutes

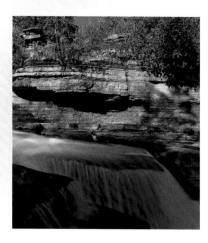

There are two waterfalls at Fourth Chute, with a combined fall of about 10 meters (33 ft.). The upper falls are easily visible from the road, where a wide reach of the Bonnechere River is forced to constrict to a small narrow notch in the bedrock. The lower waterfall is just a few hundred meters downstream, and is much more interesting than the upper falls. It can be accessed by walking along a weak trail through the scrub on the south side of the river.

Formed in well-jointed Ottawa limestone, the river tumbles over several prominent rock ledges, including one waterfall about 5 meters (16 ft.) in height. During lower flows, the river runs through wide fractures in the bedrock,

leaving much of the rockbed high and dry and ready for exploration. The pattern of fractures and bedding gives the bedrock a neat building-block-like character.

A trip to Fourth Chute should definitely include a visit to the Bonnechere Caves, located immediately adjacent to the river. They are open between early May and October, although only on weekends during the early and late portion of the season. Guided tours take you through an extensive network of narrow floodlit passages and tunnels. The temperature inside the caves remains between 10°C and 13°C (50°F and 54°F) all year, so you may wish to bring a sweater, even during summer.

While you are in the area you may also want to visit Second Chute, which is located just downstream of the Highway 60 bridge over the Bonnechere River in Renfrew, beside the historic McDougall Mill Museum.

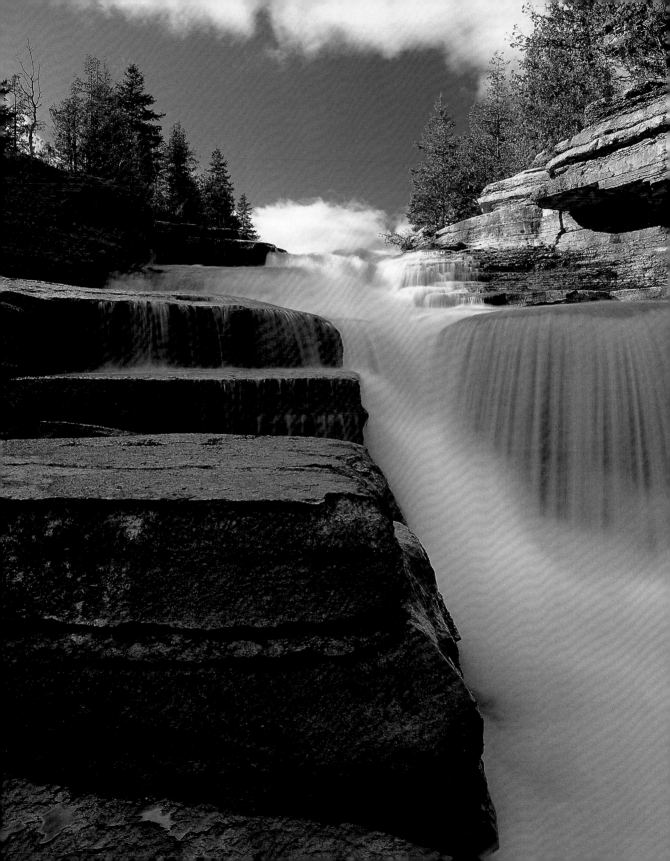

Grand Falls

🚗 Go west on Hwy. 417 to Hwy. 7. Continue west to just a few kilometers before Carleton Place, where you'll turn right onto Lanark Rd. 17. Drive north to Lanark Rd. 49 (March St.), and turn left. Follow this road into town and go over both channels of the Mississippi River. Park in the parking lot for Metcalfe Park, which is on the right side of the road, about 300 m (1,000 ft.) past the bridge. Walk across the grass field toward the woods alongside the river.

COUNTY:	Lanark
NEAREST SETTLEMENT:	Almonte
RIVER:	Mississippi River
CLASS:	Step
TRAIL CONDITIONS:	Moderate
ACTIVITY:	Busy
SIZE:	Medium
RATING:	Average
NTS MAP SHEET:	31 F/1
UTM COORDINATES:	18T, 405890, 5008715
WALKING TIME:	3 minutes

At Almonte, the Mississippi River splits into two channels: the north channel spilling over Mill Falls, and the south channel dropping at the Upper and Lower Grand Falls, located behind the shops of Mill Street. A third, much smaller channel is hidden to the north.

Upper Grand Falls can be safely viewed from the Almonte Street Bridge. The uppermost portion of the falls has been somewhat spoiled by a concrete dam, but the lower portion of the falls is formed of an interesting multistepped outcrop of gray Ottawa limestone. The purpose of the dam is to help divert a portion of the river's flow to the Almonte Hydroelectric Generating Station, located immediately north of the falls. A plaque on this handsome little building notes that it was first built in 1925, and after renovation in 1991 now provides 2400 kW of electricity.

The lower portion of the falls can be easily explored on foot via Metcalfe Park. As you walk through the woods toward the falls, scan the ground for the remains of an old stone foundation.

After flowing under the Almonte Street bridge, the river widens to about 50 meters (165 ft.) across and falls as a steep cascade about 4 meters (13 ft.) in height. The bedrock does not include a thick "massive" layer more resistant than the others, but rather exhibits relatively thin layers, all of similar resistance. The resulting waterfall is steep, but not a true plunge waterfall, since there is no weaker rock layer to undercut the uppermost formations. Below the falls, the river is about 100 meters (325 ft.) wide and is choked with limestone boulders, stretching for a distance of roughly 200 meters (650 ft.). During periods of high flow this entire area floods and is completely impassable on foot.

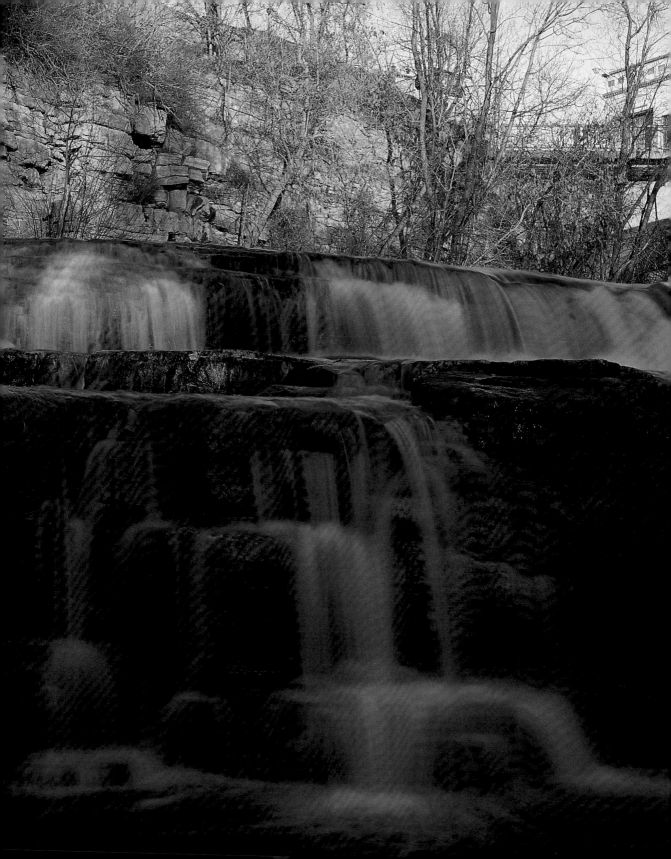

High Falls (Papineau Creek)

🚗 **Drive north on Hwy. 62 through Bancroft, following signs for the highway through town. Continue north to the village of Maynooth, where the highway bends to the right and becomes Hastings Rd. 62. Follow this road to Musclow Rd., and then a further 2.1 km (1.3 mi.) to a point where the road bends to the left as it descends a hill. Find a safe place to park. (If you reach Boulter Rd., you have driven too far.) You will need to carefully climb down a boulder-covered hill on the south side of the road. The falls are located a short distance into the woods at the bottom of the hill. Follow your ears! (Not recommended for small children or the elderly.)**

COUNTY:	Hastings
NEAREST SETTLEMENT:	Maple Leaf
RIVER:	Papineau Creek
CLASS:	Cascade
TRAIL CONDITIONS:	Difficult
ACTIVITY:	Quiet
SIZE:	Small
RATING:	Mediocre
NTS MAP SHEET:	31 F/5
UTM COORDINATES:	18T, 278646, 5018313
WALKING TIME:	5 minutes

This is one of several unspoiled little waterfalls on Papineau Creek. The creek snakes its way over three small cascades, each no more than 2 meters (7 ft.) in height. Despite the name, High Falls is not high. The falls are only a short distance from the road, but are set in a thick woods, so you should expect to clamber over (or under) at least a few fallen logs.

Settlement of this rather remote area of Hastings County took place primarily in the late 1890s, with many early settlers finding work cutting timber along Papineau Creek. Some of the first settlers were Robert and William Conroy, two lumbermen brothers who began clearing timber further to the south along the York River, and didn't stop until they had moved a number of kilometers upstream from nearby Neuman Falls. Their surname lives on at the Conroy Marsh, which is a pristine 2000-hectare (5,000 acre) wetland located to the east, currently accessible only by water.

Other smaller cascades are found nearby at the Papineau Creek Day Park just to the east off Boulter Road, and at Papineau Creek on the north side of Hastings Road 62 just 1 kilometer (0.6 mi.) east of Lutheran Church Road. A far more interesting site in the area, however, can be found at Crooked Slide Park, located near Combermere, about 20 kilometers (12 mi.) to the east. A 19th-century log chute has been completely restored to its former glory. These wooden structures once dotted the Ontario bush and were used to help direct logs around the many rapids and waterfalls that would normally result in large "log jams" that proved fatal to so many a lumberjack.

Crooked Slide Park is definitely recommended for small children, as they can swim under the 3-meter (10-ft.) high jet of water falling from the wooden chute. To reach the park, continue east on Hastings Road 62 for about 20 kilometers (12 mi.) to the village of Combermere. Follow Road 62 over the bridge and turn right on Old Barrys Bay Road. Continue north for about 1.7 kilometers (1.1 mi.) to the park, which is on the left side of the road.

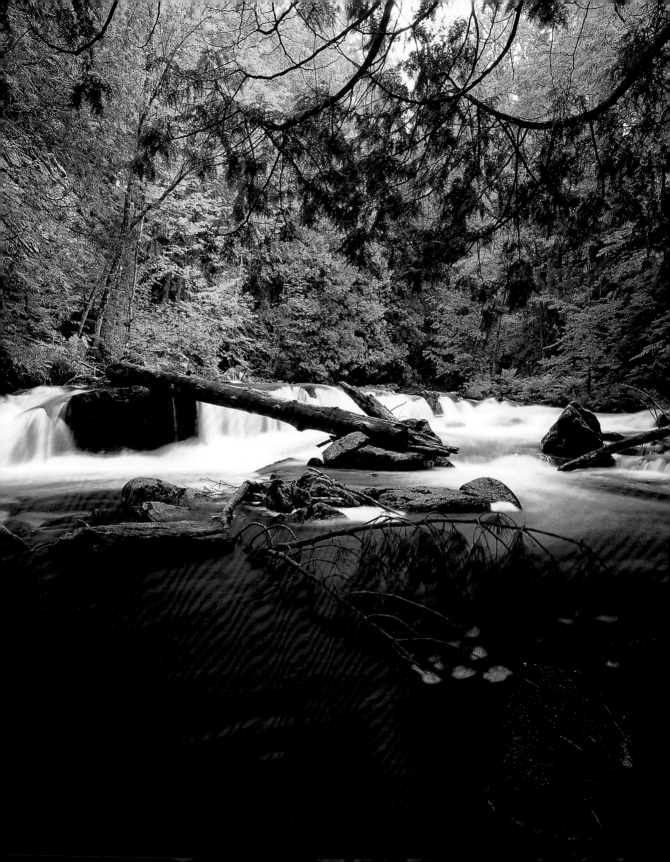

High Falls (York River)

🚗 From Bancroft, go north on Hwy. 62 for about 5 km (3 mi.). (Consider taking the short side-trip to Eagle's Nest Lookout for a spectacular view of the entire area.) Turn left on Baptiste Lake Rd., follow the road for 2 km (1.2 mi.) and then turn right onto High Falls Lane, which takes you directly to the falls.

COUNTY:	Hastings
NEAREST SETTLEMENT:	Birds Creek
RIVER:	York River
CLASS:	Cascade
TRAIL CONDITIONS:	Easy
ACTIVITY:	Quiet
SIZE:	Medium
RATING:	Average
NTS MAP SHEET:	31 F/4
UTM COORDINATES:	18T, 270599, 4999999
WALKING TIME:	1 minute

Although High Falls is promoted in many Bancroft-area travel brochures, it is not uncommon to find yourself alone at this site. This impressive waterfall has been reduced in stature somewhat by a large concrete dam constructed to maintain water levels in Baptiste Lake. A short walkway leads visitors across the top of the dam and provides an excellent view of the entire site. The waterfall is probably 25 meters (80 ft.) wide and about 75 meters (250 ft.) long. Unfortunately, the effect of the dam has been to leave the far portion of the original falls as a dry, bare expanse of rock.

Provided the flows are low enough, you can carefully explore the rocks immediately below the dam. The rock here is gneiss: a metamorphic rock characterized by "bands" of alternating light and dark minerals formed under great heat and pressure. Closer examination of the rocks below the dam will reveal large quartz crystals occurring in long veinlike structures up to 50 centimeters (20 in.) wide. These pegmatites are newer rocks that have intruded across the pre-existing gneiss, and are favorites of

mineral collectors.

A dirt trail from the parking lot leads you along the left bank of the York River for at least several hundred meters. Note that the forest in the area is dominated by white pine, white birch and trembling aspen. The prevalence of these species suggests that the area is currently reforesting. Nevertheless, two rather large white pines along the path have somehow escaped the lumberjack's axe.

Baptiste Lake acts as a reservoir to help maintain flows over High Falls for the entire year. You may not want to visit the area in May and June in order to avoid the hoards of black flies.

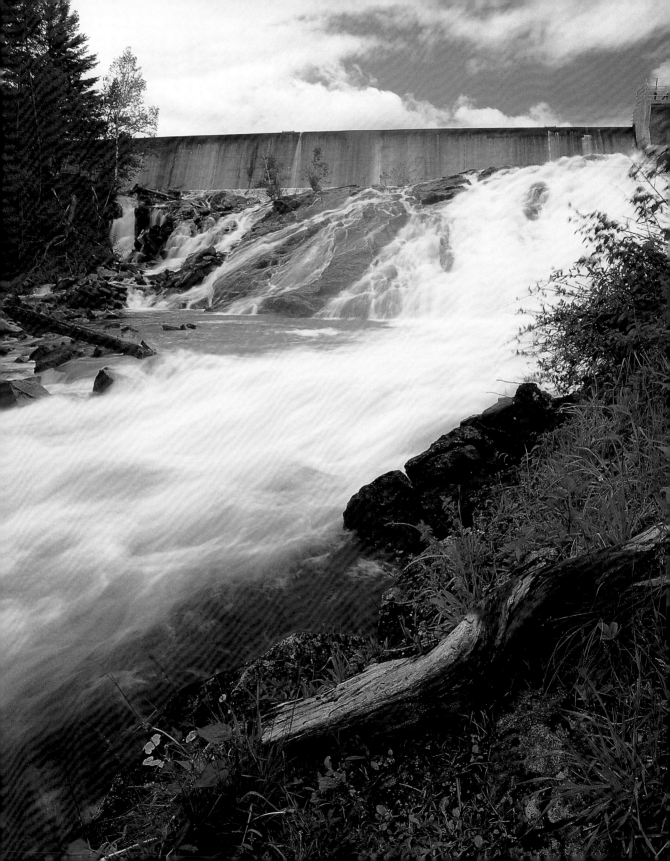

McArthur Falls

🚗 McArthurs Mills is located about 25 km (15 mi.) east of Bancroft. Follow the directions to Egan Chute (page 190), but continue east on Hwy. 28 for another 14 km (9 mi.). The little waterfall is located just south of the highway.

COUNTY:	Hastings
NEAREST SETTLEMENT:	McArthurs Mills
RIVER:	Little Mississippi River
CLASS:	Cascade
TRAIL CONDITIONS:	Easy
ACTIVITY:	Moderate
SIZE:	Small
RATING:	Average
NTS MAP SHEET:	31 F/3
UTM COORDINATES:	18T, 297760, 5000239
WALKING TIME:	2 minutes

Located at the little settlement of McArthurs Mills, this waterfall is quite small, and far from spectacular. Formed on a low, rounded ridge of bedrock, the falls are no more than a few meters in height. Nevertheless they form a pleasant backdrop for a popular wading and swimming area, immediately above and below the falls.

The settlement of McArthurs Mills was founded by Archie McArthur during the 1860s. McArthur, who was a brass band leader, had come from Almonte (see Grand Falls, page 194, and Mill Falls, page 202) to tour what was then a nearly uninhabited landscape. McArthur was impressed with the potential of the waterfall and so returned to build a lumber mill and a gristmill beside the falls. Soon after, other settlers opened a blacksmith, cheese factory and general store, and the little settlement was born. McArthur also built a school here in 1896 (its first teacher earned $25 per month).

In addition to McArthur Falls, several other waterfalls are found in the area. About 6 kilometers (4 mi.) south on the river are a set of rapids marked on topographic maps as "The Big Chute." Roughly 25 kilometers (15 mi.) to the north, Palmer Rapids on the Madawaska River is a site popular with whitewater enthusiasts. Finally, Highland Falls forms a low, but wide step in the Madawaska River, just upstream of Griffith along Highway 41. The falls can be reached a short paddle upstream from the highway bridge. There may be a land route from Hyland Creek Road, although most of the land appears to be private.

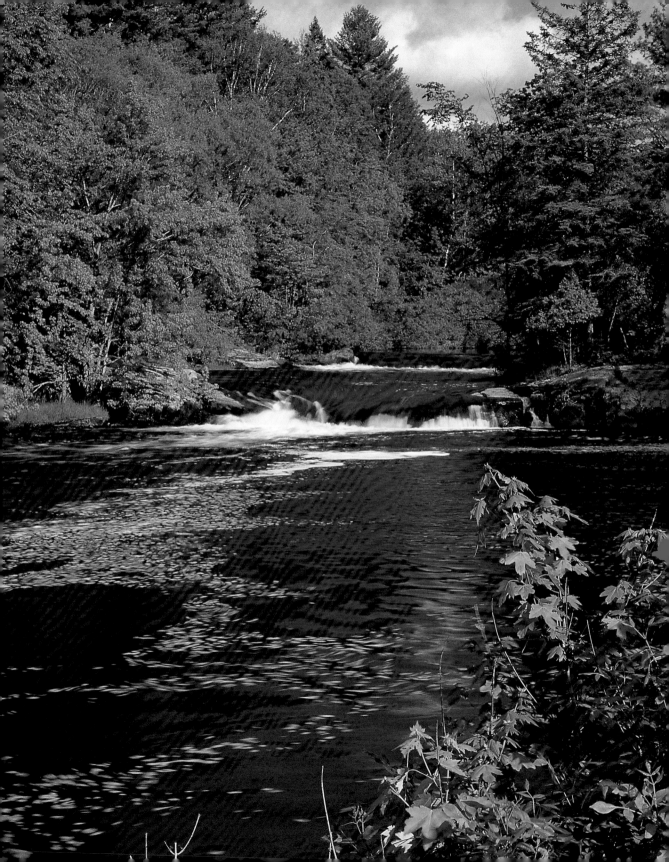

Mill Falls

🚗 Drive west on Hwy. 417 from Ottawa to Hwy. 7. Continue west on Hwy. 7, and turn right onto Lanark Rd. 17. (If you pass Carleton Place, you have gone too far.) Drive north to Lanark Rd. 49 (March St.), and turn left. Follow this road into the town of Almonte, and after crossing the first river channel, turn right on Coleman St. At the end of this street, turn left, then make a quick right onto Wellington St. Follow the road to the end, but do not drive over the one-lane bridge, as this is private property.

COUNTY:	Lanark
NEAREST SETTLEMENT:	Almonte
RIVER:	Mississippi River
CLASS:	Plunge
TRAIL CONDITIONS:	Easy (Private)
ACTIVITY:	Busy
SIZE:	Medium
RATING:	Mediocre
NTS MAP SHEET:	31 F/1
UTM COORDINATES:	18T, 405813, 5009096
WALKING TIME:	2 minutes

Once called Shepherds Falls, Almonte is a town that owes its existence to its waterfalls. Toward the end of the 19th century, there were no fewer than seven mills tapping the natural power provided by two falls in the town. The area was one of the most important wool manufacturing centers in the Ottawa Valley.

Mill Falls is a set of two pretty plunge-class waterfalls. Other than Rideau Falls in downtown Ottawa, these appear to be the only examples of the plunge form in the Ottawa Valley Region. The upper waterfall is about 3 meters (10 ft.) high, while the lower is roughly 5 meters (16 ft.) high; each is about 8 meters (26 ft.) wide. Unfortunately, the land beside both of these waterfalls is private. A wooden bridge over the top of the upper bridge leads to a residence, while the lower falls is adjacent to a large condominium development (built in the shell of an abandoned mill building), surrounded by private property. Nevertheless, a photo of the falls can be made from the forested area beside the waterfall.

The falls at Almonte are the largest of a number of small, yet interesting waterfalls along the Mississippi River. At Blakeney, just a five-minute drive to the north, the river splits into several different channels exhibiting numerous rapids and tiny waterfalls. The channels are separated by little forested islands of red granite, which are connected to each other by short wooden footbridges. The site is a favorite for fly-fishing and white-water paddling.

Further north at Pakenham, the river falls over a low, but wide fault occurring in the Black River limestone. The falls are immediately downstream of a beautiful five-span masonry bridge, which is the only such bridge in North America. Other small falls also occur at Galetta, Appleton and Carleton Place.

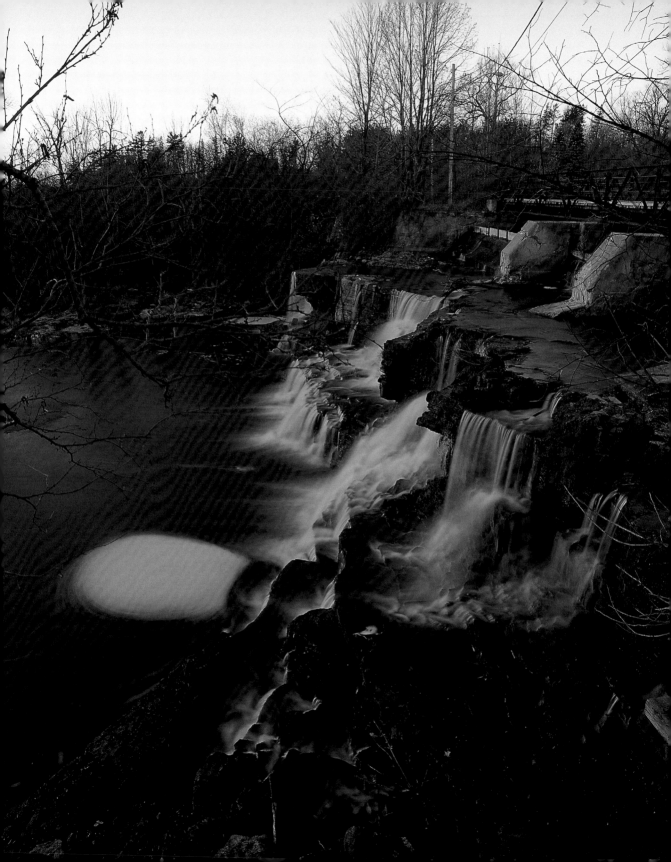

Neuman Falls

🚗 **Drive north on Hwy. 62 to Bancroft, and follow the signs for the highway through the town. Drive north for about 24 km (15 mi.) to the little village of Maynooth, where the highway bends to the right and becomes Hastings Rd. 62. Follow this road for 6.2 km (3.9 mi.) from the main intersection in Maynooth to Lutheran Church Rd. Turn left here, followed by a quick right onto Church Rd., and then left again on Frantz Rd. After 0.8 km (0.5 mi.) the road bends to the left as it crosses a rocky creek. Park here on the side of the road and observe the falls. As always, please respect private property as if it were your own.**

COUNTY: Hastings	
NEAREST SETTLEMENT: Maple Leaf	
RIVER: Papineau Creek	
CLASS: Cascade	
TRAIL CONDITIONS: Moderate (Private)	
ACTIVITY: Quiet	
SIZE: Small	
RATING: Mediocre	
NTS MAP SHEET: 31 F/5	
UTM COORDINATES: 18T, 274864, 5015671	
WALKING TIME: 1 minute	

This is perhaps the largest of a number of pretty little waterfalls found on Papineau Creek along the Hastings Road 62 corridor. Unfortunately, it is located on private property, and you will have to settle for viewing this waterfall from the roadside.

On the west side of the road, the creek drops over two little bedrock steps each no more than a meter in height. It crosses under the road and then drops rather abruptly over a steep cascade, perhaps 4 to 5 meters (13 to 16 ft.) high and 10 meters (33 ft.) wide.

The property around the falls was originally allotted in 1899 to Jonas Grant, who constructed one of the area's first sawmills on Papineau Creek. The property later passed into the hands of the Neuman family, who operated a gristmill near the falls during spring and early summer, after which the stream did not generate enough power. The mill equipment was apparently moved to another, presumably more productive, site in 1945.

Just a few steps back along the road, a 6-meter (20 ft.) high rock outcrop shows a good example of metamorphic rock. This kind of rock is formed when existing rocks are subjected to the intense heat and pressure several kilometers beneath the Earth's surface. The rock often takes on a highly contorted appearance, like a swirled frozen soup of mineral crystals. Even the most amateur geologist will appreciate the intense forces that would have been required to produce the intricate folds apparent in this rock exposure.

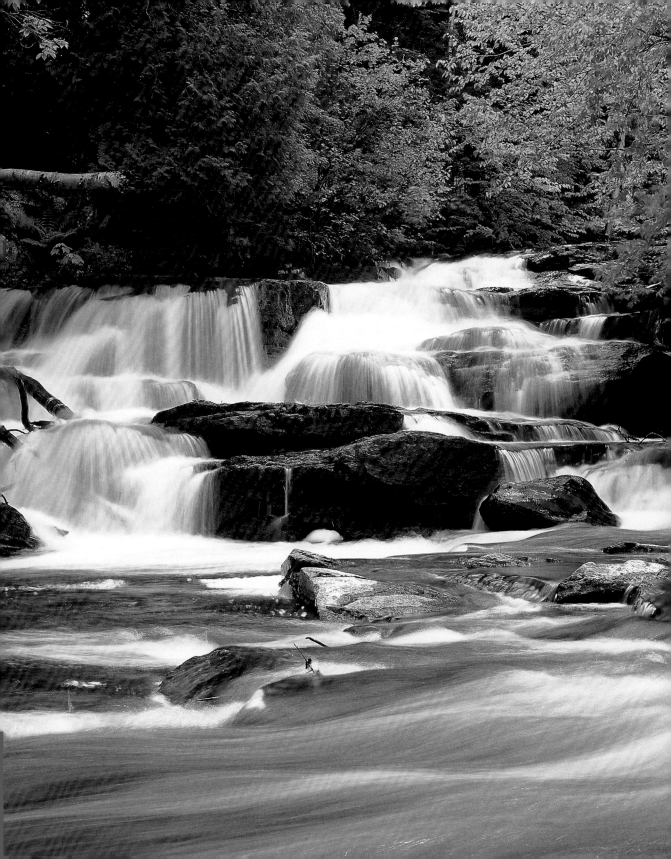

Price Rapids

🚗 **Exit Hwy. 401 at Hwy. 37 in Belleville and go north to the end of Hwy. 37, then turn left onto Hwy. 7. Price Rapids is located on the south side of Hwy. 7, just 300 m (1,000 ft.) west of the terminus of Hwy. 37. Look for the signs for the conservation area, and park in the small lot on the east side of the river.**

Flinton Falls may be visited by car by going east on Hwy. 7 from Price Rapids, following Flinton Rd. north and keeping to the left once you reach the village. Park in the little lot at the small park on the right side of the road.

COUNTY:	Hastings
NEAREST SETTLEMENT:	Actinolite
RIVER:	Skootamatta River
CLASS:	Cascade
TRAIL CONDITIONS:	Moderate
ACTIVITY:	Moderate
SIZE:	Small
RATING:	Mediocre
NTS MAP SHEET:	31 C/11
UTM COORDINATES:	18T, 315104, 4935381
WALKING TIME:	3 minutes

Price Rapids is actually made up of several small cascades located along the Skootamatta River within the Price Conservation Area. No more than a few meters in height, the falls themselves are rather unspectacular. But the little conservation area makes for a pleasant pit stop on the five-hour drive between Toronto and Ottawa. The first rapids are within sight of the Highway 7 bridge, but are easily missed since they face south.

Billa Flint moved from Belleville to build a sawmill here in 1853, and in 1864, built what was at the time the largest flour mill in Hastings County. At the time, the nearby village of Actinolite was known as Troy; it later became Bridgewater. Flint also went on to open a sawmill, a flour mill and other early industries at the village of Flinton, about 18 kilometers (11 mi.) to the northeast.

If you have a canoe, you can also visit High Falls which is located 3 kilometers (1.8 mi.) up the river from Price Rapids. If you want to paddle upstream for a few days, you may also enjoy visiting Vartys Rapids, Hare Falls, The Chute, Log Jam Falls and finally Flinton Falls. The trip to Flinton from Highway 7 is about 36 kilometers (22 mi.) by canoe. There are a few road crossings, but much of the route is wilderness. This route is only for experienced backwoods paddlers.

Although partially ruined by a concrete dam, Flinton Falls tumbles about 3 meters (10 ft.) and can be pretty during higher flows. The bedrock here is Tudor amphibolite, a dark black metamorphosed volcanic rock.

Prince of Wales Falls

🚗 Follow Hwy. 417 to Riverside Dr. and exit south. Follow Riverside Dr. south for about 6 km (4 mi.). Turn right onto Hogs Back Rd. and drive about 400 m (1,300 ft.) to the parking lot for the falls, on the right side of the road.

COUNTY:	Ottawa-Carleton
NEAREST SETTLEMENT:	Ottawa
RIVER:	Rideau River
CLASS:	Cascade
TRAIL CONDITIONS:	Wheelchair accessible
ACTIVITY:	Very busy
SIZE:	Large
RATING:	Average
NTS MAP SHEET:	31 G/5
UTM COORDINATES:	18T, 445256, 5024300
WALKING TIME:	2 minutes

Also known as the Hogs Back, this has long been a popular spot for an afternoon stroll, bird-watching and painting. The river falls about 7 to 8 meters (23 to 26 ft.) over a reach about 200 meters (650 ft.) long. Although this waterfall is in the middle of the city, its surroundings are not quite as sterile as at Rideau Falls, 12 kilometers (8 mi.) downstream. A high concrete retaining wall part way along the left bank ruins some of the natural beauty, but does afford a safe view of the giant cascade. The trail along the top of the retaining wall leads to a few not-so-secret fishing spots below the falls. The falls are within Hogs Back Park, which has a little snack bar and walking trails. Don't even think about hopping the fence! The rocks can be very dangerous, and there is a $100 fine.

The physical structure of this waterfall is of great interest to geologists. Unlike at most of the waterfalls in the province formed on sedimentary rock, the once-flat bedrock now "dips" into the ground at angles up to 45 degrees. Furthermore, the rock layers on one side of the river do not correspond perfectly to those on the other. If you study the rock patterns, you can see that the rock has been faulted and folded. The rocks on the east are primarily exposures of Ottawa limestone with some dolostone and shale. Rock on the west belongs to the Rockcliffe formation, which is slightly older than the Ottawa.

A trip to Prince of Wales Falls is recommended any time of year. The river blasts through the shallow chasm during spring melt, but picks its way through the rock along three or four different channels during drier times of the year.

Rideau Falls

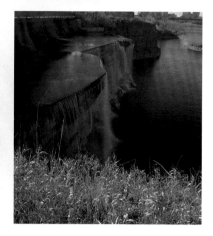

🚗 Follow Hwy. 417 to Nicholas St. and exit north. Go north for 2 km (1.2 mi.) to Rideau St. and turn right. Only a short distance further, turn left onto King Edward Ave., and continue north to Sussex Dr. Turn right onto Sussex Dr. and as soon as you cross the river, look for a parking spot. Parking may be available at Ottawa City Hall or the French Embassy, both of which are located within steps of the waterfalls. There are also a limited number of parking spots on the residential streets to the east, such as Stanley, John or Alexander Sts.

COUNTY:	Ottawa-Carleton
NEAREST SETTLEMENT:	Ottawa
RIVER:	Rideau River
CLASS:	Plunge
TRAIL CONDITIONS:	Wheelchair accessible
ACTIVITY:	Very busy
SIZE:	Large
RATING:	Mediocre
NTS MAP SHEET:	31 G/5
UTM COORDINATES:	18T, 445497, 5032076
WALKING TIME:	3 minutes

Hidden just four blocks from the residence of the Prime Minister of Canada, Rideau Falls has been a well-known feature of Ottawa's landscape for more than a century. Early European explorers paddling up the Ottawa River would have been treated to a beautiful pair of curtainlike waterfalls plunging straight over the high cliffs along the south side of the river. The east falls are separated from the smaller west by Green Island, barely 100 meters (325 ft.) apart. It is thought that Samuel de Champlain gave the falls their name, which means "curtain" in French.

Unfortunately, today's view of the falls from shore is arguably lackluster. The big city has been engineered all around the Rideau River in an apparently determined attempt to remove any evidence of nature from the once beautiful site. A footbridge allows busloads of tourists to walk right above the crest of the falls, but even further clutters the channelized reaches of the Rideau River. The city's nighttime lighting of the two falls was completed in 1997 and was very tastefully done.

The site has played an important role in the development of Ottawa. Towards the middle of the 18th century, a giant milling complex was developed beside the falls by Thomas MacKay. MacKay also built Rideau Hall, which was occupied by his family before becoming the current official residence of Canada's Governor-General. The mills made use of the power available from the 9-meter (30 ft.) drop of the waterfall. The river plunges over the Ottawa formation, which is primarily a well-bedded and well-jointed dull gray limestone. In winter, the waterfall takes on a whole new appearance as it freezes during the dead of the Ottawa winter.

Before leaving Rideau Falls, walk east along Sussex Drive to No. 24 to view the Prime Minister's residence.

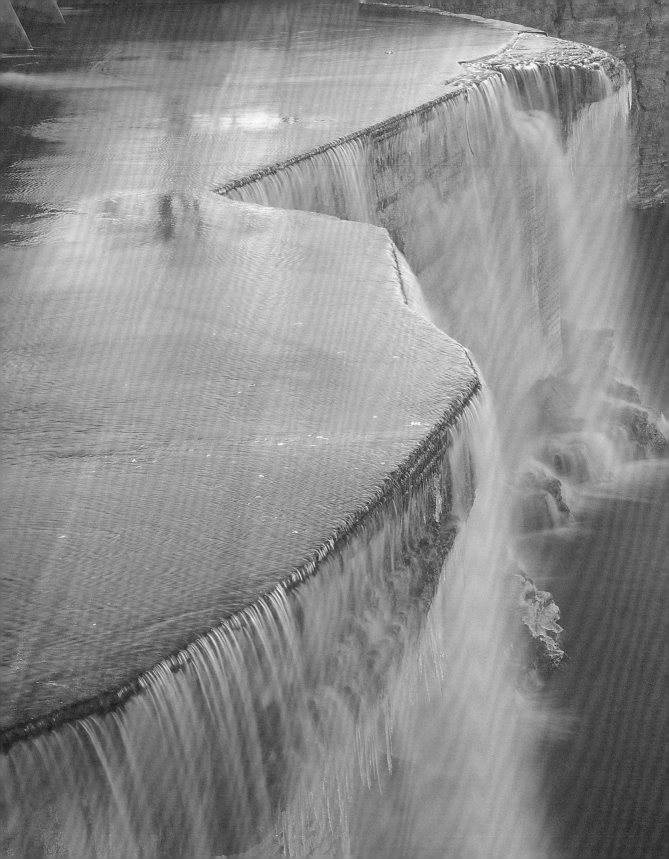

INVENTORY
OF WATERFALLS

USING A COMBINATION of travel, map analysis, research and word-of-mouth, we have developed what we believe is the most comprehensive list of waterfalls in Ontario yet compiled. Still, this list is no doubt incomplete and there are surely many more picturesque waterfalls hidden away in remote corners of the province. We have personally explored many of the sites in the list, but there are many others that we have not yet been able to visit – these have nevertheless been included in order to provide the reader with more falls to explore on their own. We would be very interested in hearing from anyone who can provide any additional information. You can write to us by mailing a letter, care of Firefly Books, or by visiting www.waterfallsofontario.ca.

Waterfalls are rated **P**, **M**, **A**, **G** and **O** for poor, mediocre, average, good and outstanding, respectively. A subscript "p" has been added to those waterfalls that are located on private property. Where no trace of the falls can be found, but the waterfall name is still used to denote a place, the letter **H** is used to indicate a historical reference. Those waterfalls that we have not personally evaluated are given no rating, denoted by a dash.

If you are using a Global Positioning System (GPS) receiver, don't expect your coordinates to always match exactly with those listed here. While we did use a GPS receiver at most of the waterfalls that we visited, we relied upon topographic maps and commercially available map software to determine coordinates for those sites that we have yet to visit. Although this could produce positional errors of up to 100 to 200 meters (325 to 650 feet), our coordinates should be good enough to help you find the falls. If you are using a topographical map, check the bottom of the map for the datum. While many older maps use the North American Datum 1927 (NAD 27), the coordinates in this list are provided in the North American Datum 1983 (NAD 83). This is a minor detail but could result in differences of up to 200 meters (650 feet) between our coordinates and your maps.

Algoma Region (and Northern Ontario)

Algoma

Waterfall	Settlement	River	Rating	NTS Map Sheet	UTM Coordinates
Agawa F.	Frater	Agawa R.	G	41N/7	16T; 686050; 5250050
Aubrey F.	Aubrey Falls	Mississagi R.	G	41J/14	17T; 331612; 5197555
Batchewana Casc.	Batchewana Bay	Batchewana	A	41K/15	16T; 688242; 5206738
Beaver F.	Island Lake	Northland C.	M	41K/9	16T; 718985; 5180206
Bells F.	Bellingham	Little White R.	A	41J/6	17T; 323801; 5140551
Black Beaver F.	Agawa Canyon	Beaver C.	A	41N/8	16T; 689600; 5254600
Bridal Veil F.	Agawa Canyon	Agawa R. Trib.	A	41N/8	16T; 689600; 5254600
Cameron F.	Massey	Sable R.	–	41J/8	17T; 411408; 5126156
Cataract F.	Blind River	Blind R.	A	41J/7	17T; 347513; 5124527
Cedar F.	Wawa	Magpie R.	–	42C/2	16T; 671907; 5342230
Chippewa F.	Chippewa Falls	Chippewa R.	O	41K/16	16T; 695954; 5200602
Chippewa F. (Upper)	Chippewa Falls	Chippewa R.	A	41K/16	16T; 695992; 5200614
Crystal F.	Sault Ste. Marie	Crystal C.	O	41K/9	16T; 708850; 5163315
Dore F.	Michipicoten Hrbr.	Dore R.	Pp	41N/15	16T; 653230; 5316118
Granary Creek F.	Blind River	Granary C.	A	41J/7	17T; 355895; 5125825
Grand F.	Cummings Lake	Cummings L. to Tunnel L.	M	41J/6	17T; 318673; 5147482
Grindstone F.	Grindstone Creek	Grindstone C.	G	41J/11	17T; 318512; 5173607
High F	Blind River	Blind R.	G	41J/6	17T; 340980; 5129530
Kennebec F.	Serpent River	Serpent R.	A	41J/2	17T; 383396; 5118676
Lady Evelyn F.	Agawa Bay	Sand R.	G	41N/7	16T; 676600; 5261300
Little R.	Little Rapids	Little Thessalon R.	A	41J/5	17T; 303565; 5130821
Magpie F.	Wawa	Magpie R.	G	41N/15	16T; 662064; 5314233
McCarthy C.	McCarthy Lake	Serpent R.	–	41J/8	17T; 389114; 5128599
McPhail F.	Wawa	Michipicoten R.	H	41N/15	16T; 673656; 5308911
Meareau F.	Massey	Aux Sable R.	–	41J/8	17T; 414309; 5129171
Michipicoton Harbour Rd F.	Michipicoten	Un-named	M	41N/15	16T; 657476; 5314212
Minnehaha F.	Sault Ste Marie	Crystal C.	M	41K/9	16T; 708829; 5163270
Mississagi F.	Blind River	Mississagi R.	–	41J/6	17T; 343537; 5118335
Pecors F.	Pecors Lake	Serpent R.	–	41J/8	17T; 390502; 5138144
Root Casc.	Odena	Root R.	M	41K/9	16T; 707332; 5163941
Sand River F.	Lake Superior PP	Sand R.	O	41N/7	16T; 670479; 5256137
Scott F.	Wawa	Michipicoten R.	H	41N/15	16T; 667861; 5310186
Second F.	Searchmont	Goulais R.	–	41J/13	17T; 272002; 5188031
Silver F.	Wawa	Magpie R.	G	41N/15	16T; 662040; 5312066
Steephill F.	Wawa	Magpie R.	–	42C/2	16T; 667077; 5329406
Wawa F.	Wawa	Magpie R.	G	41N/15	16T; 661892; 5312039
White F.	Blind River	Blind R.	A	41J/6	17T; 344880; 5125616

Sudbury

Waterfall	Settlement	River	Rating	NTS Map Sheet	UTM Coordinates
Bear C.	Bayswater	Wanapitei R.	M	41/2	17T; 513785; 5103685
Casc. F.	Crean Hill	Vermillion R.	–	41I/6	17T; 478121; 5142409
Centre F.	Lady Evelyn Lake	Lady Evelyn R.	G	41P/8	17T; 550800; 5238199
Duncan C.	Whitefish	Vermillion R.	–	41I/6	17T; 476130; 5140094
Frank F.	Lady Evelyn Lake	Lady Evelyn R.	–	41P/8	17T; 552600; 5239400
Gordon C.	Webbwood	Wakonassin R.	A	41I/5	17T; 425938; 5150000
Helen F.	Lady Evelyn Lake	Lady Evelyn R.	G	41P/8	17T; 550300; 5237700
High F.	High Falls	Spanish R.	H	41J/1	17T; 456143; 5136394
Kettle F.	Sturgeon PP	Sturgeon R.	–	41P/2	17T; 522255; 5218908
Lorne F.	Nairn	Vermillion R.	M	41J/1	17T; 459949; 5129412
McCharles Lake Casc.	Whitefish	Vermillion R.	–	41I/6	17T; 478374; 5137952
McFadden F.	Crean Hill	Vermillion R.	–	41I/6	17T; 478176; 5144998
Meshaw F.	Bigwood	French R.	A	41I/2	17T; 533290; 5099493
Nairn F.	Nairn	Spanish R.	A	41I/5	17T; 455898; 5132396
Onaping F.	Levack Station	Onaping R.	G	41I/11	17T; 470861; 5159963
Plunge F.	Roosevelt	Hannah L.	–	41I/4	17T; 457532; 5113783
Sturgeon C.	Bayswater	Wanapitei R.	–	41I/2	17T; 513077; 5102072
The Chutes.	Massey	Aux Sables R.	G	41J/1	17T; 417362; 5119127
Timmins C.	Stinson	Wanapitei R.	H	41I/10	17T; 522282; 5152078
White Pine C.	Wanup	Wanapitei R.	–	41I/7	17T; 513422; 5135140
Whitefish C.	Whitefish Falls	Whitefish R.	G	41I/4	17T; 443319; 5107292

Thunder Bay

Waterfall	Settlement	River	Rating	NTS Map Sheet	UTM Coordinates
Aguasabon F.	Terrace Bay	Aguasabon R.	G	42D/14	16T; 491000; 5402900
Alexander F.	Nipigon	Nipigon R.	–	52H/1	16T; 400793; 5443131
Cameron F.	Cameron Falls	Nipigon R.	–	52H/1	16T; 401900; 5445200
Canoe Lake F.	Canoe L. Hwy 17	Canoe L. outlet	–	42D/15	16T; 503100; 5410800
Current River Bridge F.	Thunder Bay	Current R.	–	52A/6	16T; 338450; 5372050
Dead Horse Creek F.	Ripple	Dead Horse C.	–	42D/15	16T; 523050; 5406700
Denison F.	Pukaskwa NP	Dog R.	–	41N/14	16T; 634460; 5316093
Dog F.	Little Dog Lake	Kaministiquia R.	–	52A/12	16T; 308200; 5393600
Horne F.	Crooks	Pigeon R.	–	52A/4	16T; 301950; 5320300
Kakabeka F.	Kakabeka Falls	Kaministiquia	O	52A/5	16T; 305650; 5364151
Kashabowie F.	Kashabowie	Kashabowie R.	–	52B/9	16T; 245610; 5394086
MacKenzie F.	MacKenzie	MacKenzie R.	–	52A/10	16T; 357000; 5375100
Middle F.	Crooks	Pigeon R.	G	52A/4	16T; 305000; 5321000
Mink Creek F.	Coldwell	Mink C.	A	42D/15	16T; 535800; 5401800
Mokoman F.	Kakabeka Falls	Kaministiquia	–	52A/5	16T; 308319; 5371011
Partridge F.	Crooks	Pigeon R.	–	52A/4	16T; 286691; 5320925
Pigeon F.	Crooks	Pigeon R.	G	52A/4	16T; 306300; 5319800
Rainbow F.	Rainbow Falls PP	Hewitson R.	O	42D/14	16T; 470700; 5410300
Silver F	Little Dog Lake	Kaministiquia R.	–	52A/12	16T; 308550; 5392701
Trowbridge F.	Thunder Bay	Current R.	–	52A/6	16T; 338250; 5373050
Umbata F.	Hemlo	White R.	G	42D/9	16T; 563033; 5377007

Cottage Country Region

Haliburton

Waterfall	Settlement	River	Rating	NTS Map Sheet	UTM Coordinates
Buttermilk F.	Buttermilk Falls	Kennisis R.	A	31E/2	17T; 677390; 4995737
Castor Oil C.	Kennaway	York R.	–	31E/1	17T; 715335; 5014131
Cope F.	Cope Falls	Cope C.	–	31D/16	17T; 718664; 4982988
Drag River F.	Gelert	Drag R.	M	31D/15	17T; 688392; 4973747
Elliott F.	Norland	Gull R.	G	31D/10	17T; 672200; 4956735
Furnace F.	Furnace Falls	Irondale R.	M	31D/15	17T; 692710; 4966546
Gooderham F.	Gooderham	Irondale R.	G	31D/16	17T; 706718; 4976042
High F.	Kennaway	York R.	G	31E/1	17T; 723326; 5009881
Kennisis Log Flume	Little Hawk Lake	Kennisis R.	A	31E/2	17T; 677492; 5000981
Long Slide	Dorset	Hollow R.	A	31E/7	17T; 668231; 5013916
Moore F.	Moore Falls	Black L.	P	31D/15	17T; 673744; 4963716

RATING KEY
O = outstanding G = good A = average M = mediocre
P = poor – = not rated H = historical p = private

Waterfall	Settlement	River	Rating	NTS Map Sheet	UTM Coordinates
Nunikani Dam F.	Little Hawk Lake	Nunikani L. to Big Hawk L.	A	31E/2	17T; 677233; 5005648
Oxtongue River R.	Oxtongue Lake	Oxtongue R.	A	31E/7	17T; 660744; 5021873
Rackety F.	Deep Bay	Bob C.	M	31D/15	17T; 675112; 4970530
Ritchie F.	Lochlin	Burnt R.	A	31D/15	17T; 689897; 4977950
Three Brothers F.	Howland	Burnt R.	A	31D/15	17T; 686870; 4964930
Workman F.	Minden	Gull R.	H	31D/15	17T; 680895; 4978710
Muskoka					
Bala F.	Bala	L. Muskoka to Moon R.	A	31E/4	17T; 609222; 4985003
Bala F. (Side)	Bala	L. Muskoka to Moon R.	M	31E/4	17T; 609222; 4985003
Baxter Lake F.	Honey Harbour	Baxter L. to South Bay	–	31D/13	17T; 597558; 4970750
Baysville Dam	Baysville	Muskoka R. (South B.)	M	31E/3	17T; 648439; 5000932
Big C.	Big Chute	Severn R.	A	31D/13	17T; 604655; 4970629
Big Eddy R.	Sahanatien	Musquash R.	H	31E/4	17T; 597950; 4985846
Bracebridge F.	Bracebridge	Muskoka R. (North B.)	A	31E/3	17T; 633259; 4988662
Bracebridge F. (Upper)	Bracebridge	Muskoka R. (North B.)	M	31E/3	17T; 633280; 4988942
Crozier F.	Purbrook	Muskoka R. (South B.)	A	31E/3	17T; 647526; 4988977
Curtain C.	Dock Siding	Moon R.	M	31E/4	17T; 590126; 4992837
Dee Bank F.	Dee Bank	Dee R.	A	31E/4	17T; 616252; 5003701
Distress C.	Brooks Mills	Big East R.	G	31E/6	17T; 649622; 5036235
Fairy F.	Baysville	Muskoka R. (South B.)	A	31E/3	17T; 648078; 4997259
Flat R.	Potter's Landing	Go Home L.	P	31D/13	17T; 591800; 4982600
Flat Rock R.	Potters Landing	Go Home R.	–	31E/4	17T; 590926; 4987175
Go Home C.	Go Home	Go Home R.	–	31E/4	17T; 587722; 4985231
Gravel F.	Oxtongue Lake	Oxtongue R.	G	31E/7	17T; 664467; 5030691
Hanna C.	Muskoka Falls	Muskoka R. (South B.)	P	31E/3	17T; 633986; 4984356
Hatchery F.	Ullswater	Skeleton R.	A	31E/4	17T; 616498; 5008801
High F.	Bracebridge	Muskoka R. (North B.)	G	31E/3	17T; 633649; 4994230
Hogs Trough	Dwight	Oxtongue R.	G	31E/7	17T; 661015; 5022342
Houseys R.	Houseys Rapids	Bass L. to Kashe L.	M	31D/14	17T; 641251; 4969908
Island Portage F.	Roderick	Moon R.	–	31E/4	17T; 600958; 4987360
Jack Knife R.	Moon River	Moon R.	A	31E/4	17T; 597407; 4989927
Kashe River Casc.	Kashe Lake	Kashe R.	–	31D/14	17T; 633200; 4966200
Little High F.	Bracebridge	Potts C.	A	31E/3	17T; 633649; 4994230
Long F.	Crooked Bay	Gibson R.	–	31D/13	17T; 604614; 4977521
Marshs F.	Dwight	Oxtongue R.	M	31E/7	17T; 657687; 5019572
Matthiasville F.	Mattiasville	Muskoka R. (South B.)	M	31D/14	17T; 641734; 4983567
May C.	Fraserburg	Muskoka R. (South B.)	–	31E/3	17T; 647357; 4990609
McCutcheons F.	Vankoughnet	Black R.	A	31D/14	17T; 653758; 4983946
McDonald River F.	Crooked Bay	McDonald R.	–	31D/13	17T; 595999; 4975672
Minnehaha F.	Ullswater	Skeleton R.	A	31E/4	17T; 616069; 5008334
Moon C.	Bala	Moon R.	H	31E/4	17T; 604538; 4986274
Moon F.	Moon River	Moon R.	–	31E/4	17T; 584721; 4994968
Moon River R.	Bala	Moon R.	–	31E/4	17T; 602694; 4986248
Muskoka F.	Muskoka Falls	Muskoka R. (South B.)	A	31E/3	17T; 633763; 4984629
Mye River Casc.	Big Chute	Mye R.	A	31D/13	17T; 602843; 4971689
Peterson F.	Vankoughnet	Black R.	–	31D/14	17T; 653800; 4982580
Port Sydney F.	Port Sydney	Muskoka R. (North B.)	A	31E/3	17T; 635401; 5008373
Potts F.	Bracebridge	Pott's C.	M	31E/3	17T; 633649; 4994230
Pretty Channel R.	Big Chute	Severn R. (Pretty Channel)	–	31D/13	17T; 604523; 4972543
Ragged F.	Oxtongue Lake	Oxtongue R.	O	31E/7	17T; 663992; 5028427
Ragged R	Bala	Musquash R.	H	31E/4	17T; 603172; 4985728
Ragged R.	Hydro Glen	Severn R.	M	31D/13	17T; 618400; 4967399
Rocky R.	Matthiasville	Muskoka R. (South B.)	–	31E/3	17T; 644882; 4985860
Rosseau F.	Rosseau Falls	Rosseau R.	G	31E/4	17T; 610253; 5009373
Rosseau F. (Upper)	Rosseau	Rosseau R.	A	31E/4	17T; 611060; 5010236
Sandy Gray F.	Potters Landing	Musquash R.	A	31E/4	17T; 593254; 4987397
Seven Sisters R.	Moon River	Moon R.	A	31E/4	17T; 594450; 4991260
Slater F.	Fraserburg	Muskoka R. (South B.)	–	31E/3	17T; 645506; 4994025
Stills F.	Foot's Bay	Bass L. to L. Joseph	–	31E/4	17T; 601444; 4996972
Stubbs F.	Huntsville	Little East R.	A	31E/6	17T; 640215; 5026833
Three Rock C.	Crooked Bay	Musquash R.	–	31D/13	17T; 590400; 4979800
Trethewey F.	Muskoka Falls	Muskoka R. (South B.)	M	31D/14	17T; 636650; 4982703
Twin R.	Moon River	Moon R.	G	31E/4	17T; 586409; 4994857
Wasdell F.	Wasdell Falls	Severn R.	M	31D/14	17T; 635013; 4959793
Whites F.	Big Chute	Six Mile L. to Gloucester P.	A	31D/13	17T; 600921; 4970140
Wilsons F.	Bracebridge	Muskoka R. (North B.)	G	31E/3	17T; 633219; 4990970
Wilsons F. (North)	Bracebridge	Muskoka R. (North B.)	A	31E/3	17T; 633219; 4990970
Northumberland					
Healey F.	Healey Falls	Trent R.	G	31C/5	18T; 278428; 4917402
Ranney F.	Campbellford	Trent R.	M	31C/5	18T; 276667; 4907624
Parry Sound					
Big Pine R.	Wolseley Bay	French R.	M	41I/1	17T; 561476; 5101899
Bingham C.	Powassan	French R. (South B.)	–	31L/3	17T; 624239; 5103635
Blue C.	Wolseley Bay	French R.	M	41I/1	17T; 561143; 5100362
Brooks F.	Emsdale	Magnetawan R.	G	31E/11	17T; 633002; 5046186
Burks F.	Burks Falls	Magnetawan R.	M	31E/11	17T; 623954; 5053224
Chapmans C.	Nipissing	South R.	A	31L/4	17T; 614487; 5106558
Corkery F.	Trout Creek	South R.	–	31E/14	17T; 622353; 5093950
Cox C.	Trout Creek	South R.	–	31E/14	17T; 622628; 5085541
Crooked R.	French River	French R.	M	41I/1	17T; 556636; 5099097
Davidson C.	Trout Creek	South R.	–	31E/14	17T; 622547; 5086518
Dutchman C.	Arnstein	Pickeral R.	–	31E/13	17T; 582722; 5080056
Elliott C.	Powassan	South R.	H	31L/3	17T; 624561; 5102019

Waterfall	Settlement	River	Rating	NTS Map Sheet	UTM Coordinates
Fagans F.	Ahmic Harbour	Magnetawan Trib.	A	31E/12	17T; 598077; 5057888
Freeman C.	Trout Creek	South R.	–	31E/14	17T; 623302; 5091057
Gimball C.	Bray Lake	South R.	–	31E/14	17T; 623655; 5083083
Gitzler F.	Trout Creek	South R.	–	31E/14	17T; 623774; 5093044
Hab R.	Broadbent	Seguin R.	–	31E/5	17T; 585844; 5028305
Knoefli F.	Chikopi	Magnetawan R.	A	31E/12	17T; 599395; 5057831
Lower Burnt C.	Maple Island	Magnetawan R.	A	31E/12	17T; 583198; 5063038
McNab C.	Nipissing	South R.	–	31L/3	17T; 617690; 5106041
Mountain C.	N. Magnetawan	Seguin R.	A	31E/5	17T; 578635; 5027847
Needle Eye R.	Maple Island	Magnetawan R.	–	31E/12	17T; 581676; 5063885
Poverty Bay C.	Chikopi	Magnetawan R.	G	31E/12	17T; 597159; 5059773
Ragged R.	Hurdville	Manitouwabin R.	–	31E/5	17T; 581706; 5029306
Recollet F.	Bon Air	French R.	A	41I/2	17T; 530662; 5095979
Seller R.	Ahmic Harbour	Magnetawan R.	A	31E/12	17T; 595170; 5060476
Serpent R.	Broadbent	Seguin R.	–	31E/5	17T; 585844; 5028312
Stirling F.	Stirling Falls	Stirling C.	A	31E/11	17T; 622105; 5060001
Thirty Dollar R.	N. Magnetawan	Magnetawan R.	A	41H/9	17T; 550666; 5065555
Truisler C.	Trout Creek	South R.	–	31E/14	17T; 623627; 5091452
Upper Burnt C.	Maple Island	Magnetawan R.	M	31E/12	17T; 584429; 5062366
Peterborough					
Anstruther Creek F.	Anstruther Lake	Anstruther C.	A	31D/15	17T; 665083; 4960374
Burleigh F.	Burleigh Falls	Otonabee R.	G	31D/9	17T; 722190; 4937459
Copper Lake F.	Anstruther Lake	Anstruther C.	A	31D/16	17T; 723603; 4962298
Haultain F.	Haultain	Eels C.	Pp	31D/9	17T; 727158; 4947285
High F. (Eels 2)	Apsley	Eels C.	–	31D/16	17T; 729559; 4965222
High F. (Eels)	Stonyridge	Eels C.	G	31D/9	17T; 731087; 4942364
Marble R.	Apsley	Eels C.	M	31D/16	17T; 730532; 4961052
North Rathbun Lake F.	Anstruther Lake	Rathbun C.	–	31D/16	17T; 720571; 4962927
Perrys Creek Casc.	Burleigh Falls	Perry's C.	M	31D/9	17T; 721522; 4937948
Rathbun Dam Casc.	Anstruther Lake	Anstruther L. to Rathbun L.	–	31D/16	17T; 721418; 4961344
Serpentine Lake F.	Anstruther Lake	Serpentine L. to Copper L.	–	31D/16	17T; 722693; 4964090
Warsaw Caves F.	Warsaw	Indian R.	A	31D/8	17T; 729320; 4926964
Simcoe					
Coopers F.	Coopers Falls	Black R.	A	31D/14	17T; 639986; 4960903
Dinnertime R.	Lost Channel Ldng.	Severn R.	–	31D/13	17T; 607900; 4972400
Lavender F.	Dunedin	Noisy R.	Pp	41A/8	17T; 563166; 4901611
Little F.	Little Falls	Severn R.	A	31D/11	17T; 632463; 4956169
Port Severn R.	Port Severn	Little L. to Severn Sound	M	31D/13	17T; 601054; 4961894
Severn F.	Severn Falls	Severn R.	M	31D/13	17T; 610262; 4970224
Sparrow Lake C.	Severn River	Sophers Landing	H	31D/14	17T; 622444; 4966133
Swift R.	Swift Rapids	Severn R.	A	31D/13	17T; 615381; 4968069
Big Eddy	Coopers Falls	Black R.	–	31D/14	17T; 642000; 4961800
Fenelon F.	Fenelon Falls	Cameron to Sturgeon L.	A	31D/10	17T; 679768; 4933797
Ragged R.	Ragged Rapids	Black R.	A	31D/14	17T; 651892; 4964131
Victoria F.	Ragged Rapids	Black R.	A	31D/14	17T; 653393; 4965897

Golden Horseshoe Region

Waterfall	Settlement	River	Rating	NTS Map Sheet	UTM Coordinates
Dufferin					
Cannings F. (Lower)	Mono Centre	Nottawasaga R.	A	40P/16	17T; 573753; 4870751
Cannings F. (Upper)	Mono Centre	Nottawasaga R.	A	40P/16	17T; 573753; 4870773
Hornings Mills	Hornings Mills	Pine R.	–	41A/1	17T; 564030; 4889890
Scotts F. (Lower)	Mono Centre	Nottawasaga R.	Pp	40P/16	17T; 573542; 4871015
Scotts F. (Upper)	Mono Centre	Nottawasaga R.	Pp	40P/16	17T; 573518; 4871015
Halton					
Hwy 7 F. (Halton Hills)	Silver Creek	Un-named	M	30M/12	17T; 582681; 4835455
Hilton F.	Campbellville	Sixteen Mile C.	G	30M/12	17T; 582508; 4817941
Limehouse R.	Limehouse	Black C.	A	30M/12	17T; 582597; 4832077
Silver Creek F.	Silver Creek	Silver C.	A	30M/12	17T; 583020; 4837857
Snow Creek F. (North)	Silver Creek	Snow C.	A	30M/12	17T; 582567; 4837350
Snow Creek F. (West)	Silver Creek	Snow C. (Trib.)	P	30M/12	17T; 582592; 4837283
Hamilton					
Albion F.	Elfrida	Redhill C.	G	30M/4	17T; 595871; 4783736
Billy Green F.	Stoney Creek	Battlefield C.	M	30M/4	17T; 600213; 4784595
Borers F.	Clappisons Corners	Borer's C.	A	30M/5	17T; 586250; 4793987
Buttermilk F.	Albion Falls	Red Hill C. (Trib.)	M	30M/4	17T; 595882; 4784294
Canterbury F.	Ancaster	Canterbury C.	A	30M/4	17T; 582792; 4787783
Chedoke F.	Hamilton	Chedoke C.	A	30M/4	17T; 589257; 4788256
Chedoke F. (East)	Westcliffe	Chedoke C.	A	30M/4	17T; 589298; 4788304
Chedoke F. (Lower)	Hamilton	Chedoke C.	M	30M/4	17T; 589248; 4788942
Cliffview F.	Westcliffe	Chedoke C.	M	30M/4	17T; 588725; 4788502
Devil's Punch Bowl	Stoney Creek	Stoney C.	A	30M/4	17T; 601067; 4784921
Devil's Punch Bowl (Lower)	Stoney Creek	Stoney C.	A	30M/4	17T; 600908; 4785099
Erland F.	Fruitland	Un-named	M	30M/4	17T; 603854; 4784644
Felkers F.	Elfrida	Red Hill C. (East B.)	A	30M/4	17T; 598280; 4784121
Glover Mountain F.	Hamilton	Un-named	M	30M/4	17T; 599560; 4784760
Golf Club F. (East)	Westcliffe	Chedoke C.	M	30M/4	17T; 588783; 4785217
Golf Club F. (West)	Westcliffe	Chedoke C.	M	30M/4	17T; 588783; 4785223
Goulding Ave F.	Mountview	Chedoke C.	M	30M/4	17T; 587558; 4788652
Hermitage F.	Ancaster	Hermitage C.	M	30M/4	17T; 581495; 4788945
Mill F.	Ancaster	Ancaster C.	M	30M/4	17T; 582708; 4785595
Mt. Albion Road Casc.	Albion Falls	Red Hill C. (Trib.)	M	30M/4	17T; 596593; 4783904
Princess F. (Lower)	Mountview	Chedoke C.	M	30M/4	17T; 586875; 4788606
Princess F. (Upper)	Mountview	Chedoke C.	M	30M/4	17T; 586881; 4788694
Rousseaux Casc.	Ancaster	Ancaster C.	P	30M/4	17T; 583383; 4786979
Scenic F.	Mountview	Chedoke C.	A	30M/4	17T; 586496; 4788487
Sherman F.	Dundas	Ancaster C.	A	30M/4	17T; 583354; 4787862
Smokey Hollow Little F.	Waterdown	Grindstone C. (Trib.)	M	30M/5	17T; 590210; 4797952
Sydenham F.	Dundas	Sydenham C.	A	30M/5	17T; 584564; 4792383
Tews F.	Dundas	Logies C.	A	30M/5	17T; 582890; 4792502
Tiffany F.	Dundas	Tiffany C.	G	30M/4	17T; 584581; 4787870
Washboard F.	Dundas	Tiffany C.	A	30M/4	17T; 584595; 4787808
Waterdown F.	Waterdown	Grindstone C.	G	30M/5	17T; 590210; 4798118
Websters F.	Dundas	Spencer C.	G	30M/5	17T; 582692; 4792000
Westcliffe F.	Westcliffe	Chedoke C. Trib.	M	30M/4	17T; 588671; 4788797

RATING KEY O = outstanding G = good A = average M = mediocre
P = poor – = not rated H = historical p = private

Niagara

Waterfall	Settlement	River	Rating	NTS Map Sheet	UTM Coordinates
Balls F.	Vineland	Twenty Mile C.	O	30M/3	17T; 631482; 4777089
Balls F. (Upper)	Vineland	Twenty Mile C.	O	30M/3	17T; 631414; 4776384
Beamer F.	Grimsby	Forty Mile C.	G	30M/4	17T; 615896; 4782161
Beamer F. (Lower)	Grimsby	Forty Mile C. (Trib.)	A	30M/4	17T; 616002; 4782197
Centennial Park F.	Grimsby	Un-named	M	30M/4	17T; 617560; 4782289
DeCew F.	Power Glen	Beaver Dam C.	G	30M/3	17T; 641210; 4774550
DeCew F. (Lower)	Power Glen	Beaver Dam C.	A	30M/3	17T; 640990; 4774549
East Eighteen Mile Cr. F.	Jordan	Eighteen Mile C. (East B.)	M	30M/3	17T; 633582; 4776871
Faucet F.	DeCew	Twelve Mile C. (Trib.)	A	30M/3	17T; 641134; 4774588
Fruitland Road F. (Lower)	Fruitland	Un-named	M	30M/4	17T; 605050; 4784444
Fruitland Road F. (Upper)	Fruitland	Un-named	M	30M/4	17T; 605040; 4784398
Hillside Casc.	Beamsville	Bartlett C.	P	30M/3	17T; 624864; 4778990
Louth F.	Jordan	Sixteen Mile C.	G	30M/3	17T; 634180; 4775968
Louth F. (Upper)	Louth	Sixteen Mile C.	M	30M/3	17T; 633950; 4775660
Martins F.	Rockway	Martins C.	M	30M/3	17T; 636636; 4774597
Middle Eighteen Mile Cr. F.	Jordan	Eighteen Mile C. (Middle)	M	30M/3	17T; 633475; 4776767
Niagara F.	Niagara Falls	Niagara R.	O	30M/3	17T; 656616; 4771456
Rockway F.	Rockway	Fifteen Mile C.	O	30M/3	17T; 636421; 4774521
Swayze F.	St. John's	Twelve Mile C. (Trib.)	G	30M/3	17T; 638094; 4772537
Terrace F.	DeCew Falls	Terrace C.	A	30M/3	17T; 639957; 4772833
Thirty Road F.	Beamsville	Thirty Mile C.	M	30M/4	17T; 620852; 4780535
West Eighteen Mile Cr. F.	Jordan	Eighteen Mile C. (West B.)	A	30M/3	17T; 632925; 4777321

Peel

Waterfall	Settlement	River	Rating	NTS Map Sheet	UTM Coordinates
Churches F.	Cataract	Credit R.	A	40P/16	17T; 578615; 4852491

Waterloo

Waterfall	Settlement	River	Rating	NTS Map Sheet	UTM Coordinates
Devil's Creek F.	Cambridge	Devil's C.	A	40P/8	17T; 553979; 4802695
Devil's Creek F. (North)	Cambridge	Devil's C.	M	40P/8	17T; 553636; 4802789

Wellington

Waterfall	Settlement	River	Rating	NTS Map Sheet	UTM Coordinates
Elora Gorge F.	Elora	Grand R.	O	40P/9	17T; 545837; 4836544
Elora Little Waterfall	Elora	Un-named	A	40P/9	17T; 545464; 4835931
Everton Casc.	Everton	Eramosa R.	A	40P/9	17T; 568213; 4834547
Irvine Creek Casc.	Elora	Irvine C.	A	40P/9	17T; 544725; 4837981

Lake Huron Region

Bruce

Waterfall	Settlement	River	Rating	NTS Map Sheet	UTM Coordinates
Colpoys F.	Colpoy's Bay	Colpoy's C.	M	41A/14	17T; 490094; 4958818
Gillies Lake F.	Gillies Lake	Gillies L. to Georgian Bay	M	41H/3	17T; 479309; 4991568
Sauble F.	Sauble Falls	Sauble R.	G	41A/11	17T; 479741; 4947009

Grey

Waterfall	Settlement	River	Rating	NTS Map Sheet	UTM Coordinates
Antheas Waterfall	Blantyre	Minniehill C.	A	41A/10	17T; 530029; 4928589
Duncan F.	Duncan	Mill C.	Pp	41A/8	17T; 543555; 4920104
Epping F.	Epping	Un-named	Pp	41A/7	17T; 535725; 4922766
Eugenia F.	Eugenia Falls	Beaver R.	A	41A/7	17T; 537755; 4906776
Fairmount F.	Fairmount	Un-named	Pp	41A/7	17T; 536143; 4926899
Feversham Gorge	Feversham	Beaver R.	G	41A/8	17T; 549371; 4909324
Hayward F.	Ebordale	Rocky Saugeen R.	Pp	41A/2	17T; 517700; 4899542

Waterfall	Settlement	River	Rating	NTS Map Sheet	UTM Coordinates
Hoggs F.	Flesherton	Boyne R.	A	41A/7	17T; 536539; 4904036
Indian F.	Balmy Beach	Indian C.	G	41A/10	17T; 503637; 4940885
Inglis F.	Inglis Falls	Sydenham C.	O	41A/10	17T; 505224; 4930346
Jones F. (Pottawatomi)	Springmount	Pottawatomi R.	A	41A/10	17T; 501151; 4933983
Keefer F.	Annan	Keefer C.	A	41A/10	17T; 512977; 4941096
Maxwell F.	Owen Sound	Maxwell C.	M	41A/10	17T; 501517; 4933519
McGowan F.	Durham	Saugeen R.	M	41A/2	17T; 515220; 4891763
Minniehill F.	Minniehill	Minniehill C.	A	41A/10	17T; 531448; 4928136
Oxenden F.	Oxenden	Gleason Brook	A	41A/14	17T; 492205; 4957009
Traverston Casc.	Traverston	Rocky Saugeen R. Trib	M	41A/7	17T; 520311; 4901831
Walters F.	Walters Falls	Walters C.	A	41A/7	17T; 522921; 4926231

Huron

Waterfall	Settlement	River	Rating	NTS Map Sheet	UTM Coordinates
Falls Reserve	Goderich	Maitland R.	A	40P/12	17T; 448038; 4839916

Lambton

Waterfall	Settlement	River	Rating	NTS Map Sheet	UTM Coordinates
Rock Glen F.	Arkona	Bear C.	G	40P/4	17T; 433202; 4770599

Manitoulin

Waterfall	Settlement	River	Rating	NTS Map Sheet	UTM Coordinates
Bridal Veil F.	Kagawong	Kagawong R.	G	41G/16	17T; 402531; 5083758
High F.	Manitowaning	Francis Brook	A	41H/13	17T; 433728; 5072175

Middlesex

Waterfall	Settlement	River	Rating	NTS Map Sheet	UTM Coordinates
Mystery F.	Hungry Hollow	Ausable R. (Trib.)	Pp	40P/4	17T; 434126; 4773037

Ottawa Valley Region

Frontenac

Waterfall	Settlement	River	Rating	NTS Map Sheet	UTM Coordinates
Bedford Mills Casc.	Bedford Mills	Devil L. to Loon L.	M	31C/9	18T; 388392; 4940050
Birch R.	Ompah	Mississippi R.	–	31C/15	18T; 354013; 4980710
Kings C.	Donaldson	Mississippi R.	–	31C/15	18T; 361985; 4977310
Kings F.	Donaldson	Mississippi R.	H	31C/15	18T; 359283; 4977091
Marble R.	Myers Cave	Mississippi R.	M	31C/14	18T; 329500; 4968922
Mountain C.	Black Donald	Madawaska R.	H	31F/2	18T; 350101; 5006418
Otter R.	Snow Road Stn.	Mississippi R.	A	31C/15	18T; 362828; 4977756
Ragged C.	Mississippi Stn.	Mississippi R.	G	31C/15	18T; 363998; 4978132
Sideham R.	Ompah	Mississippi R.	–	31C/15	18T; 356736; 4980853
Whitefish R.	Myers Cave	Mississippi R.	A	31C/14	18T; 332844; 4967321

Hastings

Waterfall	Settlement	River	Rating	NTS Map Sheet	UTM Coordinates
Belleville R.	Belleville	Moira R.	M	31C/3	18T; 308720; 4897418
Big C.	McArthur Mills	Little Mississippi	Pp	31F/5	18T; 300782; 4997925
Callaghans R.	Marmora	Crowe R.	A	31C/5	18T; 285753; 4924820
Chisholms Mills	Chisholms Mills	Moira R.	A	31C/6	18T; 316033; 4913616
Conroy R.	Boulter	York R.	–	31F/5	18T; 294000; 5013400
Cordova F.	Cordova Mines	Crowe R.	G	31C/12	18T; 275717; 4937661
Cordova F. (Lower)	Cordova Mines	Crowe R.	A	31C/12	18T; 276091; 4937360
Cordova F. (Middle)	Cordova Mines	Crowe R.	A	31C/12	18T; 275854; 4937035
Egan C.	Bowen Corner	York R.	G	31F/4	18T; 284515; 4995230
Farm C.	Bancroft	York R.	A	31F/5	18T; 283655; 4995898
High F.	Maple Leaf	Papineau C.	A	31F/5	18T; 278646; 5018314
High F.	Actinolite	Skootamatta R.	A	31C/11	18T; 315216; 4937171
High F.	Birds Creek	York R.	C	31F/4	18T; 270600; 5000000
McArthur F.	McArthur Mills	Little Mississippi	A	31F/3	18T; 297760; 5000239
Neuman F.	Maple Leaf	Papineau C.	M	31F/5	18T; 274864; 5015672
Price R.	Actinolite	Skootamatta R.	M	31C/11	18T; 315104; 4935382

Waterfall	Settlement	River	Rating	NTS Map Sheet	UTM Coordinates
The Big C.	Hartsmere	Little Mississippi	–	31F/5	18T; 300408; 4997551
The Gut	Lake	Crowe R.	G	31C/13	18T; 272043; 4960911
Lanark					
Appleton R.	Appleton	Mississippi R.	M	31F/1	18T; 411655; 5003592
Arklan R.	Carleton Place	Mississippi R.	M	31F/1	18T; 411255; 5000557
Blakeney R.	Blakeney	Mississippi R.	G	31F/8	18T; 402038; 5013482
Craigs C.	French Line	Clyde R.	–	31F/2	18T; 379976; 4997636
Fergusons F.	Fergusons Falls	Mississippi R.	P	31F/1	18T; 398762; 4989626
Grand F.	Almonte	Mississippi R.	A	31F/1	18T; 405891; 5008716
High F.	Dalhousie Lake	Mississippi R.	H	31C/15	18T; 373075; 4979025
Innisville F.	Innisville	Mississippi R.	P	31F/1	18T; 401487; 4989544
Mill F.	Almonte	Mississippi R.	M	31F/1	18T; 405813; 5009097
Smiths F.	Smiths Falls	Rideau R.	M	31C/16	18T; 419330; 4972188
Watsons R.	Brightside	Clyde R.	–	31F/1	18T; 382795; 4997751
Leeds and Grenville					
Jones F.	Jones Falls	Rideau R.	H	31C/9	18T; 401785; 4933162
Old Slys Locks Casc.	Smiths Falls	Rideau R.	M	31C/16	18T; 419455; 4971237
Lennox and Addington					
Buttermilk F.	Forest Mills	Salmon R.	M	31C/6	18T; 336183; 4910464
Crooked Slide	Combermere	Rockingham C.	A	31F/5	18T; 295269; 5027476
Crowe Bridge R.	Crowe Bridge	Crowe R.	A	31C/5	18T; 280547; 4917701
Flinton F.	Flinton	Skootamatta R.	A	31C/11	18T; 324696; 4950986
Forest Mills	Forest Mills	Salmon R.	A	31C/6	18T; 336788; 4911045
Napanee F.	Napanee	Napanee R.	M	31C/7	18T; 344660; 4901592
Newburgh F.	Newburgh	Napanee R.	A	31C/7	18T; 350536; 4909602
Yarker F.	Yarker	Napanee R.	A	31C/7	18T; 358996; 4914620
Nipissing					
Allen R.	Coldspring Lake	Nippissing R.	–	31E/15	17T; 667607; 5082383
Brigham C.	Algonquin Park	Barron R.	G	31F/3	18T; 293913; 5084823
Crow River F.	Francis Lake	Crow R.	G	31E/16	17T; 718072; 5093010
Crystal F.	Crystal Falls	Sturgeon R.	H	31L/5	17T; 587298; 5144675
Daisy Lake F.	Daisy Lake	Petawawa	A	31E/10	17T; 661791; 5060549
Devils Cellar R.	Lake Traverse	Petawawa R.	A	31E/16	17T; 725395; 5092628
Devils C.	Lake Traverse	Petawawa R.	A	31L/1	17T; 704454; 5098950
Duchesnay F.	North Bay	Duchesnay R.	A	31L/5	17T; 614620; 5132436
Eau Claire Gorge F.	Eau Claire	Amable du Fond R.	G	31L/7	17T; 660500; 5124532
Gravelle C.	Kiosk	Amable du Fond R.	–	31L/2	17T; 659528; 5112388
Gut R.	Kennaway	York R.	A	31E/1	17T; 722044; 5011237
High C.	L'Amable	Madawaska R.	–	31E/9	17T; 724334; 5043531
High F.	Achray	Barron R.	G	31F/3	18T; 291023; 5081828
High F.	Achray	Carcajou C.	A	31F/3	18T; 284347; 5079165
High F.	Whiskyjack Lake	Nipissing R.	G	31E/15	17T; 675985; 5086007
Laurel Lake F.	Little Cauchon L.	Cauchon C.	M	31L/2	17T; 684058; 5103178
Lion C.	Mattawa	Antoine C.	–	31L/7	17T; 664540; 5136015
Long R.	L'Amable	Madawaska R.	–	31E/9	17T; 722554; 5043456
Palmer R.	Palmer Rapids	Madawaska R.	G	31F/5	18T; 300905; 5022673
Paresseaux F.	Eau Claire Station	Mattawa R.	G	31L/7	17T; 656204; 5129647
Petit Paresseaux F.	Eau Claire Station	Mattawa R.	–	31L/7	17T; 656145; 5128667

Waterfall	Settlement	River	Rating	NTS Map Sheet	UTM Coordinates
Red Pine C.	Rutherglen	Kaibuskong R.	–	31L/6	17T; 647195; 5127488
Sandy F.	Harfred	Sturgeon R.	–	31L/5	17T; 586200; 5136713
Squirrel R.	Number One Lake	Barron R.	M	31F/3	18T; 301507; 5082818
Stone C.	Achray	Carcajou C.	–	31F/3	18T; 281043; 5080271
Sturgeon F.	Sturgeon River	Sturgeon R.	H	31L/5	17T; 581962; 5135577
Talon C.	Blanchards Ldng.	Mattawa R.	A	31L/6	17T; 653881; 5127364
Tea F.	Tea Lake	Oxtongue R.	–	31E/7	17T; 675464; 5039827
Tim River F.	Queer Lake	Tim R.	A	31E/10	17T; 665788; 5066713
Upper Twin F.	Tea Lake	Oxtongue R.	M	31E/7	17T; 673089; 5037782
Ottawa-Carleton					
Burritts R.	Burritts Rapids	Rideau R.	H	31B/13	18T; 437235; 4981052
Chaudiere F.	Ottawa	Ottawa R.	–	31G/5	18T; 443536; 5029862
Prince of Wales F.	Ottawa	Rideau R.	A	31G/5	18T; 445256; 5024301
Rideau F.	Ottawa	Rideau R.	M	31G/5	18T; 445497; 5032077
Prescott and Russell					
High F.	Casselman	South Nation R.	H	31G/6	18T; 492707; 5018658
Jessups F.	Jessups Falls	South Nation R.	H	31G/11	18T; 495068; 5045003
Prince Edward					
Millford F.	Milford	Black C.	A	30N/14	18T; 331159; 4866875
Renfrew					
Aumonds R.	Guiney	Madawaska R.	M	31F/6	18T; 310049; 5017001
Barrett C.	Barrett Chute	Madawaska R.	H	31F/7	18T; 361366; 5012241
Black C.	Rocher Fendu	Ottawa R. (Main Channel)	A	31F/10	18T; 363201; 5065330
Bonnechere F.	Castleford Station	Bonnechere R.	G	31F/7	18T; 378049; 5039574
Chats F.	Arnprior	Ottawa R.	H	31F/8	18T; 402836; 5037396
Coliseum C.	Rocher Fendu	Ottawa R. (Main Channel)	A	31F/10	18T; 364397; 5064815
Constant Creek Bridge C.	Calabogie	Constant C.	M	31F/7	18T; 361516; 5017147
Constant Creek F.	Calabogie	Constant C.	M	31F/7	18T; 361280; 5017367
Dochart Creek F.	Arnprior	Dochart C.	Pp	31F/8	18T; 392114; 5033274
Exam Time R.	Bruceton	Madawaska R.	–	31F/3	18T; 315686; 5011794
Fifth C.	Eganville	Bonnechere R.	M	31F/11	18T; 336528; 5044566
Foresters F.	Foresters Falls	McNaughton's C.	–	31F/10	18T; 361452; 5059489
Fourth C.	Fourth Chute	Bonnechere R.	G	31F/11	18T; 343128; 5040857
Fourth C. (Upper)	Fourth Chute	Bonnechere R.	M	31F/11	18T; 343121; 5040891
Grants Creek F.	Stonecliffe	Grants C.	A	31K/4	17T; 273105; 5120040
Highland F.	Griffith	Madawaska R.	A	31F/6	18T; 327788; 5013467
Jacks C.	Bonnechere	Bonnechere R.	–	31F/12	18T; 298254; 5060889
Jenkins C.	Paugh Lake	Sherwood R.	–	31F/12	18T; 296454; 5052602
Loneys C.	Ireland	Little Mississippi R.	–	31F/5	18T; 299979; 5008524
Pakenham F.	Pakenham	Mississippi R.	A	31F/8	18T; 399170; 5021116
Rifle C.	Bruceton	Madawaska R.	M	31F/3	18T; 316049; 5011573
Second C.	Renfrew	Bonnechere R.	A	31F/7	18T; 367652; 5037276
Slate F.	Griffith	Madawaska R.	–	31F/3	18T; 321521; 5011695
Split Rock R.	Bruceton	Madawaska R.	A	31F/3	18T; 316553; 5011080
Third C.	Douglas	Bonnechere R.	–	31F/10	18T; 348774; 5041185
Wadsworth R.	Griffith	Madawaska R.	M	31F/3	18T; 325386; 5012607

RATING KEY	O = outstanding G = good A = average M = mediocre
	P = poor – = not rated H = historical p = private

Glossary

Abrasion Wearing and smoothing of rock by a stream. Most of the wear is caused by sand and rock particles carried by the stream as opposed to the water itself.

Basalt A dark black igneous rock formed from ancient lava flows. Individual mineral crystals cannot be seen. Occasionally found in Canadian Shield area.

Bedding plane Horizontal cracks between layers of sedimentary rock. The cracks represent breaks during the deposition of the material composing the rock.

Bedrock Refers to any mass of rock that is not separated from the ground.

Cap rock A resistant layer of rock situated on top of a weaker layer of rock.

Crest The part of the waterfall where the water begins to fall. Can be difficult to accurately define in cascade class waterfalls.

Debris ring Pile of cobbles, gravel and deadwood around the outside of a plunge pool. This is material pushed out of the plunge pool by swift moving waters, which can not be moved further due to the loss of stream energy downstream of the falls.

Dike Narrow band of igneous rock cutting across surrounding rock. Dikes may be more resistant than the surrounding rock, and are always newer.

Discharge Volume of water flowing along a stream per unit of time. Measurements for large streams are usually give in cubic meters per second or cubic feet per second; in small streams, liters or gallons per second.

Dolostone Rock similar in appearance to limestone. It is formed in the same way, but also contains magnesium. Dolostone forms the cap rock of the Niagara Escarpment in most of southern Ontario.

Erratic A boulder that is not the same rock type as the local bedrock. Erratics were transported for perhaps hundreds of miles by the glaciers. For example, boulders of rock types normally found in the Canadian Shield can be found in Niagara.

Face Rock behind the waterfall. When stream flows are low, the waterfall face may be partially dry.

Fracture A crack running through a rock formation. Often form due to the relief of stress and pressure within the rock mass.

Gneiss Metamorphic rock common in Canadian Shield region. Often mistaken for granite, but has bands of different colored minerals. Very resistant to erosion.

Gorge A steep-sided valley eroded out of bedrock by a stream. Over time, the length of a gorge increases due to the upstream movement of the waterfall by erosion.

Granodiorite Igneous rock similar to granite, but with smaller crystals.

Head Engineering term for the height of fall of a waterfall. Given equal discharges, more power is generated by falling water with a higher head.

Igneous rock Rocks formed either by volcanic activity or by solidification of magma deep underground. Formed of small interlocking mineral crystals, of varying colors and sizes.

Jackladder Powered conveyor belt once used to push logs uphill. Usually used to lift logs up to the level of a particular lake, after which the logs would be floated downstream.

Jet Stream of water flowing over a waterfall.

Karst A unique landscape sometimes formed where limestone rock is actually dissolved by carbonic acid in rain. In other parts of the world this can create huge caverns; in Ontario it is usually confined to small fissures and holes in the rock.

kW (kilowatt) One thousand watts of power.

Left bank When looking at a river and facing downstream, this is the stream bank on the left.

Limestone Sedimentary rock formed from the remains of coral reefs, and precipitation of calcite at the bottom of shallow seas. Often contains fossils. See also Dolostone.

Log flume A long "waterslide" built of wood, once used to transport logs around the destructive waters at waterfalls.

Marble Metamorphic rock that forms when limestone is exposed to great heat and pressure.

Massive Refers to a rock formation with very few fractures or bedding planes.

Metamorphic rock Rock that has undergone modification due to the extreme temperatures and pressures below the Earth's surface. Often appears layered, but unlike sedimentary rocks, often has various colors of crystals.

Penstock Large diameter pipes used to transport water downhill to a hydroelectric generating station.

Plucking Removal of bedrock pieces loosened by moving water. Bedrock pieces normally separate along fractures or bedding planes.

Plunge pool Small pool at the base of a waterfall. The force of the falling water and the debris it carries causes the bedrock to be eroded, and kept clean of even fairly large boulders. Most common in plunge-class waterfalls, but also occurs at others.

Pothole Circular depression formed in bedrock stream beds due to drilling action of the stream.

Quartzite Metamorphic rock that forms when sandstone is exposed to great heat and pressure. Usually very resistant to erosion.

Right bank When looking at a river and facing downstream, this is the stream bank on the right.

Sandstone Sedimentary rock formed by the cementation ("gluing") of sand grains. Usually a uniform color, and often resistant to erosion.

Sedimentary rock Rock formed by the cementation ("gluing") of sand, clay or organic particles. Usually appears layered, and uniform in color. Geologists give proper names to various formations, which outcrop at different locations (e.g., Lockport dolostone).

Shale Fine-grained sedimentary rock, formed from the compaction and cementation of mud and silts that settle at the bottom of the ocean. Easily eroded, and may be broken by hand. Can be dark black, gray, red or even green.

Tributary A small creek that flows into a larger creek.

Watershed The area of land that drains towards a particular stream. The watershed affects the characteristics of flow in a stream. Larger watersheds usually have more flow. When land is urbanized or farmed, flows can be very low during droughts.

Bibliography

Amabel Township Historical Society. *Green Meadows and Golden Sands: The History of Amabel Township.* Wiarton: Echo Graphics, 1984.

Baird, D. M. *Guide to the Geology and Scenery of the National Capital Area.* Ottawa: Geological Survey of Canada, 1968.

Bennett, Carol, and D. W. McCuaig. *In Search of Lanark.* Renfrew: Juniper Books, 1982.

Berton, Pierre. *Niagara: A History of the Falls.* Toronto: McLelland and Stewart Inc, 1992.

Biggar, Glenys. *Ontario Hydro's History and Description of Hydro-Electric Generating Stations.* Ontario Hydro, 1991.

Bishop, Paul, and Geoff Goldrick. "Morphology, Processes and Evolution of Two Waterfalls Near Cowra, New South Wales." *Australian Geographer,* Vol. 23 (2), pp. 116–121 (1992).

Boyce, Gerald E. *Historic Hastings.* Belleville: Hastings County Council, 1967.

Bruce Trail Association. *The Bruce Trail Reference: Trail Guides and Maps* (Ed. 21). Toronto: Bruce Trail Association, 2000.

Chapman, L. J., and D. F. Putnam. *The Physiography of Southern Ontario.* Toronto: University of Toronto Press, 1966.

Coombe, Geraldine. Muskoka: Past and Present. Toronto: McGraw-Hill Ryerson Ltd, 1976.

Douglas, Dan. *Northern Algoma: A People's History.* Toronto: Dundurn Press, 1995.

Ensminger, Scott A. *Finger Lakes Falls.* North Tonawanda: Falzguy Publishing, 2001.

——— *Niagara's Sisters.* North Tonawanda: Falzguy Publishing, 2002.

Gayler, Hugh J. (ed). *Niagara's Changing Landscapes.* Ottawa: Carleton University Press, 1994.

Gilbert, G. K. *Niagara Falls and Their History.* National Geographic Society, Monograph 1, No. 7, pp. 203–236 (1895).

Head, Stephen D., and Robert F. Nixon. *Waterfalls in the City of Hamilton.* City of Hamilton, unpublished Web document, 2002.

Hewitt, D. F. *Geology and Scenery: Peterborough, Bancroft and Madoc Area.* Ontario Department of Mines, 1969.

——— *Rocks and Minerals of Ontario.* Toronto: Ontario Department of Mines and Northern Affairs, 1972.

Hewitt, Kenneth. *Elora Gorge: A Visitors Guide.* Toronto: Stoddart, 1995.

Hudson, Brian J. *Waterfalls of Jamaica.* Kingston: University of West Indies Press, 2001.

Humphries, Doris and Campbell. *Horton: The Story of a Township.* Renfrew: Juniper Books, 1986.

Jacob, Katherine. *44 Country Trails.* Guelph: Conservation Lands of Ontario, 1998.

Keddy, Paul. *Earth, Water, Fire: An Ecological Profile of Lanark County.* Carleton Place: Motion Creative Printing, 1999.

Kor, P. S. G. *Earth Science Inventory and Evaluation of the Cannings Falls Area of Natural and Scientific Interest.* Ontario Ministry of Natural Resources.

——— *Earth Science Inventory and Evaluation of the Rockway Falls Area of Natural and Scientific Interest.* Ontario Ministry of Natural Resources.

———— *Earth Science Inventory and Evaluation of the Spencer Gorge Area of Natural and Scientific Interest.* Ontario Ministry of Natural Resources.

Lawton, Jerry and Mikal. *Waterfalls: The Niagara Escarpment.* Erin: Boston Mills Press, 2000.

Liberty, B. A. *Geology of the Bruce Peninsula, Ontario.* 40P, 41A, 41H (parts of). Ottawa: Geological Survey of Canada, 1966.

Liberty, B. A., and T. E. Bolton. *Paleozoic Geology of the Bruce Peninsula Area, Ontario.* Ottawa: Geological Survey of Canada, 1971.

Long, Gary. *This River, The Muskoka.* Erin: Boston Mills Press, 1989.

Marsh, E. L. *A History of Grey County.* Owen Sound: Fleming Publishing Company, 1931.

McIlwraith, Thomas. *Looking for Old Ontario.* Toronto: University of Toronto Press, 1997.

Mika, Nick, Helma Mika and Larry Turner. *Historic Mills of Ontario.* Belleville: Mika Publishing Company, 1987.

Miller, Jerry R. "The Influence of Bedrock Geology on Knickpoint Development and Channel-bed Degradation Along Downcutting Streams in South-central Indiana." *Journal of Geology.* Vol. 99, pp. 591–605 (1991).

Penrose, Laurie. *A Guide to 199 Michigan Waterfalls.* Friede Publications, 1996.

Plumb, Gregory. "A Scale for Comparing the Visual Magnitude of Waterfalls." *Earth Science Reviews.* Vol. 34, pp. 261–270 (1993).

Pye, E. G. *Geology and Scenery: North Shore of Lake Superior.* Ontario Department of Mines, 1975.

Rannie, William F. *Lincoln: The Story of an Ontario town.* Lincoln: W.F. Ranney, 1974.

Richardson, Bond and Wright. *History of Derby Township.* Owen Sound: Richardson, Bond and Wright Ltd., 1972.

Robertson, J. A., and K. A. Card. *Geology and Scenery: North Shore of Lake Huron Region.* Ontario Division of Mines, 1972.

Sanford, John T., I. P. Martini and R. E. Mosher. *Niagaran Stratigraphy: Hamilton, Ontario.* Michigan Basin Geological Society, 1972.

Tesmer, Irving H., and J. C. Bastedo, (ed.). *Colossal Cataract.* Albany: State University of New York Press, 1989.

Tinkler, Keith J. *Field Guide: Niagara Peninsula and Niagara Gorge.* Congress from the 3rd International Geomorphology Conference, 1993.

———— "Rockbed Wear at a Flow Convergence Zone in Fifteen Mile Creek, Niagara Peninsula, Ontario." *Journal of Geology.* Vol. 105, pp. 263–274 (1997).

Tiplin, A. H. *Our Romantic Niagara.* Niagara Falls: Niagara Falls Heritage Foundation, 1988.

Wake, Winifred (ed.). *A Nature Guide to Ontario.* Toronto: University of Toronto Press, 1997.

Waterdown East Flamborough Centennial Committee. *Waterdown and East Flamborough, 1867–1967.* Hamilton: Waterdown East Flamborough Centennial Committee, 1967.

Whipple, Kelin X., Gregory S. Hancock and Robert S. Anderson. "River Incision into Bedrock: Mechanics and Relative Efficacy of Plucking, Abrasion and Cavitation." *Geological Society of America Bulletin.* Vol. 112, pp. 490–503 (2000).

Wilson, Alice E. *A Guide to the Geology of the Ottawa District.* (A monograph issue of the Canadian field-naturalist). Ottawa: Ottawa Field-naturalist Club, 1956.

Young, R. W. "Waterfalls: Form and Process." *Zeitschrifte fur Geomorphologie,* Suppl. 55, pp. 81–95 (1985).

Zyvatkauskas, Betty. *Naturally Ontario.* Toronto: Random House of Canada, 1999.

Index

About the Authors

George Fischer

George Fischer is the author of a distinctive poster series and a number of photographic essays, including *Malta: A Journey Across Time*, *Chariots of Chrome: Classic American Cars of Cuba*, *Costa Rica: A Rainbow of Colors*, *Along the St. John River*, *The Magdalens: Islands of Sand* and *Sentinels in the Stream: Lighthouses of the St. Lawrence River*, among others. His photographs have appeared in such publications as the *New York Times*, *Islands Magazine*, *Mountain Living* and *Explore*, as well as in a variety of calendars and promotional brochures. Additional photographs may be found on his website: www.georgefischerphotography.com.

Mark Harris

Trained as a Physical Geographer, Mark Harris is also an amateur photographer, weekend explorer and self-professed waterfall junkie. He has brought his love of environment and ecotourism together to complement George's spectacular photography. Mark currently resides in London with his wife, Lisa, and works for the provincial government in natural resource management. This is his first book. Mark maintains a website about Ontario waterfalls at www.waterfallsofontario.ca. You are encouraged to visit and share stories and information about even more waterfalls.